❧ AFRICAN AMERICAN
QUILTMAKING IN MICHIGAN

# African American Quiltmaking in Michigan

### Marsha L. MacDowell, Editor

Michigan State University Press
in collaboration with the
Michigan State University Museum
East Lansing, Michigan

All Michigan State University Press books are produced on paper which
meets the requirements of American National Standard of
Information Sciences—Permanence of paper for printed materials
ANSI Z39.48-1984.

Michigan State University Press

East Lansing, Michigan 48823-5202

Library of Congress Cataloging-in-Publication Data

African American quiltmaking in Michigan / edited by Marsha MacDowell.
p.    cm.
Includes bibliographical references and index.
ISBN 0-87013-410-8 (alk. paper)
1. Afro-American quilts—Michigan—History.  2. Afro-American
quiltmakers—Michigan—Biography.  I. MacDowell, Marsha.
NK9112.A36   1997
746.46´089960774—dc21                                                                    97-17124
CIP

Printed and Bound in Hong Kong

# ᖭCONTENTS

# ꠸ ACKNOWLEDGMENTS

Special recognition is due many individuals and organizations for completing quilt inventory forms; loaning quilts; donating quilts and information; assisting at Quilt Discovery Days and in publications, exhibitions, and related educational programs; and providing financial or moral support: Lenetia Agnew, Milton Alstin, Howard Anderson, Patricia Anderson, John Barnes, Taylorie Bailey, Charline Beasley, Dave Benac, Steven Berg, Eva Boicourt, Betty Boone, Patricia Boucher, Sallie Brody, Janie Brooks, Ernie Brown, Sharon Anderson Brown, Audrey Bullett, John Cantlon, Helena Carey, Leona Center, Mildred Chenault, Gary Clark, Blanche Cox, Pat Davis, Marit Dewhurst, Richard Dunlap, Mary Lou Enders, Anne Fairchild, Bruce Fox, Deborah Grayson, Bernice Fitzpatrick Green, John Green, Bruce Haight, Bill Harris, Mary Ellen Hicks, Todd Edwin Hollis, Jennifer Jones, Maggie Jones, Joyce Laing, Mymia Large, Dorothy Lester, Ruth Lorenger, Betty MacDowell, Pepper Cory Magyar, Michelle Manning, Ben Mitchell, Peggy Moore, Lori S. Naples, Jeff Niese, Gerri Peeples, Stephanie Polzin, Kathryn Pore, Melissa Prine, Gregory Reed, Harry Reed, Janice Rolston, Joe Rolston, Lucille Rolston, Timothy Rosin, Betty Shelby, Lester Shick, Merri Silber, Ray Silverman, Consuelo Smith, Marcia Sparks, Ron Sparks, Elaine Steele, Henrietta Summers, Cledie Taylor, Pat Thompson, Corky Tuttle, Fran Vincent, Jane Wade, Steve Webster, Madeline Berry White, Nicole Wilhite, Sylvia Williams, Ben Wilson, Pat Wilson, Martha Wimbush, Naomi Wright, Cynthia Young, and members of the 1988 Michigan State University Black Heritage Celebration Caucus—Linda Beard, Anita Marshall, Annie Pitts, Harry Reed, George Rowan, and Silas Taylor.

The development of this publication benefitted greatly from discussions over the years with Cuesta Benberry, Deborah Smith Barney, Betty MacDowell, Anita Marshall, Sarah Carolyn Reese, Carole Harris, and Gladys-Marie Fry. I am also indebted to Deborah Smith Barney, Derenda Collins, C. Kurt Dewhurst, Ruth D. Fitzgerald, Deonna Green, LaNeysa Harris-Featherstone, and Elaine Steele for their helpful comments on the manuscript. Lynne Swanson's contributions were numerous—from conducting field interviews and writing exhibit labels to providing coordination of a wide variety of research and collection-management activities related to this project. Graduate assistants Deborah Smith Barney, Denise Pilato, and Catherine Johnson Adams all contributed exemplary fieldwork as did the late contracted fieldworker Wythe Dornan. Michigan State University Museum colleagues Laurie K. Sommers, LuAnne G. Kozma, Yvonne Lockwood, and Julie Avery provided encouragement and support as did Betty Boone of the Michigan Council for Arts and Cultural Affairs.

Mary Whalen deserves special recognition for her sensitivity to each quilter and her dedication to high-quality photographs that capture the strength, vitality, and individuality of each quilter. Michigan State University librarian and former co-president of the MSU Museum Associates Anita

Marshall volunteered to undertake the compliation of an annotated bibliography. Her diligence and enthusiasm have produced a wonderful tool for those we hope will be inspired to continue the task of researching African American quilters in Michigan.

Kurt and Marit Dewhurst provided needed support and encouragement at home during the many early mornings, long evenings, and weekends while this was written. Without their love and patience, it would have been impossible to have spent the writing time that so obviously took away from other family activities.

Lastly, I want to thank Fred Bohm and Julie Loehr of the Michigan State University Press, Kathleen McKevitt of IDIOM, and graphic artist Nicolette Rose for seeing that these stories and artworks are shared by many through this publication.

## CREDITS ✣

*Project Researchers*
Catherine Johnson Adams, Deborah Smith Barney, Marie Combs, C. Kurt Dewhurst, Wythe Dornan, Remi Kouessi-Tanoh Douah, Lisa Fishman, Ruth D. Fitzgerald, Deborah Grayson, Junius Griffin, Maryellen Hains, Kimberly Jenkins, Cheryl Lyons-Jenness, LuAnne G. Kozma, Yvonne H. Lockwood, Denise Pilato, Lynne Swanson, Mary Whalen, and Peter H. Wehr

*Advisory Committee Members*
Derenda Collins, Marie Combs, Maryellen Hains, Carole Harris, Cheryl Lyons-Jenness, Anita Marshall, Ben Miller, and Jeffalone Rumph

*Photographer of Quilters*
Mary Whalen (unless otherwise noted)

*Exhibit Designers*
Lynne Swanson and Carole Harris

*Exhibit Registrar and Assistant Curator*
Lynne Swanson

*Collection Coordinators*
Chantel Cummings, LaNeysa Harris-Featherstone, and Dan Gilmore

*Curatorial Assistants*
Catherine Johnson Adams and Melanie Atkinson

*Exhibit Technicians*
Phil Lienhart and Walt Peebles

*Educational Programming*
Martha Brownscombe and Kristine Morrissey

*Computer Program Development*
Catherine Johnson Adams, Kevin Hendrickson, and Peter H. Wehr

*Gallery Notes Editor*
Sue Caltrider, Publications and Design, MSU

*Administrative Assistance*
Judy DeJaegher, Francie Freese, Terry Hanson, and Rosanne Jekot

*Traveling Exhibit Coordinators*
Gerna Rubenstein and Frances Vincent

*Funding*
Funding for this project was provided by grants from the Michigan State All-University Research Initiation Grant Program, Michigan State University Foundation, Greater Lansing Foundation, Michigan State University Black History Celebration Committee, the National Endowment for the Arts—Folk Arts Program, and the Office of the Vice-President for Research and Graduate Studies, MSU. In-kind support for Quilt Discovery Days was provided by local co-sponsors: Muskegon County Cooperative Extension Service, Muskegon Community College, Ingham County Cooperative Extension Service, Detroit Historical Museum, Museum of African American History (Detroit), Kent County Cooperative Extension Service, Idlewild Crochet Club (Idlewild), and the Lake County Cooperative Extension. Additional support for the traveling itinerary for the exhibit was provided by the Elizabeth Halsted Lifelong Education Traveling Exhibition Endowment and the following exhibit venues: the Museum of African American History (Detroit), the Flint Institute of Arts, and the Ella Sharp Museum (Jackson).

Ongoing financial support for administration of this project was also provided by the Michigan Council for Arts and Cultural Affairs (MCACA) through funding of the Michigan Traditional Arts Program (MTAP) at the Michigan State University Museum. MTAP advances cross-cultural understanding and equity in a diverse society through the documentation, preservation, and presentation of folk arts and folklife in Michigan. Among major ongoing activities of the program are the Festival of Michigan Folklife, the Michigan Heritage Awards, the American Indian Heritage Pow Wow, the Michigan Quilt Project, the Michigan State University Museum/4-H FOLK-PATTERNS Project, the Summer Folklife Institute, the Traditional Arts Traveling Exhibits Program, and a regranting program: the Michigan Traditional Arts Apprenticeship Program.

## ✽QUILTMAKERS REPRESENTED IN THE EXHIBITION

Mary Atkins, Henrietta Bailey, Taylorie Bailey, Emma P. Brown, Charlesetta Buie, Louella Calvin, Clara Clark, Derenda Collins, Josephine Collins, Julie Copeland, Blanche Cox, Viney Crawford, Evelyn Lewis Cross, Zelma Dorris, Mattie Douglas, Alva Gamble, Alandress Gardner, Dora Gardner, Edmund Gardner, John Gardner, Martha Gilbert, Deonna Green, Ramona Hammonds, Carole Harris, Margaret Harris, Effie Hayes, Mary Hicks, Elaine Hollis, Mary Holmes, Marguerite Berry Jackson, Elizabeth Jaggers, Lethonee Jones, Willie Maddox, Teressie May, Ailene McKeller, Johnnie Miller, Dolores Moore, Rosa Parks, Myla Perkins, Sina Phillips, Kitty Pointer, Denise Reed, Lucille Riley, Essie Robinson, Laura Rodin, Jeffalone Rumph, Maggie Shanks, Gwen Spears, Elizabeth Thomas, Ione Todd, Isabell Turner, Mary Turner, Cora Vanderson, Mary White, Rosie Wilkins, Lubertha Williams, Lula Williams, Mary Williams, Maggie Wood, Mattie Woolfolk, Naomi Wright, members of the Missionary Society of the Missionary Baptist Church (Hughes, Arkansas), and members of the Young Creators 4-H Club (Muskegon, Michigan).

## ✾AFRICAN AMERICAN QUILT DISCOVERY DAYS AND LOCAL SPONSORS

February 15, 1986, Muskegon, Michigan
Muskegon County Cooperative Extension Service and Muskegon Community College

February 16, 1986, Lansing, Michigan
Ingham County Cooperative Extension Service

June 7 & 14, 1986, Detroit, Michigan
Detroit Historical Museum and Museum of African American History

June 21, 1986, Grand Rapids, Michigan
Kent County Cooperative Extension Service

July 10-11, 1986, Idlewild, Michigan
Idlewild Crochet Club and Lake County Cooperative Extension Service

# ⚘CONTRIBUTORS

**Catherine Johnson Adams** is currently a doctoral candidate in history at the University of Illinois at Urbana. She previously worked as a graduate assistant in the Michigan State University Museum and was responsible for assisting in a variety of research and public programming aspects of the African American quilt project.

**Deborah Smith Barney** is Assistant Professor, University of Michigan–Dearborn; Adjunct Research Specialist, Michigan State University Museum; and director of the McDonalds'/MSU Museum GospelFest. Dr. Barney conducted field-based research with Michigan African American quilters and has done extensive work on African American gospel music announcers. She received her Ph.D. in American studies from Michigan State University.

**Cuesta Benberry** is author of *Always There: The African-American Presence in American Quilts* (Louisville: The Kentucky Quilt Project, Inc., 1992). Ms. Benberry has been engaged in the study and research of quilt history for more than thirty years. Since 1975 her research has centered on African American quilting and she has served as author of numerous publications and consultant and curator of many exhibition and research projects in the United States and abroad. She holds a master's degree from University of Missouri–St. Louis. Ms. Benberry lectured on South African quilts in the MSU Museum's public programs associated with the African American quilt exhibition.

**Wythe Dornan** was a graduate of Kalamazoo College. She served as a fieldworker for the South Carolina Quilt Project before conducting fieldwork in Michigan for the African American quilt project. She passed away in 1994 as a result of an automobile accident.

**William Harris** is author of the play *Robert Johnson: Trick the Devil* produced Off-Broadway in New York in 1993. Harris was formerly Curator of Education at the Museum of African American History in Detroit and currently teaches at Wayne State University. He is married to quilter/designer Carole Harris.

**Darlene Clark Hine** is Hannah Distinguished Professor of History, Michigan State University, and author of numerous publications and recipient of many awards and grants. Most recently, Dr. Hine is the editor, with Elsa Barkley Brown and Rosalyn Terborg-Penn, of the widely acclaimed *Black Women in America: An Historical Encyclopedia* (Brooklyn, N.Y.: Carlson Publishers, 1993).

**Marsha L. MacDowell** is Curator of Folk Arts, Michigan State University Museum and Professor, Department of Art, MSU. Dr. MacDowell was

director for the research project that led to the exhibition *African-American Quiltmaking Traditions in Michigan.* Dr. MacDowell also serves as the coordinator of the Michigan Traditional Arts Program in partnership with the Michigan Council for Arts and Cultural Affairs and has conducted numerous research projects on traditional arts that have resulted in many exhibitions, publications, and public programs.

**Anita Marshall** is a librarian with the Chicago Public Schools. Formerly a librarian at Michigan State University, she was an active member of the MSU Black History Celebration Committee, served as co-president of the MSU Museum Associates, and was a member of the advisory committee for the African American quilting in Michigan project.

**Denise Pilato** was a graduate assistant in the Michigan State University Museum and is currently a doctoral candidate in American studies at Michigan State University.

**Lynne Swanson** is Assistant Curator of Folk Arts and Cultural Collections Manager, Michigan State University Museum. She conducted research on African American quilting, wrote exhibition label texts, co-designed the exhibition, and coordinated all loans of materials. Ms. Swanson holds a master's degree in American studies from Michigan State University and has been involved in numerous research and exhibition projects related to traditional arts.

**Mary Whalen** is a professional photographer based in Kalamazoo, Michigan, where she also works for the Kalamazoo Institute of Arts. Her work has been included in many local and regional exhibitions.

# ❧INTRODUCTION

Marsha L. MacDowell

This is the first volume on the quiltmaking traditions of African Americans[1] in Michigan. Like the exhibition *African-American Quiltmaking Traditions in Michigan*, this companion publication examines the history and meaning of quilting within Michigan African American communities. The project is part of an emerging body of knowledge about African American women. The contributions of black women have only recently been accepted as a legitimate arena of scholarly inquiry. Similarly, the study of quilts has only recently emerged as a subject of serious academic research. It is within this context that the study of Michigan's African American quilting traditions has taken place.

In the introduction to the catalogue accompanying the landmark national exhibition *Always There: The African-American Presence in American Quilts*, quilt historian Cuesta Benberry led the call to:

> dispel certain myths that had developed about African-American quilts, to examine some of the influences on these creations, to portray the enormous diversity that characterized black-made quilts, and, when possible, give voice to the quilt-makers themselves . . . [and] to listen to what African-American quiltmakers say about their work and to give them credence, whether or not their comments coincide with researchers' theories and interpretations.[2]

*African-American Quiltmaking in Michigan* responds to Benberry's challenge and demonstrates the essential role of multiple perspectives in the documentation and interpretation of cultural history. Quilters, quilt owners, folklorists, historians, community scholars, museum curators, designers, students, a playwright, family members—black and white, paid and volunteer, university and community-based, representing a spectrum of knowledge and experiences—provided input for this documentation of African American quilting in Michigan.

In 1984 the Michigan Quilt Project was established at the Michigan State University Museum. Through fieldwork, archival research, and a series of community Quilt Discovery Days, Michigan Quilt Project staff work with contracted researchers, students, community cultural specialists, volunteer historians, and textile artists to locate, document, and collect information on Michigan quilts, quilters, and quilting traditions.[3] By 1985, seventeen Quilt Discovery Days had been completed. These days gave quilters and quilt owners an opportunity to have their quilts documented and registered in the state inventory at a central community location. In addition to the documentation (photographs, quilt stories, and quilt inventory forms) gathered at these events, data were collected through archival and library research, oral history interviews, and quilt survey forms.

❧

**Opposite:** Sandy Kittle and Ann Smith-Diéye. *Family History.* (See figure 38, page 32.)

1

**Figure 1**. Advertising flyer for the African American Quilt Discovery Days in Idlewild, 1986. Photograph by MSU Instructional Media Center, courtesy Michigan State University Museum.

**Figure 2**. Quilts on display at Muskegon African American Quilt Discovery Day, February 13, 1986. Photograph by Marsha MacDowell.

**Figure 3**. Quilter being interviewed at Muskegon African American Quilt Discovery Day, February 13, 1986. Photograph by Marsha MacDowell.

The documentation methods used in the first year gathered a wide range of statewide data, but did not elicit much information about African American or other non-Euro-American quiltmaking history. Working with local organizations in communities of predominantly black populations or historically important black settlements, museum staff held a series of African American Community Quilt Discovery Days in 1986 (figure 1). Quilters and quilt owners in Detroit, Grand Rapids, Muskegon, Lansing, and Idlewild were encouraged to share their quilts and stories. Because of the active involvement of African American leaders in these communities, the African American Quilt Discovery Days successfully identified many quilts and quilters. At the first event, held in Muskegon, the work of more than thirty quilters was recorded (figures 2 and 3). More importantly, these events triggered community interest in learning more about African American quilting heritage and sharing it with a wider public.

Subsequent research included photographic documentation of African American quilters, quilts, and quilting activities; review of primary and secondary archival and library sources; and interviews with scores of African American quilters and quilt owners (figure 4). Through these efforts, hundreds of quilts were viewed and quilt survey inventory forms were completed on 240 quilts. More than fifty tape-recorded interviews were conducted and transcribed.

A wide range of individual styles and traditions of quilting designs, construction techniques, and uses within Michigan's African American communities was revealed. Such breadth provided an opportunity to examine major controversies in African American quilt scholarship—the issues of African survivals in African American material culture and whether or not a "typical African American" quilt exists. As outlined by some scholars, characteristics of such quilts include vivid color palettes, strongly contrasting color combinations, asymmetrical and strip piecing, multiple patterning, uneven and large quilting stitches, use of protective charm symbols, large design elements, use of appliquéd figurative images, and individualistic interpretations of Anglo-American traditional patterns.[4] According to Maude Southwell Wahlman, one of the leading scholars of quilts incorporating these elements, "In their choice of techniques, textiles, forms, design names, and colors, African American quilters perpetuate African techniques and ideas."[5] Wahlman, John Michael Vlach, and others have identified the similarities of these elements to textile traditions of the peoples of West and Central Africa, the groups in which much of the slave trade was centered. Despite the forced migration of Africans to the United States—primarily the southeastern states—and the suppression of many of their traditions, the body of cultural knowledge and beliefs carried by these people to the New World was not wholly erased. Indeed many traditions flourished, though sometimes altered or hidden from view.

Most studies of African American quilting or what Cuesta Benberry refers to as "ethnic quilting" have been based on quilts and quilters with strong ties to Southern rural communities, the areas of the country where the majority of the African slave populations originally existed and where

their descendants still live.[6] It is not surprising then that so many quilts containing the characteristics of African textiles are found in this region. The Michigan data included "typical African American" quilts, generally made by women who had been born and raised in the South and who migrated North and/or who kept in close contact with relatives who lived in the South. However, research also documented quilts reflecting many other traditions rooted in a variety of other experiences, including urban, Northern, multi-ethnic, occupational, and African. Thus the exhibit did not reveal a "typical African American" quilt type, but a diversity of styles, pattern names, techniques, and uses found within the Michigan African American experience.

An advisory committee composed of quilters, academic scholars, and community scholars assisted MSU Museum staff in reviewing research and developing a plan for interpreting and presenting African American quilts in an exhibition. Among the stated objectives was that this exhibition represent the diversity of quilting traditions found within the African American community. Themes outlined by the group formed the basis for the selection of the quilts and development of educational programs and included: (1) quilts as records of patterns of migration and settlement; (2) quilts expressing or documenting ethnic identity; (3) quilters as artists/quilts as art; (4) quilts as documents of personal, family, and community history; and (5) quilting traditions. The exhibition was planned to include quilt topics such as quilt clubs, quilt exhibits, the use of recycled fabrics, exchanges of patterns and fabrics, quilts used as fundraisers or for income, and quilts made as gifts for special occasions, including weddings, graduations, births, anniversaries, and other rites of passage.

In November 1990, the exhibition *African-American Quiltmaking Traditions in Michigan* opened at the Michigan State University Museum (figures 5 and 6). Fifty-four quilts representing the work of more than sixty artists were included. Accompanied by friends and family members, many of the quilters attended the opening gala and shared personal stories about their quilting experiences. Additional activities and materials to publicize the event and enhance public understanding of the exhibit included a gallery guide written by Marsha MacDowell and designed by quilter Carole Harris, an interactive computer program in the gallery to intrepret the *Todd Family Quilt* (figure 131) made by Deonna Green and Ione Todd, a series of lectures by invited scholars, workshops and demonstrations by quilters, and family activity days.[7]

The exhibition clearly demonstrated the complexity and futility of labeling a single quilt style as "typically African American." Hung next to each other, Carole Harris's *Appropriateness of Yellow* quilt (figure 128) and Rosie Wilkins's String quilt (figure 16) demonstrated similarities in the use of construction techniques and a preference for yellows, but here the similarities ended. Harris's quilt was intended for installation in an architectural setting. Wilkins's quilt was made as a bed covering. Using the scraps of satin fabric at hand, Wilkins put her pieces together as she randomly picked them up. Harris, in contrast, carefully worked out a design and chose fabrics to fit the

**Figure 4.** Deonna Green and Ione Todd talking about their quilts, Remus, Michigan, April 12, 1989. Photograph by Marsha MacDowell.

**Figure 5.** *African-American Quilting Traditions in Michigan* exhibition, Michigan State University Museum, 1991. Photograph by Marsha MacDowell.

**Figure 6.** *African-American Quilting Traditions in Michigan* exhibition, Michigan State University Museum, 1991. Photograph by Marsha MacDowell.

**Figure 7.** Educational materials in conjunction with the traveling exhibit hosted by the Flint Institute of Arts, Museum of African American History (Detroit), and the Ella Sharp Museum (Jackson). Photograph by MSU Instructional Media Center, courtesy Michigan State University Museum.

design. As her work progressed on the quilt, she constantly assessed the emerging design, improvising only slightly as she went along. Displayed alongside the "ethnic" quilts, there could be no stronger example of the diversity within African American quilting than Rosa Parks's pastel-colored, meticulously appliquéd quilt, constructed from a purchased kit of materials and pattern and executed with the even stitches of a professional seamstress (figure 143).

After closing at the Michigan State University Museum, a smaller version of the exhibition traveled to the Flint Institute of Arts, the Ella Sharp Museum (Jackson), and Museum of African American History (Detroit). At each of these venues, additional lectures and educational workshops were planned with local quilters and members of African American communities (figure 7). Reports from museum administrators and quilters testified that these activities generated new relationships between museums and community members.

Another set of voices in the exploration of African American quilting is now gathered together in this volume. The contributors and selections were chosen to represent even more perspectives on the history and meaning of quilting within individual artist's lives and in community and family contexts. These contributions describe the process of designing and conducting research that ensures that: (1) the wide range of styles, techniques, and traditions that are found among African Americans in this state is summarized; (2) opportunities for the quilters to tell their own stories through interviews are provided; and (3) this study is placed in the context of research on African Americans and other studies of African American quilts.

In an essay originally published in *American Visions*, Cuesta Benberry, among the foremost scholars of African American quilting history, outlines the recent history of scholarship in this field. She poses a series of questions challenging previous assumptions about the quilting activities of African Americans, calls for further research on African American quilting, and asks, when possible, to give voice to the quiltmakers themselves.

Darlene Clark Hine, Hannah Distinguished Professor of History at Michigan State University, examines quiltmaking as a form of women's artistic contribution historically having great meaning within African American family and community contexts, but receiving little recognition of value outside those contexts. Hine addresses the ongoing need to study and publish on the historical contributions of African American women in this country.

Marsha MacDowell's essay provides an overview of African American quiltmaking in Michigan. She explores the meaning quilts have within family and social, cultural, religious, and occupational groups; the ways quilts serve as tangible records of history, migration, and settlement; the ways in which quilts affirm African American and African identity; and the wide-ranging diversity of Anglo-American and African American designs, motifs, and techniques by Michigan quilters. Attention is also given to how some quilters use this particular form of art to express individuality and new ideas creatively.[8]

Playwright and museum educator Bill Harris contributes a poetic and jazzy tribute to Carole Harris, a graphic artist and quilt designer in Detroit. He focuses on her improvisational process of design and her sometimes deliberate, sometimes unconscious incorporation of traditional African American techniques and fabrics.[9] She is one of a small but quickly growing group of talented African American quilters whose work is heralded in national contemporary art exhibitions such as *Uncommon Beauty in Common Objects: The Legacy of African American Craft Art.* Bill Harris also addresses the underlying reasons why quilts, particularly those made by African American women, have been undervalued by Western European culture.

Through transcribed interviews, the insights and experiences of four quilters are presented. Deborah Smith Barney's interview with Rosa Parks reveals the role quiltmaking has played in this civil rights leader's life. In the interview by Marsha MacDowell with quilters Deonna Green and her mother Ione Todd, the complexity of using written and oral tradition in the production of a story quilt is revealed. Green, who sometimes collaborates on quilts with her mother, has gained national recognition for her "family history" quilts. Using embroidered words and pictures, she produces quilts that illustrate family documents, places, artifacts, and oral narratives related to the pioneer settlement of African Americans in the mid-Michigan area. Quiltmaker Sarah Carolyn Reese shares, through an interview with Marsha MacDowell, the history and philosophy behind the development of the American African quilting activities she initiated at the Hartford Memorial Baptist Church in Detroit. The classes, lectures, and exhibitions held over the past few years have had a tremendous influence in the metropolitan Detroit area.

The volume also includes a series of photographs of individual quilts and quilters that provide a sampling of the experiences of African American quilters in Michigan. The photographic portraits taken by Kalamazoo-based artist Mary Whalen sensitively capture the quiltmakers and the use of their quilts within the context of their homes and studios. The majority of these quilts and quilters were included in the exhibition at Michigan State University Museum.

To conclude the volume, Anita Marshall, a former Michigan State University librarian and member of the advisory committee for this project, compiled an extensive and annotated bibliography for those who are inspired to continue the study of African American quilters. Her references are divided into sections addressing African American quilting in general, African American quilting in Michigan, and individual quilters. Included are newspaper and journal articles, educational programs, exhibition catalogues, books, festival materials, and exhibition schedules.

More than 300 significant historical and contemporary quilts are now part of the Michigan State University Museum collections and include numerous examples of African and African American quilts. African American quilters are well represented in the Michigan Traditional Arts Research Collections. Materials include Michigan Quilt Project inventory

**Figure 8.** Rosie Wilkins (foreground) at the Smithsonian Institution's 1987 Festival of American Folklife Michigan Program in Washington, D.C. Photograph by Marsha MacDowell.

**Figure 9.** Members of the Flint Afro-American Quilt Guild at the 1991 Festival of Michigan Folklife, East Lansing, Mich. Photograph by Al Kamuda.

forms, tape-recorded interviews, photographs, videotapes, exhibit announcements, patterns, news clippings, and other materials related to Michigan quilting history. These quilts and supporting materials provide the basis for ongoing research projects that result in development of publications, exhibitions, public programs, and media projects.

The exposure offered by the exhibit has increased public awareness of African American quilters and provided the impetus for increased involvement in individual and community quilting activities. Carole Harris, for instance, has renewed her enthusiasm for exploring creative ideas in this medium and her work is now regularly included in local, state, and national exhibits. The Flint Afro-American Quilt Guild is now featured in annual Black History month educational programs at the Michigan Historical Museum, and a one-woman show of the quilts of Rosie Wilkins was held at the Michigan Women's Historical Center and Hall of Fame.

Several quilters have been invited participants in thematic programs at the Smithsonian Festival of American Folklife in Washington, D.C. and the Michigan State University Museum's annual Festival of Michigan Folklife (figures 8 and 9). In 1992, master quiltmaker Lula Williams was awarded a Michigan Traditional Arts Apprenticeship Award to teach two apprentices. In 1995 Deonna Green and in 1997 Lula Williams were honored with prestigious Michigan Heritage Awards, a recognition given annually to outstanding tradition bearers who continue with excellence and authenticity their family and community folklife.

This was a project of collaborations of many kinds—individuals with organizations, quilters with non quilters, community scholars with academic scholars, African Americans with members of other cultural backgrounds. Many voices, reflecting a wide array of experiences and interests, prompted a complex dialogue that informed the development and implementation of the research plan, the exhibition and educational programming in 1991, and now this publication. These collaborations and the chorus of voices ultimately contribute to a greater understanding of African American quiltmaking. The history of quiltmaking in Michigan by African Americans has only begun to be recorded; there are many more quilters and quilts whose stories must be documented and shared. It is hoped that this volume will prompt further investigation and expand knowledge of quilters, quilt groups, and quilt traditions so that new stories might also become part of the record.

# Notes

1.  Throughout this volume various terms and punctuation are used to describe African Americans, including Afro-Americans, Blacks, blacks, American Africans, and African-Americans. Similarly, Americans of European extraction are refered to as white, White, European-American, and, when specifically from the British Isles, Anglo-American. Every attempt has been made to honor the individual author's preferences as well as formal names of organizations.

2.  Cuesta Benberry, "Introduction," in *Always There: The African-American Presence in American Quilts* (Louisville: The Kentucky Quilt Project, Inc., 1992), 16.

3.  For a description of the project, see C. Kurt Dewhurst, Ruth D. Fitzgerald, and Marsha MacDowell, "The Michigan Quilt Project" in *Michigan Quilts: 150 Years of a Textile Tradition*, eds. Marsha MacDowell and Ruth D. Fitzgerald (East Lansing: Michigan State University Museum, 1987), 165-70.

4.  See especially Maude Southwell Wahlman, *Signs and Symbols: African Images in African-American Quilts* (New York: Studio Books in association with Museum of American Folk Art, 1993); Robert Farris Thompson, "African Influences on the Art of the United States," in *Black Studies in the University: A Symposium*, eds. A. Robinson, et al. (New Haven, Conn.: Yale University Press, 1969); *The Afro-American Tradition in Decorative Arts* (Cleveland: The Cleveland Museum of Art, 1978); Eli Leon, *Who'd A Thought It: Improvisation in African-American Quiltmaking* (San Francisco: Craft and Folk Art Museum, 1987); and Roberta Horton, *Calico and Beyond: The Use of Patterned Fabric in Quilts* (Lafayette, Calif.: C & T Publishing, 1986), 44.

5.  Wahlman, *Signs and Symbols*, 116.

6.  Cuesta Benberry, conversations with author. See also Penny McMorris, *Quilting II* (Bowling Green, Ohio: Bowling Green State University, WBGU, 1982), 53.

7.  See Marsha MacDowell, "African-American Quiltmaking Traditions in Michigan," printed gallery notes, Michigan State University Museum, 1991. For a description of the interactive computer program see "Quilts on Computers?," *The Associate* (Newsletter of the Associates of the Michigan State University Museum) 8, no. 3 (1991): 7.

8.  Biographical data and excerpts of narratives were drawn from Michigan Quilt Project Inventory forms, field notes, and the tape-recorded interviews, conducted by C. Kurt Dewhurst, Yvonne Lockwood, Melissa Prine, Remi Kouessi-Tanoh Douah, Marsha MacDowell, Lynne Swanson, Denise Pilato, Deborah Smith Barney, and Wythe Dornan. These materials are housed in the Michigan Traditional Arts Research Collections at Michigan State University Museum. Materials collected by Denise Pilato are catalogued under the name Denise Grusz; those collected by Catherine Johnson Adams are catalogued under Catherine Johnson.

9.  Harris, whose work *Robert Johnson: Trick the Devil* was produced Off-Broadway in New York City, is married to Carole Harris.

# ❦THE THREADS OF AFRICAN- AMERICAN QUILTERS ARE WOVEN INTO HISTORY

Cuesta Benberry

Why, after many years of near invisibility, have African-American quilts become so engrossing to art historians, folklorists, ethnologists, and quilt historians? African Americans have made quilts in this land continuously from the late eighteenth century, yet their work is conspicuously absent from the many published accounts of American quilt history.

Several factors, products of the times, form the basis for the current explorations of African-American quilts. As a result of the 1960s–1970s civil rights movement, black history attained the status of a legitimate discipline. Concomitant with blacks' civil rights actions was the women's movement, which coincided with the quilt movement of the last quarter of the twentieth century. Further impetus came from ecologists, who espoused the need to return to plain, self-reliant, and healthy living.

A new cadre of quilt historians treated the study of patchwork quilts as a scholarly discipline, and not as a minor adjunct to the studies of art history, folklore or women's studies. These historians were determined to produce an accurate history of quilts, to document fully quilts and quiltmakers past and present, and to explore topics never before researched in the context of quilt history.

Another factor was the 1976 bicentennial of the Declaration of Independence, an event accompanied by a celebration of ethnic diversity in our multicultural society. Certain historians placed a priority on investigating the ways quilts of various ethnic groups connected to the social, political, and economic conditions of their lives in America. High drama was associated with early research on African-American-American quilts. Scholars located a small group of quilts profoundly different visually from the accepted aesthetic of traditional American patchwork quilts. These idiosyncratic quilts from black women of rural Southern and similar backgrounds were examined closely for stylistic variances, construction techniques, fabric color choices, and symbolic design references.

Most exciting of all was a linkage between black American quilts and African design traditions, believed to indicate an unconscious cultural memory in the quiltmakers of their faraway motherland. African-American quilts became one of America's newest forms of exotica.

Continued scrutiny of the quilts resulted in the promulgation of a number of theories that were immediately accepted as fact. Visual criteria for recognizing African-American quilts (stitch length, asymmetrical organization of quilt patches, size of patches, frequent use of bright colors) were devised. Long-established canons of quilt history research, such as determining the quiltmaker's identity, the quilt's provenance, the date of making and the fabric content, were no longer deemed essential. One needed only apply the recently created visual criteria to identify with certainty quilts of African-American origin.

❦

Opposite: Isabella Major, Blazing Star. (See figures 100-101, page 67.)

This essay originally appeared in *American Visions* 8, no. 6 (December–January 1993): 14–18 and is used here by permission of the author and publisher.

Such an extremely myopic view of African-American quilts made many scholars of black history and quilt history researchers uneasy. How could this small sample of late-twentieth-century African-American quilts represent in its entirety the contribution of thousands of black quiltmakers working at the craft over two centuries? Would the history of blacks in America affirm that they had been a monolithic group, without different experiences, environments, customs, and beliefs that would affect their creative efforts? What should one think of African-American quilts, made over such a long period of time, that did not conform to the aesthetics-based identification?

The casual answer that African-American quilts not in compliance with the criteria were simply copies of white-made, traditional Euro-American quilts was unacceptable. That reply was of dubious historical validity—a facile assessment, derived from the popular culture, of American quilt history.

What were we seeing here? How could the quiltworks of hundreds of thousands of African Americans of many regions, times, and circumstances be correctly assessed in a conjectural, non-statistically based one-sentence answer? Where was the evidence to sustain the broad conclusion? More and more questions about African-American quilts emerged as quilt historians realized that findings gathered in these early studies of black-made quilts had been extrapolated far beyond what the evidence would legitimately support.

Further research began to place African-American quilts in the larger context of black history. There was a need to dispel certain myths that had developed about African-American quilts, to examine some of the influences on these creations, to portray the enormous diversity that characterized black-made quilts, and, when possible, give voice to the quiltmakers themselves.

It is important to listen to what African-American quiltmakers say about their work and to give them credence, whether or not their comments coincide with researchers' theories and interpretations. It is certainly not useful to view African-American quilts merely as isolated folk art objects, divorced from the lives of blacks and the social, political, and economic conditions under which they have lived.

A small percentage of African-American quilts are visually exotic; the majority are not. More important than aesthetic considerations, or a discerned decorative imagery, the quilts represent a diverse body of work by an ethnic group distinguished for its lengthy participation in American quiltmaking. The record should so state, and then African-American quilts and quiltmakers will begin to attain their rightful place in American quilt history.

# ❧QUILTS AND AFRICAN-AMERICAN WOMEN'S CULTURAL HISTORY

Darlene Clark Hine

On July 19, 1988, Jesse Jackson addressed the Democratic Party Convention in Atlanta, Georgia, and made poignant remarks about the functional and political dimensions of Black women's quilting. He declared:

> When I was a child growing up in Greenville, South Carolina and Grandmomma could not afford a blanket, she didn't complain, and we didn't freeze. Instead she took pieces of old cloth—patches—wool, silk, gaberdeen [sic], crockersak—only patches, barely good enough to wipe off your shoes with. But they didn't stay that way very long. With sturdy hands and a strong cord, she sewed them together into a quilt, a thing of beauty and power and culture.[1]

In telling this story Jackson paid tribute to the way in which a Black woman's quilting provided a resourceful solution to an urgent family problem as well as an object considered by them as beautiful. That he chose to convey this story to a national audience on such a historic occasion suggests the importance that quiltmaking has played in the lives of Black men and women in this country.

Quilts are often the only physical evidence or historical testament revealing aspects of the inner lives and creative spirits of many otherwise obscure and unknown Black women. Imbedded in quilts through history are deep reflections on the everyday activities, values, and beliefs of ordinary folk. But the quilt, like any other document, needs to be interpreted and analyzed in order to appreciate fully its significance in the history of African-Americans and, in particular, African-American women's cultural history.

Increasingly scholars are focusing attention on the history of Black women's experiences in America. For centuries African-American women existed outside of history. They were neither subjects nor objects of history. Indeed, during my formative years as a young historian, Black women were deemed important and worthy of note only as they were related to men, organizations, or institutions. A facile assumption held that whatever was said and written about Black men applied to Black women, and that the study of white women's history covered Black women as well. Scholars rarely granted Black women separate and distinct treatment. In most school textbooks the only three Black women discussed were Phillis Wheatley, Harriet Tubman, and Sojourner Truth. Accordingly, in the late 1960s Black women fell through the cracks between emerging Black Studies and Women's Studies on most of the nation's campuses. By the 1980s both Black history and women's history had become accepted and legitimate areas of scholarly inquiry. Few scholars noticed the absence of Black women, let alone their contributions in the realm of material culture.

Two of the important early works challenging the exclusion of Black women from the historical record were Gerda Lerner, ed., *Black Women in White America: A Documentary History*[2] and Rosalyn Terborg-Penn and Sharon Harley, eds., *The Afro-American Woman: Struggles and Images.*[3]

**Opposite:** Rosie L. Wilkins, Log Cabin. (See Figure 77, p. 53.)

13

Following the Black women's cultural renaissance of the late 1970s (that witnessed the rise of several writers including Alice Walker, Toni Morrison, and Paule Marshall), modern reclamation scholars have published several important books and articles that chronicle the lives and deeds of individuals and analyze the collective social reform work of Black women across the nation. One of the benchmarks in the flowering of Black women's history was the publication of the two-volume *Black Women in America: An Historical Encyclopedia* (1993) edited by Elsa Barkley Brown of the University of Michigan, Rosalyn Terborg-Penn of Morgan State University, and Darlene Clark Hine of Michigan State University.[4]

The publication of the *Encyclopedia* signaled the existence of a new system of meaning, based upon Black women's experiences, triumphs, and tribulations in the ongoing struggle against racial intolerance and sexual exploitation. The *Encyclopedia*, with more than 600 biographical entries and 150 topical essays, enhances the visibility of Black women and validates the viability of Black women's history. It is within this intellectual and academic context of an emerging body of new knowledge and insights about Black women and their culture and community that the present work, *African American Quiltmaking in Michigan*, makes a unique and significant contribution.

A study of Michigan quilters and their artistic creations enhances our ability to know and to see Black women in more complex, less stereotypical ways. Black women and their history were validated through their creative works. An examination of this complex creativity of Black women as manifested through their quilts opens a window onto their culture and their community. The art of quiltmaking brought women together in protected spaces where they could cement friendships, share ideas, acquire information, and find and give to each other essential support and encouragement. As their stories and quilts amply demonstrate, Black women's artistic contributions allowed a greater appreciation of the traditional practices and ways they devised to "make community," to thus ensure the survival of their people and maintain respect for themselves as women. By "making community," I mean the process of creating social, religious, educational, health care, philanthropic, political, and familial institutions and organizations that ensured racial survival and progress.[5]

In his *Black Culture and Black Consciousness: Afro-American Folk Thought from Slavery to Freedom*, historian Lawrence Levine describes Black culture as a dynamic product of interaction between the past and present, characterized by its ability to react creatively and responsibly to the realities of a new situation. He called for the development of a fresh sensitivity "to the ways in which the African world view interacted with that of the Euro-American world into which it was carried and the extent to which an Afro-American perspective was created."[6] Levine is quick to point out that African-American culture is neither "abject surrender of all previous cultural standards in favor of embracing those of the white master" nor inflexible resistance to change.

Quilting is perhaps one of the most striking illustrations and embodi-
ments of African-American women's culture. Even though the quilt is one of
the most commonplace domestic examples of Black American material cul-
ture in United States history, few scholars actively engaged in its study until
relatively recently. In 1978, a landmark exhibition at the Cleveland Museum
of Art entitled *The Afro-American Tradition in Decorative Arts* presented, for
the first time, Black material folk culture in a fine arts setting. John Vlach,
curator of the exhibit and author of the accompanying catalogue, challenged
visitors to reexamine previous conceptions and misconceptions about deco-
rative arts and to view this material culture, including quilts, as an essential
part of African-American art and cultural history.

This exhibition served as a catalyst for examining the ways in which
quiltmaking embodies Euro-American, African-American, and African
artistic traditions. Vlach observed that "the Afro-American quilt provides us
with an example of how European artifacts may be modified by African
canons of design and thus stand as statements of cultural survival rather
than surrender."[7] Quilting gave to many enslaved Black women, and later to
the freedwomen, a mechanism with which to transmit and preserve a "cul-
tural memory."

The techniques of quilt construction, designs, styles, and patterns used
by Black quilters are derived from both African and Euro-American sources.
Much has been published on and about the nineteenth- and early twentieth-
century Black quilters, primarily from Southern states, whose work reflects a
distinctly African aesthetic. For instance, in the string or "strip" quilt, women
sew together scraps of cloth into strips and then assemble the strips into var-
ious patterns. Vlach commented on the "transatlantic continuity of aesthet-
ic preferences" evidenced by this form of quilting:

> When a Sea Islands woman mixes and matches thirteen assort-
> ed strips of cloth to make a quilt, she is inspired by the same
> creative muse that leads the Ashanti weaver to make a priest's
> robe out of fifteen different strips of Kente Cloth. The African
> weaver continues to use the techniques of his [her] ancestor
> while the Afro-American quilter has had to learn new tech-
> niques. The ancestral ideas, however, remain the same.[8]

Appliquéd quilts that communicate a story often are linked to African
oral narrative and design traditions. One of the most famous enslaved quil-
ters of this style was Harriet Powers (1837-1911) of Athens, Georgia. Her two
known extant *Bible* quilts (c. 1886 and c. 1898) are owned respectively by the
Boston Museum of Fine Arts and the Smithsonian Institution in
Washington, D.C. To convey both local history and Biblical events and sto-
ries, Powers used appliquéd silhouettes of human figures, geometric motifs,
and other design combinations that resemble the styles found among the
people of ancient Dahomey in West Africa. Although quilters of other racial

and ethnic backgrounds use string and strip techniques and also produce story quilts, Vlach asserts that "what may in the end be regarded as the most important feature of Afro-American quilting is the apparent refusal to simply surrender an alternative aesthetic sense to the confines of mainstream expectations. Euro-American forms were converted so that African ideas would not be lost."[9]

Women of various racial and ethnic backgrounds convert utilitarian quilts into objects of art and transform quilting into a social and cultural community affair. Ex-slave Mary Wright of Kentucky reminisces about quilting: "den wemns [women] quilt awhile den a big dinner war spread out den after dinner we'd quilt in de evening, den supper and a big dance dat night, wid de banjo a humming 'n us niggers a dancing. . . ."[10] The importance of quilting as a social activity today is witnessed in such Michigan groups as the Flint Afro-American Quilt Guild and the Quilting Six Plus group in Detroit. Contemporary Black woman artist Samella Lewis reminds us that African art rose from its roots in utility, indeed that the majority of works of African art were made to fulfill the needs of the communities.[11] By studying these groups and their individual members one can learn much about individual African-American women as well as artistic, social, religious, and even political dimensions of community histories.

Although art serves political and social needs, this did not negate the fact that it also represents individual expression. It is especially suggestive that quilting is a creative process whereby women can give voice and vision, structure and substance, to their personal and spiritual lives. For Black women the quilting process provides an opportunity to create forms that meaningfully reflect their African-American experiences. In the introduction to the 1980 museum exhibit catalogue *Forever Free: Art by African-American Women, 1862-1980*, the first anthology of the art specifically of African-American women, editors Arna Bontemps and Jacqueline Fonville-Bontemps correctly point out:

> Black women—through the intellectual and aesthetic choices they made and the traditions they helped preserve—played a vital role in developing those meaningful forms of self-expression by which Black people in America have managed to survive two-and-a-half centuries of chattel slavery and nearly half a millennium of racial oppression.[12]

The art and the biographical sketches of Michigan Black women quilters included in this volume provide eloquent testimony to the existence of a vibrant and vital Black women's cultural tradition. May the historical contours and value of these quilts and the stories of their makers continue to excite and enrich us all.

# Notes

1.    Quoted in Gladys-Marie Fry, *Stitched from the Soul: Slave Quilts from the Ante-Bellum South* (New York: Dutton Studio Books, 1990), 1. Also see: Cuesta Benberry, *Always There: The African-American Presence in American Quilts* (Louisville: The Kentucky Quilt Project, Inc., 1992).

2.    Gerda Lerner, ed., *Black Women in White America: A Documentary History* (Indianapolis: Bobbs-Merrill, 1972).

3.    Rosalyn Terborg-Penn and Sharon Harley, eds., *The Afro-American Woman: Struggles and Images* (New York: Kennikat Press, 1978).

4.    Elsa Barkley Brown, Darlene Clark Hine, and Rosalyn Terborg-Penn, eds., *Black Women in America: An Historical Encyclopedia* (New York: Carlson Publishing, 1993).

5.    Darlene Clark Hine, *Hine Sight: Black Women and the Reconstruction of American History* (New York: Carlson Publishing, 1994), xxii.

6.    Lawrence Levine, *Black Culture and Black Consciousness: Afro-American Folk Thought from Slavery to Freedom* (New York: Oxford University Press, 1977). Also see: William Ferris, ed., *Afro-American Folk Art and Craft* (Jackson: University of Mississippi, 1983), 67-78; Eli Leon, *Who'd A Thought It: Improvisation in African-American Quiltmaking* (San Francisco: Craft and Folk Art Museum, 1987).

7.    John Michael Vlach, *The Afro-American Tradition in Decorative Arts* (Cleveland, Ohio: The Cleveland Museum of Art, 1978), 44.

8.    Ibid., 67.

9.    Ibid., 44-75; Robert Farris Thompson, "African Influences on the Art of the United States," *Journal of African Civilizations* 3 (November 1978): 44; Gladys-Marie Fry, "Harriet Powers: Portrait of a Black Quilter," in *Missing Pieces: Georgia Folk Art, 1770-1976* (Atlanta: Georgia Council for the Arts and Humanities, 1976), 16-23; Maude Southwell Wahlman, *Signs and Symbols: African Images in African-American Quilts* (New York: Studio Books, 1993), 64.

10.   Quoted in Irene V. Jackson, "Black Women and Music: From Africa to the New World," in Filomena Chioma Steady, ed., *Black Woman Cross-Culturally* (Rochester, Vt.: Schenkman Books, 1981), 393. Also see: Wahlman, *Signs and Symbols,* 64.

11.   Samella S. Lewis and Ruth G. Waddy, *Black Artists on Art* (Los Angeles: Contemporary Crafts Publishers, 1971), 2: ix.

12.   Arna Alexander Bontemps, ed., *Forever Free: Art by African-American Women, 1862-1980* (Alexandria, Va.: Stephenson, Inc., 1980), 9.

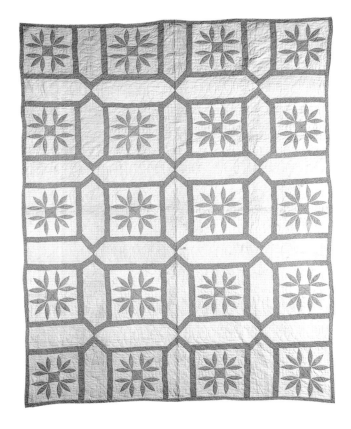

# AFRICAN AMERICAN QUILTMAKING IN MICHIGAN

Marsha L. MacDowell

## Historical Background of African Americans in Michigan

Early records establish that African Americans first came to Michigan, as both slaves and free individuals, with French and English missionaries and fur traders. One famous independent African American explorer, Jean Baptiste Point Du Sable, was held by the British as a political prisoner at Fort Michilimackinac in 1780.[1] African Americans arrived in sizable numbers during the 1830s and 1840s following the Underground Railroad. While some sought employment in the major population centers, others joined previously settled friends or family members as pioneers in rural areas to log off virgin timber and establish farms. By the 1850s African American rural communities had been established in Allegan, Berrien, Calhoun, Cass, Hillsdale, Isabella, Lake, Mecosta, Montcalm, St. Joseph, and Van Buren counties. Prompted by labor needs in northern industrial centers before and during World War I and World War II, thousands of rural Southern blacks moved to Michigan. The major cities—Detroit, Grand Rapids, Kalamazoo, Pontiac, Lansing, Grand Rapids, Flint, Muskegon, Saginaw—all saw substantial increases in their black populations.[2]

Early African American residents of Michigan were usually native Michiganders, foreign born, or from Eastern states, but by the early twentieth century the majority came from Ohio, Indiana, Kentucky, Tennessee, West Virginia, and Virginia.[3] The last great wave of African Americans coming to Michigan, which occurred in the World War II period, were mainly from the Carolinas and the Deep South states of Mississippi, Georgia, and Alabama. With these migrants and immigrants came a wide variety of new social, political, religious, and cultural organizations and traditions that merged with and enriched the already diverse character of the communities in which they settled.

As settlers adapted to new occupations and geographical surroundings and came in contact with the cultural traditions of their new neighbors, some, if not most, of their traditions were affected. Traditions that were no longer feasible or appropriate in their new environment were immediately discarded or gradually ceased. Some adapted the traditions of their neighbors to their own purposes, often altering the traditions to make them more meaningful or relevant to their own experiences. Other traditions were strengthened because of their importance in maintaining family or community identity. It is in this context of migration, settlement, and continuity and change of traditions that the study of African American quilting in Michigan is set.

## Nineteenth-Century African American Quilts in Michigan

Although there are few known extant examples of historical quilts and little published information on quiltmaking among early African American settlers in Michigan, oral tradition firmly establishes that quiltmaking has been a widespread activity for many years. The earliest quiltmaking activity in Michigan was documented in the 1830s.[4] It is also known that slaves dominated plantation textile production in America in the eighteenth and early

Figure 10 (opposite). Attributed to Mary Jane Batson. *The Couples Quilt*. Photograph courtesy of Marcia and Ron Sparks.

Figure 11 (opposite). Attributed to anonymous member of Norman family. Orange Peel, made ca. 1857-58, Mississippi. Collection of Sally Brodie. Cotton with cotton filling, 74" x 96", MQP 90.57.

**Figure 12.** Attributed to anonymous member of Baker family. Oak Leaf, made ca. 1850, probably Alabama. Collection of Michigan State University Museum. Cotton, 19" x 19", MSUM 6646.

nineteenth centuries. Written historical documents and recorded slave narratives attest to the practice of making quilts for plantation owners as well as for their own use as bedcovers and gifts. Slave quilting parties were very much a part of plantation life.[5] Therefore it is highly likely that the African Americans, of both free and slave backgrounds, living in late eighteenth- and early nineteenth-century Michigan had some exposure to, and actively made and used, quilts.

One of the few published references to the historical presence of quilts in African American families in Michigan appeared in *The Michigan Manual of Freedmen's Progress*. The publication accompanied the Michigan Exhibit of Freedmen's Progress at the National Half-Century Exposition at Chicago, Illinois, held to celebrate the fiftieth anniversary of Emancipation. At least two quilts, one listed as "heir loom, age 60 years," were included among nearly 200 items on exhibit.[6] One rare extant nineteenth-century quilt with strong Michigan ties is *The Couples Quilt*, now owned by collectors in Arizona (figure 10). According to oral tradition, the quilt was begun ca. 1880 by Mary Jane Batson, once a slave on the Batson plantation outside Richmond, Virginia. She later gave the pieces to her granddaughter, Mariah Chapman, who assembled them and quilted the top. In 1922, Chapman gave the quilt to her niece, Malinda Spain, who lived in Detroit. Spain, in turn, gave the quilt to William Kern, a school principal, in appreciation for helping to feed and clothe her children during the Great Depression[7]

During research for the African American quilt exhibit, two examples of slave-made quilts were discovered in Michigan. The first, an Orange Peel pattern cotton quilt was made, according to oral tradition, ca. 1857–58 by a slave who lived on a Mississippi plantation (figure 11). The quilt was used by the plantation owner's family and brought to Michigan in the 1950s. Leona Norman, descendant of the plantation's owner, gave the quilt to a friend, Sally Brodie, the current owner.[8] In 1987, Patricia Anderson donated one of a set of seven identical and finely stitched blocks done in the Oak Leaf pattern (figure 12) to the Michigan State University Museum. Anderson received these blocks from her friend Mattie Baker of Inkster, Michigan. Narratives shared within Baker's family tell that the blocks were made by an Alabama slave and passed down in the family to Baker.[9]

## Quilts as Records of Migration and Settlement

Like quilts made by members of other cultural groups, quilts made by African Americans in Michigan sometimes serve as visual records of patterns of migration and settlement. Denise Curtis Reed's *Migration* quilt creatively interprets the historical movement of African Americans from Africa to America and from slavery to contemporary professional experiences (figures 13 and 14). Research shows that certain quilt patterns, pattern names, color

**Figure 13.** Denise Curtis Reed.

**Figure 14.** Denise Curtis Reed. *Migration* made 1989, Detroit, Wayne County, Mich. Collection of the artist. Cotton with cotton filling, 28" x 31-1/2", MQP 90.31.

**Figure 15.** Rosie Wilkins. Photo by Bruce Fox.

**Figure 16.** Rosie L. Wilkins (b. 1911). String, made 1980s, Muskegon, Muskegon County, Mich. Private collection. Satin with polyester filling, 62" x 83", MQP 89.022.

palettes, and construction techniques used by African American quilters in Michigan are linked to those used by African American quilters in Southern states. Some quilts also demonstrate particular construction techniques and characteristics of style and color that some scholars link to textile traditions found in West Africa.[10] For instance, Rosie Wilkins, who moved to Muskegon, Michigan from Mississippi in the 1950s, commonly used strip and string quilting techniques of her Southern birthplace (figures 15 and 16).

Three quilters whose work is included here had direct connections to African quilting experiences. Lethonee Jones, now a retired Western Michigan University faculty member, served in the Peace Corps in Africa in 1963 (figures 17 and 18). There she learned quiltmaking from a Euro-American woman and collected African fabrics that she shipped back to the states and used in some of her first quilts. Jones continues to use African materials or symbols in her quilts along with fabric techniques borrowed and adapted from Euro-American and American Indian textile traditions.[11] Liberian residents Isabella Major and Henrietta Bailey made quilts as gifts to send to their children living in Flint (figure 19). They both learned quilting from their grandmothers and have many relatives who are also active quilters.[12]

Major belonged to one of several quilt cooperatives in Liberia that were started in Monrovia and nearby communities. Although the history of quilting in Liberia has been traced to the nineteenth century, these new cooperatives have quickly grown in membership and productivity. With assistance from the U. S. Ambassador's Self-Help Fund and the U. S. Agency for International Development, the cooperatives have successfully developed a

**Figure 17.** Lethonee Jones.

**Figure 18.** Lethonee Jones (b. 1938). *Roadkill*, made ca. 1986, Kalamazoo, Kalamazoo County, Mich. Fur, cotton, cotton/polyester with polyester filling, 89" x 44," MQP. 90.0055, MSUM 1996:109.

᠁

**Figure 19.** Henrietta Bailey (b. December 14, 1914, died May 6, 199?). *Pineapple*, made 1988, Monrovia, Liberia. Collection of Taylorie Bailey. Cotton with cotton filling, 3" x 38", MQP 90.0054.

market for their quilts. Favorite patterns used by cooperative members include the appliquéd Liberian Flag, Princess Feather, and Wreath of Roses, and the pieced patterns include Lone Star, Basket of Flowers, and Double Wedding Ring.[13]

The interchange of fabrics, patterns, techniques, and traditions between Michigan and Africa will likely increase in future years as more printed information about quilting becomes available to both Africans and African Americans. In addition to direct family connections, the growing distribution

Figure 20. Cora Vanderson.

Figure 21. Cora Vanderson (b. 1930). *Lone Star*, made 1988, Flint, Genesee County, Mich. Collection of the artist. Cotton and cotton/polyester, 81" x 92", MQP 90.33.

Figure 22. Ollie Stamps, *Alpha Phi Alpha*, made 1990, Utica, Hinds County, Miss. Private collection. Cotton/polyester with polyester filling, MQP 95.14

of quilt magazines, the circulation of exhibitions, and increased travel between Michigan and Africa are already fostering new contacts between those who quilt in each locale as well as those who collect and study quilts.

**Quilts as Links to African and African American Identities**

The use of certain motifs, colors, materials, and construction techniques in quiltmaking can be linked with an artist's African American identity. Some quilters choose to incorporate African textiles or fashion their quilts in colors associated with African or African American social or political organizations. For instance, the red, green, and black Lone Star quilt made in 1975 by Cora Vanderson reflects the official colors of the African National Congress (figures 20 and 21). Several quilters in Michigan have paid tribute to important figures in African and African American history. Rosa Parks, Nelson Mandela, and Malcolm X are among the most commonly honored individuals, and the quilts often celebrate historic moments in their lives, such as Mandela's release from prison (figure 35).

Bennie Mae Latimer made a *Sigma Gamma Rho Quilt*, the central motif of which is the emblem of her sorority. It was displayed in 1979 at a regional convention of the sorority in St. Louis, Missouri, as well as at other local-sorority events.[14] When Detroiter LaNeysa Harris married Orlando Featherstone, she commissioned her grandmother Ollie Stamps of Utica,

Mississippi to make the *Alpha Phi Alpha Quilt* (figure 22) to match an embroidered pillow her husband had been given by another friend. Done in the gold and black colors of the fraternity, the quilt also carries the appliquéd Greek letters of the fraternity. The Featherstones display the quilt when friends or family visit. Stamps has made sorority or fraternity quilts for her other four grandchildren as well as for other friends and family members.[15]

Myla Perkins named one of her quilt designs Underground Railroad, a variation on Grandmother's Fan (figure 23). Ramona Hammonds uses African fabrics in a pattern she calls African Dolls, a variation of a pattern sometimes known as Streak of Lightning (figures 24 and 25). Jeffalone Rumph uses scraps collected in both Ghana and her hometown of Eupora, Mississippi. In her *Flag* quilt, Mildred Chenault of Lansing incorporated one small piece of African fabric in an overall red, white, and blue American flag design to show that the maker is of African American heritage (figures 26 and 27).

Karen Simpson, a textile artist from Ann Arbor, was inspired to make quilts when she found a picture at the Smithsonian of two African tribesmen on horses draped with quilts.[16] She now explores color and design in a medium she feels is strongly connected to her past (figures 28 and 29 a and b). A large piece of African material was used for the whole-cloth style quilt made by Ollie Stamps as a gift for her second-eldest son and his wife. Stamps finished the top by quilting around the edges of the block-printed fabric (figure 30).

**Figure 23.** Myla Perkins. Underground Railroad or Grandmother's Fan Variation, made 1984, Detroit, Wayne County, Mich. Cotton/polyester with polyester filling, 69" x 90", MQP 90.51, MSUM 7421.1.

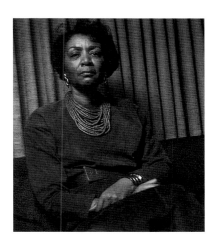

**Figure 24.** Ramona Hammonds.

**Figure 25.** Ramona R. Hammonds (b. 1937). African Dolls, made 1990, Detroit, Wayne County, Mich. Collection of the artist. Cotton/polyester and cotton with polyester filling, 65" x 68", MQP 90.59.

**Figure 26.** Mildred Chenault.

**Figure 27.** Mildred Chenault. *Flag*, made 1993, Lansing, Ingham County, Mich. Cotton with polyester filling, MQP 95.27.

**Figure 28**. Karen Simpson.

**Figure 29a**. Karen Simpson. Strip quilt, made ca. 1990, Ann Arbor, Washtenaw County, Mich. Cotton/polyester, 41-1/4" x 44", MQP 95.006.

**Figure 29b**. Karen Simpson. Pillowcase, made ca. 1990, Ann Arbor, Washtenaw County, Mich. Cotton/polyester, MQP 95.0006.

**Figure 30.** Ollie Stamps. Nine Patch, made 1992, Utica,
Hinds County, Miss. Private collection. Cotton with
polyester filling, 83" x 89-3/4", MQP 95.15.

Carole Harris (figure 127) first began studying the design traditions of Africa during her course work as an art major at Wayne State University. In the late 1980s she was inspired to make a series of quilts she called the *Memory* series, based on an African aesthetic. *Reclamation*, the first one finished in this series, was begun on February 11, 1990, the day Nelson Mandela was released from prison.[17]

Sarah Carolyn Reese of Detroit constructed a quilt that provides a new interpretation of symbols found stamped on an original adkinkra cloth (figure 136).[18] Every autumn for several years Reese has organized an American African Quilt and Fabric Exhibition at Hartford Memorial Baptist Church. Members of the church's Wednesday Quilting Sisters group (figure 137) exhibit their work along with African textiles and quilts loaned by others.[19] The church also offers workshops and demonstrations by African American textile artists, hosts visiting artists from Africa, and sponsors lectures by African American textile authorities.

Justine Burnell was introduced to quilting when she began attending Hartford Memorial Baptist Church. Through quilting she combines her training in drafting, her love of African fabrics and motifs, and her desire to celebrate personal, familial, and African American history. In her *Black Madonna* quilt she incorporates adkinkra symbols, images of great kings and queens in Africa, and vintage photos of herself, parents, siblings, and children, all surrounding the image of the Madonna (figures 31 and 32).[20]

Figure 31. Justine Burnell.

Figure 32. Justine Burnell, *Black Madonna*, made 1990-93, Sterling Heights, Macomb County, Mich. Collection of the artist. Cotton and cotton/polyester with polyester filling, 110" x 98-1/2", MQP 93.131.

Beverly Ann White of Pontiac uses African and African-inspired fabrics in her work and made a quilt she named *Mother Africa*, based on the best-selling *Kaffir Boy*.[21] Her *View from the Mountain Top* quilt was made to teach students, family, and friends about important heroes of the movement (figures 33 and 34). She made one quilt to honor Nelson Mandela (figure 35) and is planning another to honor Rosa Parks.[22] White recently joined the newly formed National Association of African American Quilters, whose philosophy stresses "each one, teach one" and aims to dispel misconceptions of what African American quilting is and should be.

**Figure 33.** Beverly Ann White.

**Figure 34.** Beverly Ann White, *View from the Mountain Top*, made July 1991, Pontiac, Oakland County, Mich. Cotton and cotton/polyester, 82-1/2" x 48-1/2," MQP 93.119.

**Figure 35.** Beverly Ann White, *Nelson Mandela*, made 1990, Pontiac, Oakland County, Mich. Cotton and cotton/polyester, 43-1/2" x 44-1/4", MQP 95.21.

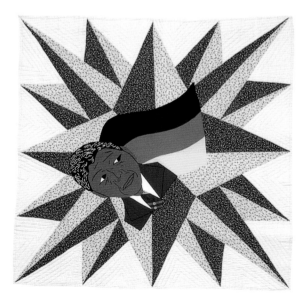

### Quilts as Documents of Community and Family History

Particular people, places, and events connected with family and community history are documented in African American quilts in Michigan. The multicultural Young Creators 4-H Club of Muskegon Heights illustrated important businesses and civic buildings of their immediate neighborhood as part of a 1985 4-H FOLKPATTERNS community history project (figure 36). Supervised by quilter and Mississippi native Maggie Shanks, each youth worked with a local business or organization to create a quilt block depicting its history. The finished quilt included the local Heritage Hospital, Bob Moore Florist, Santana Mexican Food, Temple Church, Martin Luther King School, and Internationally Famous Hair Style. Shanks's daughter, Naomi Wright (figure 37), and her friend Rose Mary Budds added the back and tied off the quilt.[23] The finished product was exhibited at the state's first African American Quilt Discovery Day held at Muskegon Community College.

**Figure 36** (below). Naomi Wright (b. 1929) and Members of the Young Creators 4-H Club (piecers), Rose Mary Budds (quilter). *Community History Quilt*, made 1985, Muskegon, Muskegon County, Mich. Cotton/polyester with polyester filling, 108" x 72," MQP 86.58.

**Figure 37** (above). Naomi Wright.

*Marsha L MacDowell*

**Figure 38** (with details at left). Sandy Kittle and Ann Smith-Diéye. *Family History*, made 1980, San Mateo, Calif. Cotton with polyester filling. MQP 96.11.

Eddie Mae Jones has made two family history quilts, one for her side of the family and one for her husband Herrod's, using the technique of transferring photographs onto fabric. She is now working on a photographic quilt portraying all the Detroit Pistons.[24] Another family history quilt, using the same technique, was made by Sandy Kittle and Ann Smith-Diéye on the occasion of Michigan residents Raymond and Anna Mae Smith's fiftieth wedding anniversary, and displays portraits of family members as well as photos of individuals at work and play (figure 38).

**Figure 39.** Mary Williams. *Donkey*, made 1939, Kerrville, Tenn. Collection of Joe and Janice Rolston. Cotton with cotton filling, 74" x 92", MQP 90.28, MSUM 7535.1.

**Figure 40.** Lucille Rolston.

Joe and Janice Rolston received a wedding gift in 1969 of a quilt documenting an unusual piece of family history. Made by his grandmother, Mary Williams, the *Donkey* quilt (figure 39) was inspired by the family's favorite donkeys, Mike and Nell. Williams, the granddaughter of a slave, came from an active quilting family and was an avid seamstress who made all of her husband's and children's clothing. Joe's mother, Lucille Rolston, was inspired by seven unquilted tops she inherited from her mother, Mary Williams; Lucille is now a member of the Afro-American Quilt Guild in Flint, Michigan (figure 40).[25]

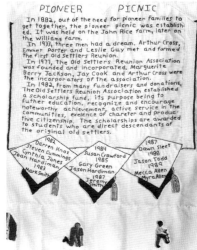

**Figure 41** (with details below). Deonna Todd Green and Ione Todd. *Old Settlers' Quilt*, made 1990, Remus, Mecosta County, Mich. Collection of Michigan State University Museum. Painted and embroidered cotton/polyester, 77" x 76", MQP 90.0022.

Some of the most ambitious quilt projects documenting community and family history have been undertaken by Deonna Todd Green (figure 130) and members of her family in Remus, Michigan. Deonna's cousin, Ken Todd, had the idea for the first family history quilt made by Deonna, Ione Todd (her mother), Carol Norman, Dolores Todd, Marion Todd, and Deonna's twin, Diana. Family photographs, oral narratives, library and archival documents, family Bibles, and visits to family-held properties provided the sources for the visuals and narratives embroidered, appliquéd, and written onto the blocks pieced and tied together. The *Todd Family Quilt* (figure 131) chronicles the story of former slave Stephen Todd, his wife Caroline Kahler, and six generations of their descendants. Included are plat maps depicting the sections of farm acreage owned by pioneering Todds; illustrations of Stephen and Caroline's original log cabin homestead; a map showing the route Stephen and Caroline took as they fled, via the Underground Railroad, through Kentucky, Indiana, and Canada to settle in Michigan; a copy of a letter Stephen received when mustering out of the army; and the names of all of the descendants. Also included are visual depictions of important family oral narratives: the escape by raft of Stephen and Caroline across the river to Canada and the two cows and twenty-four chickens that constituted their original personal property.[26]

When the quilt was raffled off to another cousin at a 1986 Todd family reunion, Deonna decided to make a second, more complex version of the *Todd Family Quilt*, which was exhibited as part of the 1990 national exhibition *Stitching Memories: African American Story Quilts* at Williams College in Massachusetts. A third version was commissioned by the Michigan State University Museum. In addition to the Todd family quilts, Green has completed a *Sawyer Family Quilt*, a *Green Family Quilt*, and a quilt that pays tribute to important African Americans in history. Assisted by her mother and other relatives, Green continues to devote hours to researching her family genealogy, collecting family photographs and documents, and gathering family stories. Quests for information have taken them to local, state, and national archives in Lansing and Detroit, Michigan; Washington; Maryland; and Kentucky.

Recently Green and Todd finished the *Old Settlers' Quilt* (figure 41), a tribute to the black families who homesteaded in Mecosta, Montcalm, and Isabella Counties in the 1860s and 1870s. The embroidered pictures and words pay homage to the people, activities, and buildings important to African Americans in these rural Michigan counties. Included are the lumbering and farming occupations that sustained early settlers, the regional Negro baseball team, the annual Old Settler's Picnic, two churches, the schoolhouse, and the Michigan historical marker honoring the heritage of the community. In 1979, Marguerite Berry Jackson (figure 42), a fourth-generation descendant of Mecosta pioneers, made a community history quilt as a fundraiser for the Mecosta Centennial.[27] Jackson and Green have discussed the possibility of collaborating on a quilt that would tell the history of African Americans in the lumbering industry of mid Michigan.

**Figure 42.** Marguerite Berry Jackson.

**Figure 43**. Dora Gardner.

**Figure 44**. Dora Gardner. *Bow Tie*, made ca. 1950s, probably Muskegon, Muskegon County, Mich. Collection of Blanche F. Cox. Cotton with cotton filling, 66" x 88", MQP 86.34.

### Quilting and Personal Narratives

As families brought quilts to Michigan from other states or countries, they also brought rich and varied stories of whom they learned from, where they got their materials, whom they quilted with, what happened at quilting bees, how they cleaned their quilts, and many other quilting-related activities. Such stories provide insights to what life was like in both their homes and new communities and how quiltmaking fit into their daily lives.

Some of Dora Gardner's (figures 43 and 44) favorite memories of living in the South are associated with October quilting bees. "These were storytelling times . . . where there were enough women to finish a quilt in a day."[28]

Mary Holmes (figure 45) recalled women at quilting bees singing, praying, and sometimes even smoking snuff and pipes. Teressie May (figure 46), who grew up in Nashville, Arkansas and moved to Flint, Michigan in 1953 recalls: "Quilting was strictly taught in the home. But I would see the ladies going to the church and that is where they . . . would go and quilt quilts. You might piece them at home, but you needed some place that you could stretch [the quilt] out. . . . They would have a day of quilting a week. Each week, one day a week, and as I say, this was during the winter months."[29]

Before she moved with her husband from Demopolis, Alabama to Muskegon, Michigan with her husand in 1953, Sina Phillips (figure 47) regularly participated in quilting bees: "we had a regular quiltin' bee at home in the wintertime, you know, that's all we had to do. After we got through farmin' we'd go from house to house and quilt."[30] Phillips learned the art of "making covers" from her mother, Ida Jones, when she was ten. Hattie Hudson began helping her mother quilt when she was eight or nine years old. She laughed as she recalled how much trouble she would get into at quilting bees when she and other children would go under the quilt and try to stand up.[31]

After working in the Georgia fields all day picking cotton or peanuts, Lillie Mae Tullis's entire family—boys and girls—would quilt, some holding oil lamps at the right angle for the stitchers to see well.[32] She recalls these as happy times when they also did candy pulling. There were so many in her family that neighbors weren't needed to help. Tullis said with all her family helping "it was a party in itself."

Several quiltmakers tell of using unginned field cotton as batting for their quilts. Mary Holmes, for instance, tells of gathering and processing field cotton in Hughes, Arkansas, for such use:

> They would use lint cotton. This would be the cotton that you could go to the gin [and get] and it wasn't any good you know they would throw it over here in the corner. The person who carried cotton to the gin could pick up a bundle of this and it was kind of trashy. But my father and his brothers would always go out in the woods and cut cane for more than one thing— fishing, caning chairs, and whipping the cotton for quilts. And we'd—that was one of the things children had to do—take a pole and you'd beat that cotton until it becomes fluffy and light. We'd whip this and get most of the trash out of it. Then we'd get down and spread that cotton out on linings so it would be nice.[33]

Holmes, however, never really cared for quilting and remembers finishing only one quilt—her first Nine Patch.

**Figure 45**. Mary Holmes.

**Figure 46**. Teressie May.

**Figure 47**. Sina Phillips.

**Figure 48**. Charline Beasley.

**Figure 49**. Charline Beasley. Wheel of Fortune, made 1994. Detroit, Wayne County, Mich. Cotton/polyester, 83" x 93", MQP 95.3.

**Figure 50**. Mary Atkins.

Charline Beasley (figures 48 and 49) learned quilting in Alabama from her mother, Janie Barrow, and her grandmother. Once she started quilting, Beasley entered and won competitions along with her mother. She recalls having to complete a quilt placed in the living room before she could entertain her boyfriend in the same room later in the day.[34] Mary Atkins (figure 50) of Kalamazoo grew up in rural Arkansas and was about eight years old when she learned to quilt from her mother, who made quilts for family use. According to Atkins, her mother taught her and her sisters to quilt to keep them out of mischief after they finished school or after doing their chores on the family farm. "There was no playing after work, but I'd sit down on a stool and begin piecing."[35]

Quilters also recall various types of frames they used to stretch the tops and quilt the tops, filling, and backing together. Willie Maddox (figure 51) of Kalamazoo, Michigan learned quilting from her mother while growing up in Alabama. Because they did so much quilting in their home, the quilting frame always remained assembled and hung from the ceiling, ready to be lowered as soon as a top was ready to be quilted.[36] At eighty-five years of age

**Figure 51.** Willie Maddox (b.1910? - 1988). Medallion Mariner's Compass, made ca. 1987, Kalamazoo, Kalamazoo County, Mich. Collection of Michigan State University Museum, acc. 6696.1. Polyester and cotton/polyester with polyester filling, 70" x 86", MQP 90.61.

**Figure 52.** Josephine Collins. Photograph by Marsha MacDowell.

Hattie Hudson described with keen memory the homemade frame her mother used. The four pieces of the wooden frame, each about two inches wide and eight feet long, were hung by strong string attached to four pieces of old shoe leather nailed to the ceiling.[37]

Josephine Collins (figure 52), born in 1921 in Madison, Mississippi, began as a child to help her mother and fifteen siblings make quilts. Now living in Muskegon, Michigan she recalls how she would beg her mother to purchase fabrics for her quilts at a local store:

> Most of the times we catch [buy] it at the ten cent store [and the] grocery store. . . . So she [the store owner] would let mother get material for fifteen cents a yard. And they'd have it on sale sometimes for ten. . . . If she had a piece [of fabric] that would fit in with my quilt I was piecing, I'd pull my mother's dress tail 'til she have to get a piece for me. And she would get it.[38]

Memories of quilting activities in Southern homes are often associated with recollections of other activities and individuals in the communities left behind. Pontiac resident Elnora Adams spent her early years as a member of a sharecropper's family who originally hailed from Mississippi. At age 107, her recollections of "quilting all the time" were intermingled with stories of home births, log cabin living, and hard work picking cotton.[39]

Jessie Wheeler, born in 1900 on a farm in Georgia, came North in 1922 with her parents and her infant children after her husband died. She recalls quilting as one of the many textile production and care skills she learned as a child for both home necessities and to earn an income. Her mother took in laundry. By the time Wheeler was twelve years old, she was working independently with her thirteen-year-old sister doing laundry. After retirement from Hudson's Department Store in Detroit, she moved in 1985 to a summer cottage she had built in Holly, Michigan. There she continued to produce quilts and embroider items until her health failed.[40]

Mary Holmes tells of a relative, Aunt Delilah Brown, who "had so many children she never got into this group [local quilting bees] and she did quite a bit of quilting because she had to do that to keep covers on the children. And that again was during the Coolidge and Hoover Days . . . when we was really struggling to live, have clothing and stuff."[41] Flint resident Taylorie Bailey uses quilts she received as gifts for her wedding and son's birth from her Liberian relatives not only as bedcovers, but also as a means of sharing stories of her African homeland with family and friends.

## Traditional Uses of Patterns, Terminology, and Techniques

Quilters often use patterns, construction techniques, and names for quilting patterns and block styles that are characteristic of their families or home communities. Josephine Collins recalls that her mother's word for an appliqué quilt was a "lay" quilt and that it was unlucky to make them.[42] She

called the first quilt she made the Muffie Ranch pattern. She has since seen another quilt sewn in that pattern and called by another name, but she only knows it as Muffie Ranch. Rosie Wilkins referred to a shell pattern of quilting as "elbow" quilting.[43] When Jeffalone Rumph (figures 53 and 54) saw someone quilting in Flint holding the needle horizontally to the quilt instead of using a running stitch, she called it "pickin," a way of quilting used among her people in the South.[44] Sina Phillips was partial to the Shirley Pine, Stove Top, and Crowfoot in the Mud patterns commonly used in her childhood Alabama home (figure 55).[45]

Detroiter Zelma Dorris, raised in a South Carolina family of generations of talented needleworkers, was taught that she "should always quilt with her needle pointing towards the north since that's where opportunities for blacks are."[46] By the time Dorris was five she was threading needles and listening to her grandmother tell spellbinding stories about how quilts were used during slavery. The hems, she was told, were hiding places for important messages from slave to slave (figures 56 and 57).

Figure 53. Jeffalone Rumph.

Figure 54. Jeffalone Rumph. Dahlia, made 1986, Flint, Genesee County, Mich. Collection of the artist. Cotton and cotton/polyester with polyester filling, 74" x 88-1/2", MQP 90.35.

Figure 55. Sina R. Phillips. Crow Foot in the Mud, made 1983, Muskegon, Muskegon County, Mich. Collection of Michigan State University Museum. Cotton/polyester and polyester, 72" x 80", MQP 87.167, MSUM 6788.

Figure 56. Zelma Dorris.

**Figure 57.** Zelma Dorris. Double Wedding Ring, made 1985, Detroit, Wayne County, Mich. Collection of the artist. Cotton/polyester, 91-1/2" x 104", MQP 86.710. MSUM 7425.1.

Until relatively recently, most quilters learned their traditions of quilting from family members, often from a mother, aunt, or grandmother. They started sewing at a very early age and easily recall the first dress, quilt block (usually in a Nine Patch pattern), and whole quilt they completed. Within the African American community, Nine Patch and Strip pattern quilts done in the String technique are most often cited by quilters as the first ones they learned and continue to prefer. String, Nine Patch, and Strip quilts documented in the Michigan Quilt Project include ones made by Rosie Wilkins (figure 16), Precious Holston (figures 58 and 59), Johnnie Miller (figure 60),

**Figure 58.** Precious Holston.

**Figure 59.** Detail, Precious Holston, Quilt.

Teressie May (figure 61), Maria Ingersoll Snipes (figure 62), and Essie Robinson (figure 63).

Teressie May made her first quilt top when she was about six or seven years of age and describes the technique: "It was a String quilt . . . you use catalog pages and sew the strings [scraps of fabric] on that . . . the next string you would turn it down [right side to right side] like this and stitch through the paper. When you get through sewing [the block], then you turn it over, cut, and tear away the paper." The String quilt was one of the first Leona Morris made, "because that way you used something someone threw away. Take nothing and make something out of it. I like the String, Nine Patch, and Diamonds. After seeing fancy quilts, the String quilt, and a Nine Patch stays with me the most."[47]

Some quilters, though competent in a variety of needlework skills, took up quilting later in life for a variety of reasons. They found it a way to keep their hands and minds active in retirement or a way to meet other people. Beverly Ann White and Jeffalone Rumph took up quilting when their fathers

**Figure 60**. Johnnie Miller.

**Figure 61**. Teressie May. String, made Flint, Genesee County, Mich. Cotton/polyester, 73" x 89-1/4", MQP 95.4.

**Figure 62.** Maria Ingersoll Snipes. Zigzag or Flying Geese. Cotton, 97" x 92-1/2", MQP 86.693.

**Figure 63.** Essie Lee Robinson. Kane Role, made 1973, Detroit, Wayne County, Mich. Collection of the artist. Cotton/polyester, 103" x 105", MQP 90.42.

became ill as a way of keeping busy while at their bedsides.[48] Although she was exposed to the quilts of her mother, aunt, grandmother, and other relatives and neighbors very early in life, Derenda Collins (figures 64 and 65) did not start her first quilt, a red-and-white Nine Patch, until she was in her late teens or early twenties. After that first quilt, Collins took a respite from quiltmaking while she finished a degree in music education, raised her children, and taught school. Her interest in quiltmaking was rekindled by her ninety–six year old grandmother, Maggie Wood (figure 66), who remarked to her, "I've been here all winter and you haven't even done one quilt!"[49]

Quilters who moved north to Michigan almost never bought patterns but rather relied on sharing patterns with friends and relatives, often exchanging them through the mail. One of the rare times Rosie Wilkins bought a pattern was when she was twelve or fourteen years old and lived in Hattiesburg, Mississippi. Her family attended an entertainment show touring the state that featured a girl who did paper cuts with her feet. Wilkins made several quilts in her lifetime from the unique pattern she purchased from the girl.[50]

More typically, African American quilters in Michigan copied their patterns from ones they admired made by friends or family. These patterns were

Figure 64. Derenda Collins.

Figure 65. Derenda Collins. Log Cabin Star, made 1989, Flint, Genesee County, Mich. Collection of the artist. Cotton/polyester with polyester filling, 76" x 78", MQP 90.37.

**Figure 66.** Maggie Wood. Dresden Plate made 1908, Dyersburg, Tenn.
Collection of the artist. Cotton with cotton filling, 75" x 76", MQP 90.38.

**Figure 67.** Roberta Allen.

**Figure 68.** Roberta Allen, Sampler. Cotton and cotton/polyester, 65" x 82", MQP 95.2.

often passed down from one generation to another. Derenda Collins is planning a Drunkard's Path quilt, using the pattern that belonged to her husband's great-grandmother.[51] Jeffalone Rumph pieced four Snowball quilts from a pattern taken from a quilt owned by her mother.[52] Holly, Michigan resident Roberta Allen's Sampler quilt is a visual record of the patterns she has collected from family members and friends (figures 67 and 68). Allen still uses the Wagon Wheel quilt made by her mother, Georgia Lee Randolph, from whom she learned her quilting skills (figure 69).[53] Mary Holmes reflected on the difficulties of keeping patterns in her hometown of Hughes, Arkansas:

> Sometimes they would have quilts, quilts galore, on display. Sometimes some of the upper class white people would come along maybe and buy some of them. I think that's how a lot of the quilts and variations got away from the blacks in that area. . . . And nine times out of ten it would be the only pattern they had. So the next thing they've got to do is kind of remember what was in the pattern and try to bring it up again. And then probably when they'd bring it up again it wouldn't be exactly like the first pattern was. But there was not time for saying I've got to make one for a pattern and then another one.[54]

Figure 69 (front and back). Georgia Lee Randolph, Wagon Wheel, made Itawamba County, Miss. Cotton and feed sacks, 74" x 80-1/2", MQP 95.1.

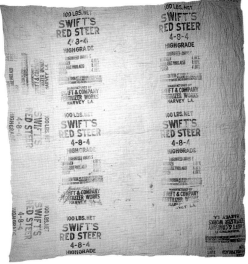

As commercially printed patterns and even ready-made quilt kits became more readily available, increasing numbers of quilters experimented with these new resources. Evelyn Cross (figure 70), a retired schoolteacher and mother of three daughters, pieced her first quilt while still in high school and has completed forty quilts. One of her hobbies is to collect quilt patterns, and she enjoys experimenting with piecing new block designs.[55] Rosa Parks made quilts from patterns from many sources. Her Appliquéd Floral Medallion (figure 143) was begun in 1939 from a purchased kit, but not finished until 1949 because of the demands of completing her education and caring for her family.[56]

Sometimes the types of quilts made were affected by the amount of time available to quilt. Dolores Moore (figure 71) reflected that, in her grandmother's time,

> women, especially those in black families, didn't really have much time to plan out their quilts. Because my grandmother had to go out in the field, and work, and then she'd run to the house—I guess they'd go watch the sun—and they'd run to the house and just throw food together and they didn't have any electricity, and she could see but she had a treadle machine—the kind that you pump with your feet—so she'd maybe have time to do that [quilting] on Saturdays. Sunday, you had to spend most of the time in church, so they really did not have time to plan quilts the way we do.[57]

## Function and Design of Quilts

All quiltmaking involves creative decisions in the selection of colors, techniques, patterns, designs, and fabrics. These decisions are heavily influenced by family or community-based aesthetics. Such traditional knowledge, combined with formal education and information from the mass media, forms quilters' attitudes about what makes a good, beautiful, or interesting quilt. Many quilters distinguish between those made for utilitarian purposes and those made for beauty. For instance, Derenda Collins tells:

> My aunt did utilitarian quilts. Beauty had very little to do with it. Hers were given for need. It did not bother her to mix fabrics. If she had a wool blend with cotton or whatever. . . . But it would hold together and keep the person or baby or whatever warm. If it was needed to chink the door, it wouldn't bother her either. But she produced many. They were not meant to be works of art. My grandmother, on the other hand, her works were meant to be folded often, or to be displayed . . . and I don't know if she did much of that utilitarian type of needlework.[58]

Figure 70. Evelyn Cross.

Figure 71. Dolores Moore.

Figure 72. Josie Bibbs. Photograph by
Marsha MacDowell.

Another quilter, Josie Bibbs (figure 72), tells of the fundamental function of quilts and preference in her family for quilts rather than blankets as bedcoverings:

> I have some blankets, but I hardly use them. I can't sleep on the blankets. . . . I just want my quilt. I was raised on the quilt and I just love my quilt. And I got one or two grandchildren saying they can't sleep on a blanket. They just itch all around and they can scratch. So they come and say grandma, I've got to have a quilt. . . . And so I had to make them quilts too.[59]

Most of the quilters interviewed tend to adhere to more traditional patterns, color schemes, techniques, and fabric choices for their utility quilts, but even among what might be considered traditionalists, women seek innovative ways of designing and putting quilts together. Sometimes they achieve a "different" look by inserting an unusual color in a block, sometimes by changing the set (or way in which pattern blocks are laid out), sometimes by experimenting with different fabrics. Ideas for new quilts might come from looking at the patterns and quilts used by friends and family; just as easily, they might come from quilts and patterns seen in fabric shops, quilt shows, or quilt publications. Mary Atkins of Kalamazoo even found inspiration for a design of one her quilts in a television advertisement for waterbeds. The advertisement displayed a bed with a commercial quilt on it, and Atkins drew on the memory of the quilt for a new design (figure 73).[60] Lillie Lee, who always pieced her quilts because she considers appliqué too slow, has a book on quilting, "but don't look at it much . . . I make up my own designs, because I can't do anyone else's. They never go together like they should (figure 74)."[61]

While some quiltmakers are more aware of and concerned about the aesthetic qualities of a quilt than others, nearly every women interviewed appreciated the amount of work and creativity that went into a quilt. Teressie May articulates well the sentiments shared by many:

> It really is an art now, because it is really something you apply yourself to, rather than making something just for a cover. . . . Quilting to me is like children's art. You give children some paint and paper, let them do their own thing and you go to a person's house and see it on the wall, you say, "Gee, that's beautiful. Where did you get it?" [The answer would be] "My kid." "My daughter made it." Or "My son made it." And you take another look at it. Some people see a lot of paint splattered on the wall, but will look at it, and see so much beauty in it. And that's the way I am about quilts. Even when they come out bad, once they are laid out, you can see the beauty.[62]

**Figure 73.** Mary Atkins. *Stove Eye*, made 1987, Kalamazoo, Kalamazoo County, Mich. Collection of Michigan State University Museum, acc. 7132.1. Cotton and cotton blends with cotton flannel filling, 77" x 86", MQP 90.62.

Some quiltmakers consciously strive to use pattern, color, fabric, and craftsmanship to create innovative or unique textiles intended as wall hangings rather than as more traditional use as bed coverings. For instance, Detroiter Carole Harris (figures 128 and 129) and Lethonee Jones (figure 18) of Kalamazoo use this textile medium as a means to express innovative ideas about color and design. Their work, intended as art to be displayed on the wall, is shown in such public forums as galleries, exhibits, or fairs where it is evaluated by art critics or professional quilting judges.

**Quilting for Income**

While most quiltmakers have made quilts for use as bedcoverings or gifts in home, family, or community, a few have quilted as a means of supplementing their income. Kalamazoo resident Lillie Lee made quilts for sale to supplement her income and as "pretties" on her bed. Rodney resident Kittie Pointer is a professional quilter who has made more than 200 quilts (figures 75 and 76). She does not consider quilting "work" since she enjoys it so much: "It's extra income, a hobby for which I have a special talent."[63]

**Figure 74.** Lillie Lee.

Michigan women have long engaged in the practice of making quilts as a means to raise funds for a wide spectrum of national or local activities of a nonracial basis. For instance, Marguerite Berry Jackson made a quilt as a fundraiser in 1985 for the Tri-County Iris Association, of which she is an active member. That quilt, done in an original design of appliquéd irises, raised more than $1,000 for the organization.[64] Detroiter Emma Brown, a member of the Plymouth Congregational Church Leisure Club's quilting group, donated a quilt to the church to raise funds for church activities. When it was raffled off, her son-in-law won it.[65] African American quilters have also been active in making quilts to support local or national needs within their own community. Quilters in Lula Williams's classes at the Evans Recreation Center in Detroit annually raffle off one of their quilts with the proceeds going towards the United Negro College Fund.[66] At an early 1980s Lett family reunion in Mecosta, Michigan, a Bluebird quilt was raffled off to raise funds for family members attending historically black colleges.[67]

**Figure 75.** Kittie Pointer.

**Figure 76.** Kittie Pointer. *Butterflies at the Crossroads*, made 1985, Rodney, Mecosta County, Mich. Collection of the artist. Cotton/polyester with polyester filling, 62-1/2" x 90", MQP 90.25.

## Traditions of Recycling

Recycling fabrics from old clothes, scraps left over from other sewing projects, or materials brought home from workplaces has long been a widespread tradition among quilters. No piece of material, however small, went to waste. Quilters even recycled worn-out quilts as fillings for new ones and incorporated remaining good blocks in new tops. Every African American quiltmaker in Michigan tells stories of using recycled fabrics in her quilts, even quilters who primarily purchase new material for their work.

Rosie Wilkins made Log Cabin quilts (figure 77) from the scraps left over from other quilt projects, since she "throws no strings [pieces] away—don't throw no pieces away." [68] According to her granddaughter, Mildred Chenault, Bertha Riddick (figure 78) made quilts during the Depression when nothing was thrown away. Riddick's Eight-Pointed Star quilt top (figure 79) was made of tiny scraps of fabrics left over from dresses worn by

**Figure 77.** Rosie L. Wilkins (b. 1911). Log Cabin, made 1988-89, Muskegon, Muskegon County, Mich. Private collection. Cotton/polyester with polyester filling, 68" x 84", MQP 89.0019.

**Figure 78**. Bertha Riddick. Courtesy of Mildred Chenault.

**Figure 79**. Bertha Riddick, (1872-1950). Eight-Pointed Star, made ca. 1940, Pontiac, Oakland County, Mich. Collection of Mildred Chenault. Cotton, 79" x 83", MQP 95.8.

**Figure 80**. Irene Maddox.

Chenault, her sister, and her cousin.[69] Irene Maddox (figure 80) has made about ten quilts with scraps from fabrics purchased at garage and yard sales. She also remembers her grandmother once pieced a quilt out of drapery material.[70]

The design of Grandmother's Flower Basket quilt (figure 81), made by Zelma Dorris (figure 56) in 1986, was modelled on both an Erica Wilson pattern and the actual arrangement of flowerbeds in Dorris's grandmother's yard. The quilt contains pieces from her children's old clothes and her grandmother's aprons. Every time women in Dorris's family began to piece a new quilt top, her grandfather would say, "It's time to run with your shirt tail," because they used so many of his old shirts in their work.[71]

Roberta Allen was born in Tupelo, Mississippi in 1920 and moved north where she was employed at Hudson's. Now living in retirement in Holly, she recalled her first quilt made of scraps. "I had been watching my mother quilt for as long as I could remember. I stole some of my mother's scrap materials and made my first quilt. I didn't show it to my mother until it was done. My mother was pleased, but not surprised."[72]

Both Lula Williams (figure 82) and Essie Lee Robinson (figures 83 and 84) have made quilts out of old blue jeans. Dora Gardner called these

**Figure 81.** Zelma Dorris. Grandmother's Flower Basket, made ca. 1980, Detroit, Wayne County, Mich. Collection of the artist. MQP 86.709.

**Figure 82**. Lula Williams.

**Figure 83**. Essie Lee Robinson.

**Figure 84.** Essie Lee Robinson. *Blue Jean Pockets,*
made 1990, Detroit, Wayne County, Mich.
Cotton with cotton filling, 78" x 90", MQP 90.52,
MSUM 7536.

**Figure 85.** Martha Gilbert.

**Figure. 86.** Ailene McKeller and Julie Copeland.
Original design, made ca. 1900, Magnolia, Ark.
Collection of Michigan State University Museum,
acc. 7140. Cotton with cotton filling, 61" x 74",
MQP 86.30.

"britches quilts," and one, made from pieces of boys' pants, was the first thing she ever pieced. Born in Hinds County, Mississippi, Gardner learned to quilt from her grandmother at the age of twenty.[73] Leona Morris of Flint also owns a "britches quilt" called the Champion pattern from her father's side of the family. "It is his people's pattern. It was an original and it has been worked over for years. Mother and Daddy told me about that type of quilt."[74]

Many quilters recall making quilts from feed, flour, or sugar sacks. Martha Gilbert (figure 85) recalled sitting as a young girl on her Cherokee Indian grandfather's lap while her grandmother, Julia Copeland, bleached, then later hand-dyed, hog feed sacks for use in constructing quilt tops (figure 86).[75] These quilts were stuffed with field cotton by Copeland and her daughter, Ailene McKeller, Gilbert's mother. The love of quilting was passed on to Gilbert, who moved to Michigan in 1962 and at eighty years of age spends twenty-four hours a week quilting in her living room.

Joann Marie Davis, a Detroit resident and long-time genealogist, remembers the textile skills of Susie Ella Allen Carter, her maternal

grandmother in North Carolina who lived from 1889 to 1978. Carter, who learned quilting from her mother, Alice Cardwell Allen, recycled flour sacks and grain bags into clothing and quilts.[76] Josephine Collins reported on a Michigan Quilt Project inventory form that she used sugar sacks in quilting.[77] When Willie Bloxson died in 1976 at the age of 107 years, one of her unquilted tops was passed on to her niece Naomi Wright, a quilter in Muskegon. The back of the quilt (figure 87) is made of unbleached fertilizer bags from Laurel, Mississippi. [78]

**Figure 87.** Detail of Bloxson quilt with fertilizer bags. Photograph by Marsha MacDowell.

Susie Porchia was born in Georgia in 1918, lived in West Virginia as a child, and eventually moved to Michigan where she now teaches quilting at a senior center in Detroit. Porchia remembers her grandmother teaching her how to make Nine Patch quilts using materials from dicarded clothing and old flour sacks. She was not sure what they used to back those quilts, but remembers her grandmother "pinning each square to newspaper and then putting them in between mattresses on the bed in order to press them."[79] Quilts were also often stored between mattresses. Nancy Taylor of Detroit remembers homemade pillowcases, sheets, and other items sewn together from flour sacks in her hometown of Sibley, Louisiana: "I made all my quilts out of them. I even had dolls and dresses made out of them."[80]

In 1986 Mary Holmes recalled her stepmother recycling the bags used in cotton picking for both quilts and decorative bed coverings:

> We would take the sacks they pick cotton in, you know . . . when the end of the year comes, most of the sacks were worn out anyway and you gonna get new ones for next year. So we would bleach them and make sheets for the beds. And they was warm plus nice and the most industrious people would make them real decorative . . . they'd take a big dishpan or something and draw a big circle in the middle and print some flowers and embroider them in.[81]

### Quilts as Gifts, Commemorations, and Demonstrations of Tribute

Many African Americans in Michigan have received or given quilts on specific special occasions, such as births, weddings, graduations, and anniversaries. Evelyn Cross made a Sunbonnet Sue quilt (figure 88) for each of three granddaughters when they were born.[82] Family history tells that when Maggie Wood was expecting her first child, a daughter, she made a full-sized patchwork quilt in celebration of the event. According to her family, her love for the expected child was so great that she made a full-size quilt rather than a crib quilt, which was the usual family custom.[83]

Ramona Hammonds made a specially designed quilt for each of her children when they graduated from college.[84] Marguerite Berry Jackson received quilts as wedding gifts and recalls attending, at age eleven or twelve, a surprise quilting party for her grandmother Porter's wedding.[85] In addition to giving quilts to each of her eight children when they married, Dolores

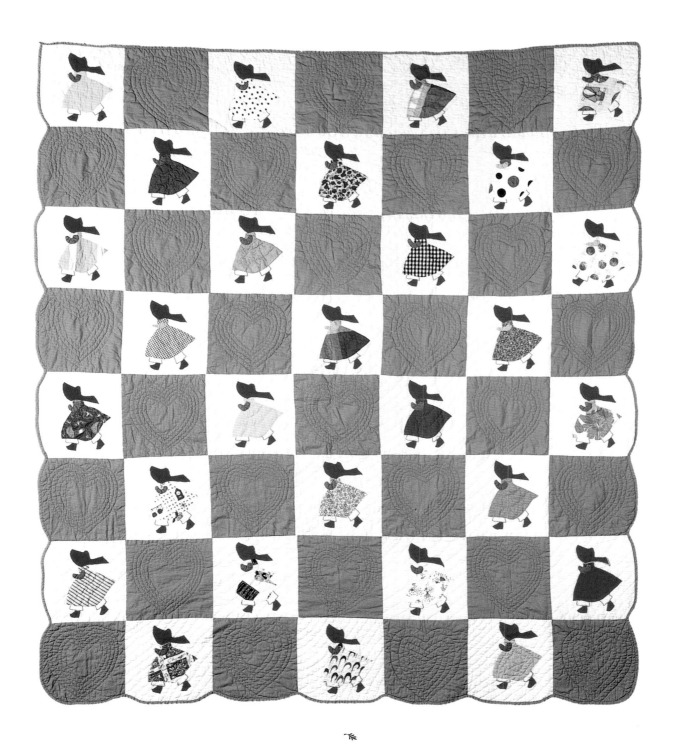

**Figure 88**. Evelyn Lewis Cross. Sunbonnet Sue, made ca. 1970s, Bardstown, Ky.
Collection of Nicole Wilhite. Cotton with cotton filling, 64" x 84", MQP 85.1335.

**Figure 89.** Dolores Moore. *Commemorating Fifty Years of Service*, made 1983, Flint, Genesee County, Mich. Collection of the artist. Cotton/polyester with polyester filling, 84" x 102", MQP 90.58. (See Appendix, p. 139, for detailed description.)

**Figure 90.** Venita Bates and Fred Turner standing in front of O'Quinn family reunion quilt. Photograph courtesy of LaNeysa Harris-Featherstone.

𐅵

**Figure 91.** Nellie V. Brown.

𐅵

**Figure 92.** Emma P. Brown, piecer;
Kathryn Frazier, quilter. Flower Basket, made
1932, Louisville, Ky. Collection of Nellie V. Brown.
Cotton with cotton filling, 80" x 84", MQP 86.713.

Moore created a quilt to honor her father's fiftieth anniversary of service as a Methodist minister in the African American Episcopal Zion Church. Photographs of family members and of the churches he pastored were included in the quilt she calls *Commemorating Fifty Years of Service* (figure 89).[86]

In 1992, the Detroit portion of the O'Quinn family hosted their annual reunion and decided to make a quilt to honor the occasion (figure 90). According to family member LaNeysa Harris-Featherstone, who was on the reunion planning committee, the hope was that the completed quilt would be passed on to the next reunion host city. The committee sold raffle tickets for the quilt to help defray reunion expenses, thinking the tickets would only be purchased by family members and therefore the quilt would be won by someone within the family. However, the quilt was won by a visiting friend who, because he had never won anything before, refused to part with it. The committee now plans to make another quilt when they are again the host site and certainly do not plan to sell raffle tickets.[87]

After Emma Brown moved from Louisville, Kentucky to Detroit to live with her daughter Nellie Brown (figures 91 and 92) and son–in–law, she kept busy with needlework activities and completed thirty-four quilts in her lifetime. Motivated to quilt because she "liked a pretty bed," Brown made

quilts for each of her three children when they married, and for the birth of each of her grandchildren.[88] Several quilters documented in Michigan told of setting personal goals of making a quilt for each member of their family. Sina Phillips of Muskegon set a goal of making a quilt in the same pattern—the Shirley Pine—for each of her children and grandchildren.[89] Isabella Major made quilts for each of her nine children and once told her daughter that she began each new baby quilt the moment she knew she was pregnant.[90]

Quilts are also made to honor a loved one or demonstrate appreciation for the contributions of an individual or organization. Viney Crawford, of Idlewild, Michigan made a String quilt especially for the Michigan State University Museum in honor of the Yates Township Senior Center in Idlewild (figures 93 and 94). As a present for her son Randolph when he went to college, Irene Maddox fashioned a quilt out of his Boy Scout handkerchiefs (figure 95).[91] In 1981 Marguerite Berry Jackson wanted to do something special for her younger sister, Madeline White, and created the Dancing Butterflies

**Figure 93**. Viney Crawford.

**Figure 94**. Viney Crawford. String, made 1986, Idlewild, Lake County, Mich. Collection of Michigan State University Museum, acc. 6521. Cotton and polyester, 64" x 80", MQP 86.1843.

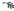

pattern (figure 96). After she appliquéd and pieced the top together, she invited all of her sisters to a quilting party in her home. At the end of the party, they surprised White by presenting her with the finished quilt. Jackson learned quilting from her Granny Lucy Berry when she was eleven or twelve years old.[92]

Rosa Parks was honored at a ceremony by the Boise (Idaho) Peace Quilt Project in 1982 with a quilt called simply *The Rosa Parks Quilt* (figure 145).[93] A fabric portrait of Parks in a central square is surrounded by thirty squares containing words and pictures executed in stencil, appliqué, embroidery, and piecework that testify to her life in the Civil Rights movement. Four versions of roses are rendered in the corner squares, and both the front and pieced back contain many fabrics printed with roses in further tribute to Parks. Parks, who considers this present one of her "most cherished gifts," herself tells of giving quilts as gifts to family members.[94]

**Figure 95.** Irene Maddox. *Boy Scout Quilt.* MQP 95.16.

**Figure 96.** Marguerite Berry Jackson (b. 1913). Dancing Butterflies, made 1981, Lansing, Ingham County, Mich. Collection of Madeline Berry White. Cotton and cotton/polyester with polyester filling, 72" x 94", MQP 90.44.

**Figure 97.** Alice Trammell. Photograph courtesy of Alfreda Cole.

**Figure 98**. Alice Trammell. Floral Appliqué, made ca. 1912, Magnolia, Ark. Cotton with cotton filling, 78" x 82", MQP 86.31.

Most quilts made for utility, even when received or given as gifts, are used up. Those that have been saved are treasured mementos. Years after they are made, these quilts serve as visual reminders of the individuals who made or received the quilt, the individuals whose clothing scraps were used to create the quilts, and the events or locations associated with the gift. Alfreda Cole of Muskegon has one quilt made by her grandmother, Alice Trammell, a woman born into slavery who learned to sew as a house servant on a plantation in Arkansas and later earned her living as a midwife (figures 97 and 98). Cole remembers her grandmother, who died at 100 years of age, as a proud woman. Several years ago, Cole decided to wash the quilt and poured bleach on it. She regrets the damage it caused to the original color in several areas but will not part with the quilt because it serves as a strong reminder of her family heritage.[95]

Derenda Collins plans to make a quilt for each of her children using scraps from dresses belonging to her grandmother, noted quiltmaker Maggie

Wood.[96] Members of the Missionary Society at Missionary Baptist Church in Mary Holmes's hometown of Hughes, Arkansas, made a Snail's Trail quilt as a wedding gift for her (figure 99). Of its making Holmes recalled:

> That was by my father's church. My aunt was president of the missionary society and she must have supervised that. But there was another lady who really loved to piece the Snail's Trails and that was Marjorie Humphrey. . . . She was a mid-wife, so [she] was pretty well known in our area. She worked in the missionary society and was a great quilter too.[97]

Flint resident and Liberian natives Taylorie (figure 100) and Reverend Emmanuel Bailey received a quilt made by Taylorie's mother as a gift for their

**Figure 99.** Members of Missionary Society of Missionary Baptist Church. Snail's Trail, made 1937, Hughes, Ark. Collection of Mary Brown Holmes. Cotton with cotton filling, 86" x 62", MQP 86.43.

wedding. According to Reverend Bailey, they put the quilt on their bed only on the anniversaries of their wedding and her mother's death (figure 101). [98]

Numerous African American quilters tell of making or receiving friendship or autograph quilts—usually signed in embroidery or ink by all its makers. Ione Todd received such a quilt signed by neighbors, friends, and family members as a wedding gift in 1945 (figure 102). Todd and daughter Green presented Marsha MacDowell with a new version of this quilt done in blue fabrics and signed with their names as a gift in 1989 (figure 103).[99] Kittie Pointer, another Mecosta County resident, hails from a family of quilters and also received a friendship quilt for her wedding more than fifty years ago.[100]

A quilt with the embroidered names of all of the seniors in the Walter Reuther Senior Center East in Detroit hangs in the center's activity room.[101] Eula Williams (figure 104) received a friendship quilt on the occasion of her retirement after thirty-four years of teaching in Arlington, Virginia (figure 105). The idea for the quilt came from Rita Strauss; art teacher Edith Symes helped students in Williams's sixth-grade class at Taylor Elementary School, Arlington, Virginia, trace their hands onto cloth. Five of the children's mothers—Faith Winters, Terry Porter, Helen Rebull, Raye Haug, and Mary Mytryshyn—appliquéd the cloth hands onto a top and completed the quilt. Williams, who has always summered in Lake County, Michigan, shared this unusual quilt and the story at the Idlewild African American Quilt Discovery Day.[102] Like a photograph or autograph album book, these quilts serve as documents of the relationship of a certain group of individuals at particular points in history.

Pieced, appliquéd, and quilted textiles are also made as a means of coping with the grief of the death of a loved one or to commemorate the achievements of the deceased. Josephine Collins recalled making mourning quilts in "three corner block and square patterns in white, blue, and black colors" in her hometown of Madison, Mississippi.[103] When her son Theron unexpectedly died, professional fiber artist Julie Richardson-Pate of Bloomfield Hills used photographic transfer and other fabric techniques to fashion a quilt that serves as a summary of his young life (figures 106 and 107). Incorporated into the textile are fabric copies of his driver's license and social security card, high school diploma, photos from his high school track and football days, and the family's last Christmas photograph. On the reverse side of the quilt is a fabric transfer of his obituary and a quote from his coach: "Theron Richardson touched us all who knew him—and we are grateful he passed our way." [104]

Among the more than 20,000 panels composing the AIDS memorial quilt created by the NAMES Project are tributes honoring the African Americans in Michigan who have died of AIDS. Made by friends, coworkers, families, and loved ones, the panels provide a lasting testimony to the contributions and memory of AIDS victims. In 1989, a panel for Joyce, an African American woman who died of AIDS in Lansing, was made at the MSU Museum's annual NAMES Project quilting bees and then included in

Figure 100.  Taylorie Bailey.

Figure 101  (see enlargement on p.8). Isabella Major (b. 1925). Blazing Star, made ca. 1972, Monrovia, Liberia. Collection of Taylorie Bailey. Cotton with cotton filling, 96" x 100", MQP 90.0053.

Figure 102.  Women of Blanchard and Remus, Mich. Crazy Friendship, made 1945, Blanchard and Remus, Mecosta County, Mich. Collection of Ione Todd. Cotton with cotton filling, 88" x 70", MQP 90.0022.

an exhibition of panels from Michigan (figure 108).[105] It was later sent to San Francisco where it is now part of the NAMES Project collection. When major portions of the NAMES Project quilt have been exhibited in Michigan, they also served to bring public attention to the ongoing tragedy of this disease within our society.

**Quilting Groups in Michigan**

Quilting traditionally serves as an opportunity for social interaction and provides an important opportunity to share productive time with friends and family. The popularity of African American quilting groups in Michigan has increased in recent years, and numerous quilting classes and groups meet in churches, homes, and recreational and senior centers around the state. Kingsley Center (Lansing), Walter Reuther Senior Center Southwest (Detroit), Walter Reuther Senior Center East (Detroit), Ecorse Senior

**Figure 103**. Deonna Todd Green and Ione Todd. Crazy Friendship, made 1989, Remus, Mecosta County, Mich. Collection of Marsha MacDowell. Cotton/polyester, 82" x 84", MQP 90.0056.

**Figure 104.** Eula Williams.

**Figure 105.** Students and students' parents of Eula G. Williams. *All My Children*, made 1986, Arlington, Va. Collection of Eula G. Williams. Cotton/polyester with polyester filling, 82" x 106", MQP 86.789.1.

**Figure 106.** Julie Richardson-Pate.

**Figure 107** (front and back). Julie Richardson-Pate. *Memorial* quilt, made 1993, Bloomfield Hills, Oakland County, Mich. Collection of the artist. Cotton with cotton filling, 62" x 53", MQP 95.18.

Citizens Club (Ecorse), Joseph Walker Williams Community Center (Detroit), Holly Senior Citizens Center (Holly), Townsend Center (Muskegon Heights), Muskegon Nutritional Center (Muskegon), Hartford Memorial Baptist Church (Detroit), Evans Recreation Center (Detroit), Jehovah Baptist Church (Detroit), Benton Harbor–Benton Township Senior Citizens Center (Benton Harbor), Mecosta Methodist Church (Mecosta), Cross Church (Remus), and Yates Township Senior Citizens Center (Idlewild) are but a few of the places in Michigan where African American quilters have regularly gathered over the past ten years.

Three sisters—Effie Hayes, Mary Turner, and Mattie Douglas—first saw their mother, Eula Bryant, and Eula's mother quilting when they were growing up in Georgia. They remember learning to piece and trying to quilt as young girls, but only Hayes (figure 109) had completed a quilt before they formed their family quilting club ten years ago. Turner's daughter, who is a seamstress, had scraps of material available; Mary suggested that the family start quilting together and put the scraps to good use. The Bryant Family Quilting Club began with seven of the eight sisters meeting at Mary's house and quilting under her supervision. Tuesday evenings from 7:00 until 10:00, each woman pieced her own top and then received help with quilting from the rest of the group. The women have made dozens of quilts for their children, grandchildren, and close friends. They also have demonstrated quilting and displayed their work at the Detroit Institute of Arts, the Fisher Building (Detroit), and the Michigan State University Museum.[106]

Dora Gardner taught all of her eleven children—sons and daughters—to quilt, and each have made quilts on their own. Through adulthood, her children would still drop by regularly at Gardner's home to work on quilts

**Figure 108**. NAMES quilt exhibit at MSU Museum. Photograph by Marsha MacDowell.

**Figure 109**. Effie Hayes.

**Figure 110.** Blanche Cox, Dora Gardner, Lubertha Williams, Edmund Gardner, Alandress Gardner, Isabell Turner, Mary White, Lucille Riley, Elizabeth Thomas, John Gardner. Trip Around the World, made ca. 1972, Muskegon, Muskegon County, Mich. Collection of Blanche Cox. Polyester knit, 84" x 89", MQP 90.39.

together. A Trip Around the World (figure 110) quilt, composed of tiny scraps of fabric leftover from making dresses and pant suits which they could not bear to throw away, was made in 1990 as a family project when Gardner was ninety-nine years old.[107]

The members of the Detroit group, The Quilting Six Plus, are connected in a number of ways, including sorority membership and friendships formed in college. The original group had two sets of sisters within the group: Myla Perkins and Clara Clark, and Charlesetta Buie and Elizabeth Jaggers. The remaining members, Alva Gamble and Gwen Spears, agree with the others that, after years of quilting, talking, and encouraging one another, the ties that bind them are stronger than ever. Jaggers also says that when the group first got together in the late 1980s, family and friends doubted that "six beautiful, intelligent black women were getting together to quilt." When The Quilting Six Plus held their own exhibit and displayed more than seventy quilts, visitors were impressed and many asked to join the group. The members have decided not to expand, choosing rather to encourage others to begin their own groups. With the death of Spears and Buie and the additions of Henrietta Lee, Margaret Lockhard, Alice Simpkins, Dolores Wilson, and Elaine Roberston, the group remains tightly bound (figure 111).[108]

In November 1980, the Senior Citizens Quilt Factory, a nonprofit enterprise, opened at the Avery Aldridge Activity Center in Flint. According to founder John Bridges, retired Chevrolet factory worker and owner of the House of Alterations next door, he started the business to provide a drop-in center for seniors that would also generate some income.[109] Here Teressie May was inspired to finish a Pinwheel quilt top (figure 112) that she had received as a wedding gift. When the Quilt Factory disbanded after a couple

Figure 111. The Quilting Six Plus. Left to right, top: Myla Perkins, Alva Gamble, Charlesetta Buie, Clara Clark. Bottom: Gwendolyn Spears, Elizabeth Jaggers.

Figure 112. Louella Calvin, piecer; Teressie May, quilter. Pinwheel, pieced 1948, quilted 1981, Flint, Genesee County, Mich. Collection of Teressie May. Cotton with cotton filling, 82" x 92", MQP 90.63.

**Figure 113.** Flint Afro-American Quilt Guild. Left to right, standing: Katherine Harris, Jeffalone Rumph, Bennye Hayes, Teressie May, Joe Rolston, Lucille Rolston, Jeffie Johnson, Cora Vanderson; seated: LaVada Brown, Leo McClain, William Etta Buck, Derenda Collins, Earnestine Holme.

of years, May kept quilting and eventually joined the Flint Afro-American Quilt Guild, started by Derenda Collins and Jeffalone Rumph in 1989. Members of the group quilt, put on exhibits of their work, demonstrate quilting at museums, and attend classes, quilt shows, and conferences together (figure 113).

Quilting also provides an opportunity for social interaction between members of diverse cultural groups. African American quilters in Michigan have taken classes from Euro-American and Hispanic instructors, regularly participate in interracial quilt clubs, and exhibit their work in a variety of venues. African American quilters are members of the Michigan Quilt Network, the American Quilt Study Group, and the American Quilter's Society—all organizations dedicated to the study and practice of quilting.

Ramona Hammonds learned quilting from Lola Choinski, a Euro-American quilter, and won first prize at an Akron, Ohio, quilt show for a quilt Choinski designed and Hammonds quilted.[110] Detroiter Mattie Wolfolk, originally of Bessemer, Alabama, produces quilt tops she then sends to be quilted by Martha Miller, an Amish woman living in Indiana. Materials, instructions, and the completed quilt are sent through the mail; the two women have never met but, nonetheless, enjoy a working partnership (figures 114 and 115).[111]

The Detroit Rainbow Stitchers is an interracial quilt cooperative including women of African American, Euro-American, and Hispanic backgrounds. Generally the women meet once every two weeks in the auditorium of Detroit's Holy Redeemer Church in space provided by the Witness for Peace and Justice in Southeast Michigan, the group's sponsor. Members divide cutting, piecing, and quilting tasks to have the freedom to work independently at home, but continue to meet because they enjoy each other's company. Completed projects are marketed to supplement their income (figure 116).[112]

**Figure 114.** Mattie Wolfolk.

**Figure 115.** Mattie Wolfolk. *Cross-stitched Birds*, made 1985, Detroit, Wayne County, Mich. Collection of the artist. Cotton/polyester with cotton filling, 86" x 90", MQP 90.46.

## Quilt Shows, Exhibitions, and Classes

The majority of quiltmakers interviewed for this project concurred that, until recently, neither they nor their relatives and friends put their quilts on exhibit in church displays, county fairs, or other community centers. Josephine Collins is one of the few whose family members engaged in this practice: "My mother would have them at the fairgrounds, you know where they used to have a fair. And she'd put one up . . . I did it one or two times. And I didn't want to be washing my quilts after so long, I didn't want to go through that.[113]

Today quilters, both black and white, are attending exhibitions in record numbers, and there are considerably more opportunities for exhibition of African American quilts in venues for primarily black as well as for general audiences. Zelma Dorris has won ribbons and honorable mentions in

*Marsha L. MacDowell*

**Figure 116.** Detroit Rainbow Stitchers. Photograph by Deborah Smith Barney.

**Figure 117.** Lily Martin at quilt show of Flint African-American Quilters.

**Figure 118.** Piecemakers quilt show, Evans Recreation Community Center. Photograph by Marsha MacDowell.

numerous quilting exhibitions and competitions. Ramona Hammonds has exhibited and won ribbons at the Michigan State Fair. In addition to the exhibition of African American quilts at Michigan State University Museum, in the last ten years exhibitions of African American quilts have occurred at the Greater Ebenezer Spiritual Temple Fellowship Hall (Benton Harbor), Kalamazoo Public Museum (Kalamazoo), Spaces Gallery (Kalamazoo), Trinity AME Church (Lansing), Evans Recreation Center (Detroit), Bethel United Methodist Church (Flint), and, of course, the annual shows at the Hartford Memorial Baptist Church (Detroit) (figures 117 and 118).

African American quilts have been included in a number of exhibitions in Michigan, including ones in Kalamazoo, East Lansing, and Muskegon, as well as a traveling exhibition organized by New Initiatives for the Arts, a program funded by Michigan Council for Arts and Cultural Affairs, designed to bring the work of minority artists to new audiences. The first one-woman show by an African American quilter was Carole Harris's at a gallery in the Fisher Building in Detroit in the mid 1970s. Rosie Wilkins and Lethonee Jones have since each had one-woman shows of their work.

Quilts by Michigan women are now being included in national exhibitions. In 1989, Deonna Green and Ione Todd's *Todd Family Quilt* was included in the national exhibition *Stitching Memories: African American Story Quilts*, which originated in Massachusetts at Williams College Museum of Art in 1989 and toured to seven other venues around the country.[114] *Playing on the Edge*, a quilt by Carole Harris, was part of the *Uncommon Beauty in Common Objects: The Legacy of African American Craft Art* exhibition which originated from the National Afro-American Museum and Cultural Center in Wilberforce, Ohio.[115]

Throughout the world, the numbers of professional instructors of quiltmaking have dramatically increased over the last twenty years. This growth has also occurred in Michigan among African American quilters. Ramona Hammonds, Elaine Yancy Hollis, Sarah Carolyn Reese, Deonna Green, Carole Harris, Denise Curtis Reed, Gwen Gillespie, Susie Porchia, Shirley Gibson Bell (figures 119 and 120), and Lula Williams are among those who have all taught classes at a variety of locations, including the Detroit Historical Museum, Michigan State University Museum, Joseph Walker Williams Community Center, Evans Recreation Center, Hartford Memorial Baptist Church, and Renaissance Church in Detroit.

Quilting is becoming a more widespread activity within public schools and is used as a way of teaching art, social studies, history, math, and a variety of other disciplines. Maxine Dillard and students in her first-grade class at Fleming Elementary School in Detroit in the early 1980s made quilts as part of a special project. More recently, under the direction of teacher Cynthia E. Patton–Long and quilters Clara B. Williams and Lillie D. Wilson, Room 217 students at Courville Elementary School in Detroit patched and tied a quilt for their project "Anything I Can Do, You Can Do Better."[116]

### Religion and Quilting Activities

Religion and quilting have been intricately intertwined in the experiences of many African American quiltmakers in Michigan. In some communities church rooms have provided the only spaces locally available big enough to set up a quilting frame. In both Northern and Southern quilters' experiences, churches serve as bases for quilting groups and as sites of quilt exhibitions and classes. Yet religion has played a deeper, more pervasive role in many of the lives of quilters interviewed during this project. Memories of quilting bees in the South included frequent mention of not only the eating and storytelling that commonly accompany the sewing, but also of singing and praying. For instance, Mary Holmes recalled quilting bees as important times of gospel-hymn and shape-note singing.[117]

Sometimes quilters took their inspiration for quilt patterns or designs directly from Biblical sources. Allie Cooper, a quilter from Lansing, embroidered a *Bible* quilt containing figures from many Biblical stories (figure 121).[118] Denise Curtis Reed, learned quilting originally from her mother and "the finer points" of the tradition from the older women in her church in Detroit. Reed adapted her *Creation* quilt design from an illustration on a Sunday School book cover

**Figure 119.** Shirley Gibson Bell .

**Figure 120.** Shirley Gibson Bell. *Busy, Busy, Spinning Spools*, made Detroit, Wayne County, Mich. MQP 91.0036.

**Figure 121.** Allie Cooper. *Bible* quilt, made 1988, Lansing, Ingham County, Mich. Private collection, Cotton, 55-1/2" x 81-1/2", MQP 95.11.

*Marsha L. MacDowell*

**Figure 122.** Denise Curtis Reed. *Creation*, made
1982, Detroit, Wayne County, Mich. Collection of
the artist. Cotton with cotton filling, 34" x 53",
MQP 90.32.

**Figure 123.** Delores Meyers.

(figure 122).[119] Delores Meyers of Kalamazoo includes variations of the cross in her quilting patterns (figure 123).

Since completing her first Pinwheel quilt almost twenty-five years ago, Lula Williams has made more than 100 quilts. She has won numerous awards, including a Michigan Traditional Arts Apprenticeship Program grant in 1992 to teach apprentices Kaye F. Robinson of Detroit and April Johnson of Hamtramck and the Michigan Heritage Award in 1997. Her original *I Am* quilt is a strong testament to the role of religion in her life. Illustrated in the quilt are the seven "I Am's" that Jesus utters in the Bible, as well as many of the "I Am's" that African American preachers often use at the end of their sermons (figure 124).[120]

Other quilters, such as Detroiter Elaine Hollis (figures 125 and 126), attribute their interest in making quilts to a sense of Christian responsibility for using and sharing their talents. She cites as her reasons for quilting: "Relaxation. Creativity. Spirituality. Being able to leave somewhat of a legacy. Being able to use one of the talents that I received from God."[121] Derenda Collins expresses similar feelings about her quiltmaking:

> I feel that by taking these tiny, little pieces, discarded pieces and making them something valuable represents sort of our human frailties and that God has a patchwork plan, pattern, appliqué. . . . Quilting has been a strong part of my life and of my growth. It has helped me to communicate with my grandmother and with myself. . . . You can think. You can dream. You can plan. You can pray. You can sing. It's a very good skill. It's a very good art. [122]

**Figure 124.** Lula M. Williams. *I Am*, made 1987, Detroit, Wayne County, Mich. Collection of the artist. Cotton/polyester with polyester filling, 60" x 76", MQP 90.23. MSUM 7424.

**Figure 125**.  Elaine Yancy Hollis.

**Figure 126**.  Elaine Yancy Hollis. *Todd* or Pyramid, made 1985, Detroit, Wayne County, Mich. Cotton with polyester filling, 75" x 89", MQP 90.26, MSUM 7424.

### The Important Role of Quilting in Women's Lives

The importance of quilting in the lives of women of all backgrounds is also evidenced by the inclusion of this activity in reports of other life accomplishments, both domestic and professional. When seventy-seven-year-old Eddie Harper of Lansing finally realized a twenty-three-year-old goal of finishing high school and receiving her diploma, the newspaper article chronicling this achievement also highlights her quilting.[123] Awareness and appreciation of the presence of quiltmakers' skills are also often mentioned by other family members. In a 1986 *New Yorker* profile on the incomparable jazz pianist and Detroit native Tommy Flanagan, he talked about his Georgia-born mother, Ida Mae Flanagan. "She was very resourceful about things like cooking and sewing . . . she made a lot of our clothes, and she made beautiful patchwork quilts."[124]

One of the most poignant but instructive clues to the important role of quilting in women's lives is the mention of quilting activities in their obituaries. When Rosetta E. Berry died in 1991, her *Detroit News* obituary stated that she was a "founding member of the Greater Macedonia Baptist church in Detroit . . . she enjoyed cooking and making quilts for her family."[125] The first line of the 1992 obituary for Michigander Cora Mays Lee stated "devoted homemaker, mother and expert quiltmaker."[126] Among the many professional accomplishments and memberships listed in Flint resident Dolores Moore's obituary in 1994 was her membership in the National Quilter's Association.[127] When Tennessee native and Flint resident Maggie Wood passed in 1991, the printed Memorial Tribute at her funeral stated "she was reputed to be a fastidious housekeeper and her homemaking skills are still in evidence as one of her utility quilts is displayed in the Michigan State University Museum."[128] Charlesetta Buie's *Detroit News* obituary in 1992 was titled "Enjoyed quilting and church work" and said Buie "became a quilter whose works have been displayed in such places as the Afro-American Museum [in Detroit]."[129]

Many of the African American quilters interviewed in Michigan express enduring interest in and, in some cases, a passion for quilting that is truly impressive. While it is true that some women have made only one or just a few quilts, others have made so many that they lost track of the number. Rosie Wilkins, for instance, figured "she has made over 100 in her lifetime."[130] Dora Gardner, a seamstress, made more than 500 quilts and only blindness prevented her from continuing.[131] Carpal tunnel syndrome in one wrist and pinched nerves in the other handicap Lillie Mae Tullis's ability to finish quilts as quickly as she once did, but she continually works on her quilts for short periods of time. Her Star Burst quilt took her eighteen months to complete.[132]

Many women told of the daily quilting goals they set for themselves, even when their lives are filled with other work and family obligations. Rosie Wilkins said, "I'll get up and do my housework in the morning, then fix my dinner in early afternoon. Then I quilt until 11 or 12 o'clock at night, every night."[133] Derenda Collins says she "tries to thread three needles a day and finish them off."[134] In addition to working on quilts at home, Charline

Beasley, who has also made more than 100 quilts, has been known to take two to three buses every day in order to work on quilts kept in frames at Jehovah Baptist Church in Detroit.[135] Essie Robinson simply says, "Quilting gives me a reason to get up in the morning. It works my brain creatively."[136] Even though Jeffalone Rumph travels a lot, she keeps up with her quilting projects, even going so far as to always take an extra piece of luggage just to carry her work in.[137]

**Conclusion**

We now understand that the history and culture of any given group can be reflected in the production and use of its material culture. The choice of color, patterns, designs, fabrics, and sewing techniques among African American quilters in Michigan has been dictated just as much by family and community-based traditions as by educational training, individual preferences, and available time, tools, and materials. Exposure to mass-circulated information about quilting, residency in communities of diverse cultural populations, and involvement in quilt classes and exhibitions have also greatly expanded the experiences of Michigan quiltmakers.

It is not surprising that this complex set of experiences and influences has fostered the wide range of quilt styles and traditions seen in Michigan. While there are many stories of similar experiences with quilts and quilting activities, no one type of quilt or quilting activity emerges in Michigan that can be called "typically African American." The basic traditions of quilt designs, construction techniques, materials, and uses are shared by all quiltmakers, regardless of race or ethnicity. Only by examining the individual quilters, their stories, and their activities can distinct connections be made with the African American experience.

Women have found in quilting an avenue to express their experiences creatively and share them with others in meaningful ways. Now this essay allows many individual stories and their connections to distinct African American experiences to be shared with others. Black women in Michigan have found many ways to, as Darlene Clark Hine describes it, "make community." Through the production, use, and now sharing of quilts, African American women create a mechanism to express individuality, strengthen family and community ties, and connect with other women outside their cultural groups.

African Americans convey vital personal, family, and community history and knowledge through the making and sharing of quilts. A recognition of the various ways in which quilts and quilting activities convey this knowledge leads to a greater understanding of the African American experience in Michigan.

As more information about African American quilts, their makers, and their users is gathered, a greater understanding of the complexity and diversity of quiltmaking as well as its importance within the community will be realized.

## Notes

1. "Black Americans," in *Ethnic Groups in Michigan, Vol. II*, eds. James M. Anderson and Iva A. Smith (Detroit: Ethnos Press in collaboration with the Michigan Ethnic Heritage Studies Center, 1983), 34.

2. Richard W. Thomas, "The Black Urban Experience in Detroit: 1916–1967," in *Blacks and Chicanos in Urban Michigan*, eds. Homer C. Hawkins and Richard W. Thomas (Lansing: Michigan History Division, Michigan Department of State, 1979).

3. Joe T. Darden, "Patterns of Residential Segregation in Michigan Cities in the Nineteenth Century," in *Blacks and Chicanos in Urban Michigan*, eds. Hawkins and Thomas, 21.

4. Unpublished letter from Elizabeth Campbell to Sophie Biddle, 22 April 1841, Sophie Biddle Collection Letters, Michigan Historical Collections, Bentley Library, University of Michigan; see also Marsha MacDowell and Ruth D. Fitzgerald, eds., *Michigan Quilts: 150 Years of A Textile Tradition* (East Lansing: Michigan State University Museum, 1987).

5. Gladys-Marie Fry, *Stitched From the Soul: Slave Quilts from the Ante-Bellum South* (New York: Dutton Studio Books in collaboration with the Museum of American Folk Art, 1990), 14.

6. John Green, *Negroes in Michigan History* (reprint of *Michigan Manual of Freedmen's Progress*, 1915) (Detroit: privately published, 1985), 37.

7. Sandi Fox, *Wrapped in Glory: Figurative Quilts and Bedcovers 1700–1900* (New York: Thames and Hudson, 1990), 119–21; see also "Quilts," *Hobbies—The Magazine for Collectors* 83, no. 5 (July 1977): 116–17.

8. Michigan Quilt Project 90.57, information supplied by Sallie Brodie.

9. MSU Museum acc#6646, information supplied by donor Patricia Anderson, 1986.

10. See especially Maude Southwell Wahlman, *Signs and Symbols: African Images in African-American Quilts* (New York: Studio Books in association with Museum of American Folk Art, 1993); Robert Farris Thompson, "African Influences on the Art of the United States," in *Black Studies in the University*, eds. A. Robinson, et al. (New Haven, Conn.: Yale University Press, 1969); John Michael Vlach, *The Afro-American Tradition in Decorative Arts* (Cleveland, Ohio:

Cleveland Museum of Art, 1978); Eli Leon, *Who'd A Thought It: Improvisation in African-American Quiltmaking* (San Francisco: Craft and Folk Art Museum, 1987); and Roberta Horton, *Calico and Beyond: The Use of Patterned Fabric in Quilts* (Lafayette, Calif.: C & T Publishing, 1986), 44.

11. Lethonee Jones, phone interview with Marsha MacDowell, 1990.

12. Emmanuel Bailey, phone interview with Marsha MacDowell, October 10, 1991 and Emmanuel Bailey and Taylorie, interview with Marsha MacDowell and C. Kurt Dewhurst, Flint, Mich., October 31, 1992.

13. For more information about quiltmaking in Liberia see Kathleen Bishop, "Quiltmakers of Liberia," Topic no. 181 (published by U.S. Information Agency): 47–48 and Cuesta Benberry, *Always There: The African-American Presence in American Quilts* (Louisville: Kentucky Quilt Project, Inc., 1992), 35–37.

14. Michigan Quilt Project 86.732.1, information supplied by Bennie Mae Latimer.

15. LaNeysa Harris-Featherstone, interview with Marsha MacDowell, East Lansing, Mich., January 31, 1995.

16. Shawn Windsor, "Quilts Display Fabric of History," *Ann Arbor News*, 17 August 1994.

17. LaNeysa Harris-Featherstone interview.

18. Benberry, *Always There*, 62–63.

19. "Quilts Old and New," *Detroit Free Press*, 14 October 1990.

20. Michigan Quilt Project 93.131, information supplied by Justine Burnell.

21. Mark Mathabane, *Kaffir Boy: The True Story of a Black Youth's Coming of Age in Apartheid South Africa* (New York: Macmillan, 1986).

22. Michigan Quilt Project 93.119, information supplied by Beverly Ann White.

23. Michigan Quilt Project 86.63, information supplied by Naomi Wright.

24. Consella A. Lee, "Quilted History," *Michigan Chronicle*, n.d.

25. Michigan Quilt Project 90.28, information supplied by Lucille Rolston.

26. Deonna Green and Ione Todd, tape-recorded interview with Marsha MacDowell, Lansing, Mich., January 21, 1991; Deonna Green and Ione Todd,

interview with Marsha MacDowell, Remus, Mich., April 12, 1989; and Marsha MacDowell, field notes, August 15, 1986.

27. Marguerite Berry Jackson, tape-recorded interview with Marsha MacDowell, Lansing, Mich., December 13, 1990, Michigan State University Museum 90.135.

28. Blanche Cox (Gardner's daughter), interview with Lynne Swanson, Muskegon, Mich., February 13, 1986.

29. Teressie May, tape-recorded interview with Wythe Dornan, Flint, Mich., October 16, 1989, Michigan State University Museum 89.121.01.

30. Sina Phillips, tape-recorded interview with Lynne Swanson, Muskegon Quilt Discovery Day, Muskegon, Mich., February 15, 1986, 86.68.1; see also Sina Phillips, tape-recorded interview with Marsha MacDowell, Muskegon, Mich., July 24, 1986, Michigan State University Museum 87.23.13.

31. Hattie Hudson, phone interview with Denise Grucz, October, 9, 1990.

32. Lillie Mae Tullis, tape-recorded interview with Denise Grucz, Detroit, Mich., October 16, 1990, Michigan State University Museum 91.14.07.

33. Mary Holmes, tape-recorded interview with Marsha MacDowell, Muskegon, Mich., May 13, 1986, Michigan State University Museum 87.23.20.

34. Charline Beasley, tape-recorded interview with Deborah Smith Barney, Detroit, Mich., August 20, 1990, Michigan State University Museum 90.081.022.

35. Information provided in letter from Cheryl Lyon Jenness, 1990.

36. Information provided in letter from Cheryl Lyon Jenness, November 10, 1990.

37. Hattie Hudson, phone interview with Denise Grucz, October 9, 1990.

38. Josephine Collins, tape-recorded interview with Marsha MacDowell, Muskegon, Mich., August 28, 1986, Michigan State University Museum 87.23.15, 16.

39. "At 107, Elnora Adams Takes Her Place as Matriarch," *Oakland Press*, 27 January 1985.

40. Jessie Wheeler, tape-recorded interview with Denise Grucz, Holly, Mich., December 21, 1990, Michigan State University Museum 91.14.04.

41. Mary Holmes, tape-recorded interview with Marsha MacDowell, Muskegon, Mich., May 13, 1986, Michigan State University Museum 87.23.20.

42. Josephine Collins, tape-recorded interview with Marsha MacDowell, Muskegon, Mich., August 28, 1986, Michigan State University Museum 87.23.15, 16.

43. Author's conversation with Rosie Wilkins, Muskegon, Mich., May 12, 1986.

44. Jeffalone Rumph, tape-recorded interview with Wythe Dornan, Flint, Mich., October 17, 1989, Michigan State University Museum 89.121.02.

45. Sina Phillips, tape-recorded interview with Lynne Swanson, Muskegon Quilt Discovery Day, Muskegon, Mich., February 15, 1986, Michigan State University Museum 86.68.1.

46. Zelma Dorris, tape-recorded interview with Deborah Smith Barney, Detroit, Mich., July 16, 1990, Michigan State University Museum 90.81.11.

47. Teressie May, tape-recorded interview with Wythe Dornan, Flint, Mich., October 16, 1989, Michigan State University Museum 89.121.01.

48. Michigan Quilt Project 93.119, information provided by Beverly Ann White.

49. Derenda Collins, tape-recorded interview with Wythe Dornan, Flint, Mich., November 30, 1989, Michigan State University Museum 89.121.03.

50. Rosie Wilkins, tape-recorded interview with Marsha MacDowell and C. Kurt Dewhurst, Muskegon, Mich., May 12, 1986, Michigan State University Museum 87.23.18.

51. Derenda Collins, tape-recorded interview with Wythe Dornan, Flint, Mich., November 30, 1989, Michigan State University Museum 89.121.03.

52. Jeffalone Rumph, tape-recorded interview with Wythe Dornan, Flint, Mich., October 17, 1989, Michigan State University Museum 89.121.02.

53. Roberta Allen, tape-recorded interview with Denise Grucz, Holly, Mich., February 1, 1991, Michigan State University Museum 91.14.02.

54. Mary Holmes, tape-recorded interview with Marsha MacDowell, Muskegon, Mich., May 13, 1986, Michigan State University Museum 87.23.20.

55. Michigan Quilt Project 85.1335, information provided by Evelyn Cross.

56. Rosa Parks, tape-recorded interview with Deborah Smith Barney, Detroit, Mich., June 30, 1994, Michigan State University Museum 94.76.2.

57. Dolores Moore, tape-recorded interview with Wythe Dornan, Flint, Mich., October 16, 1989, Michigan State University Museum 89.121.04.

58. Derenda Collins, tape-recorded interview with Wythe Dornan, Flint, Mich., November 30, 1989, Michigan State University Museum 89.121.03.

59. Josie Bibbs, tape-recorded interview with Marsha MacDowell, Muskegon, Mich., July 24, 1986, Michigan State University Museum 87.23.14.

60. Letter from Marie Combs to MacDowell, April 21, 1991.

61. Information provided in letter from Cheryl Lyon Jenness, November 10, 1990.

62. Teressie May, tape-recorded interview with Wythe Dornan, Flint, Mich., October 16, 1989, Michigan State University Museum 89.121.01.

63. Kittie Pointer, tape-recorded interview with Deborah Smith Barney, Rodney, Mich., June 24, 1990, Michigan State University Museum 90.81.8.

64. Marguerite Berry Jackson, tape-recorded interview with Marsha MacDowell, Lansing, Mich., December 13, 1990, Michigan State University Museum 90.135.

65. Michigan Quilt Project 68.714–722, information provided by Nellie V. Brown.

66. Author's conversation with Lula Williams, Flint, Mich., November 10, 1990.

67. Author's conversation with Ernie Browne, Michigan Black History Network meeting, January 20, 1986.

68. Rosie Wilkins, tape-recorded interview with Marsha MacDowell and C. Kurt Dewhurst, Muskegon, Mich., May 12, 1986, Michigan State University Museum 87.23.18.

69. Mildred Chenault, phone interview with Catherine Johnson, April 8, 1991.

70. Irene Maddox, phone conversation with Marsha MacDowell, October 12, 1990.

71. Zelma Dorris, tape-recorded interview with Deborah Smith Barney, Detroit, Mich., July 16, 1990, Michigan State University Museum 90.81.11.

72. Roberta Allen, tape-recorded interview with Denise Grucz, Holly, Mich., February 1, 1991, Michigan State University Museum 91.14.02.

73. Blanche Cox (Gardner's daughter), interview with Lynne Swanson, Muskegon, Mich., February 13, 1986.

74. Leona Morris, tape-recorded interview with Wythe Dornan, Flint, Mich., November 24, 1989, Michigan State University Museum 89.121.

75. Martha Gilbert, interview with Lynne Swanson, 1986 and November 7, 1990.

76. "Jelly Jars, Quilts, and Flour Sacks," *Michigan Chronicle*, 29 April–5 May 1992.

77. Michigan Quilt Project 86.41, information provided by Josephine Collins.

78. Michigan Quilt Project 86.58, information provided by Naomi Wright.

79. Susie Porchia, tape-recorded interview with Denise Grucz, Detroit, Mich., January 15, 1991, Michigan State University Museum 91.14.06.

80. Nancy Taylor, in Diane Hofsess, "Historical Smells," *Lansing State Journal*, 24 February 1994.

81. Mary Holmes, tape-recorded interview with Marsha MacDowell, Muskegon, Mich., May 13, 1986, Michigan State University Museum 87.23.20.

82. Michigan Quilt Project 85.1335, information provided by Evelyn Cross.

83. Derenda Collins, tape-recorded interview with Wythe Dornan, Flint, Mich., November 30, 1989, Michigan State University Museum 89.121.03.

84. Ramona Hammonds, telephone interview with Marsha MacDowell, September 14, 1990.

85. Marguerite Berry Jackson, tape-recorded interview with Marsha MacDowell, Lansing, Mich., December 13, 1990, Michigan State University Museum 90.135 and interview with author, Lansing, Mich., January 15, 1991.

86. Dolores Moore, tape-recorded interview with Wythe Dornan, Flint, Mich., October 16, 1989, Michigan State University Museum 89.121.04 and Michigan Quilt Project 90.58, information provided by Dolores Moore.

87. LaNeysa Harris-Featherstone, interview with Marsha MacDowell, East Lansing, Mich., January 31, 1995.

88. Michigan Quilt Project 86.714–722, information provided by Nellie V. Brown.

89. Sina Phillips, interview with Lynne Swanson, Muskegon Quilt Discovery Day, Muskegon, Mich., February 16, 1986.

90. Taylorie Bailey, interview with Marsha MacDowell, Flint, Mich., November 10, 1990.

91. Irene Maddox, tape-recorded interview with Denise Grucz, Detroit, Mich., February 18, 1991, Michigan State University Museum 91.14.01.

92. Marguerite Berry Jackson, tape-recorded interview with Marsha MacDowell, Lansing, Mich., December 13, 1990, Michigan State University Museum 90.135.

93. Rosa Parks, interview with Marsha MacDowell and C. Kurt Dewhurst, June 26, 1994. For more information on this quilt and the Boise Peace Quilt Project, see Jacqueline Marx Atkins, *Shared Threads: Quilting Together—Past and Present* (Viking Studio Books in association with the Museum of American Folk Art, 1994), 84–85.

94. Rosa Parks, tape-recorded interview with Deborah Smith Barney, Detroit, Mich., June 30, 1994, Michigan State University Museum 94.76.2.

95. Alfreda Cole, phone interview with Catherine Johnson Adams, 1991.

96. Derenda Collins, tape-recorded interview with Wythe Dornan, Flint, Mich., November 30, 1989, Michigan State University Museum 89.121.03.

97. Mary Holmes, tape-recorded interview with Marsha MacDowell, Muskegon, Mich., May 13, 1986, Michigan State University Museum 87.23.20.

98. Emmanuel Bailey, telephone interview with Marsha MacDowell, October 10, 1991.

99. Ione Todd and Deonna Green, interview with Marsha MacDowell, Remus, Mich., April 12, 1989.

100. Kittie Pointer, interview with Marsha MacDowell, Mecosta, Mich., August 15, 1986. See also Kittie Pointer, tape-recorded interview with Deborah Smith Barney, Rodney, Mich., June 24, 1990, Michigan State University Museum 90.81.8.

101. Field notes, Marsha MacDowell, May 25, 1989.

102. Michigan Quilt Project 86.789, information provided by Eula Williams.

103. Michigan Quilt Project 86.41, information provided by Josephine Collins.

104. Ami Simms, *Creating Scrapbook Quilts* (Flint, Mich.: Mallery Press, 1993), and Barbara Gash, "Master Pieces: More Than Ever Before, the Quilt Can Tell the Story," *Detroit Free Press*, 12 October 1993.

105. Panel made for Joyce; for more information on the NAMES project, see Cindy Ruskin, *The Quilt: Stories from The NAMES Project* (New York: Pocket Books, 1988).

106. The Bryant Sisters (Effie Hayes, Mary Turner, and Mattie Douglas), tape-recorded interview with Deborah Smith Barney, Detroit, Mich., July 25, 1990, Michigan State University Museum 90.081.14.

107. Blanche Cox (Gardner's daughter), interview with Lynne Swanson, Muskegon, Mich., February 13, 1986.

108. The Quilting Six Plus, tape–recorded interview with Deborah Smith Barney, Detroit, Mich., April 7, 1990, Michigan State University Museum 90.81.5, 6, 7.

109. "Factory Mixing Quilting, Socializing," *Flint Journal*, 18 November 1981.

110. Ramona Hammonds, telephone interview with Marsha MacDowell, September 14, 1990.

111. Mattie Woolfolk, tape-recorded interview with Deborah Smith Barney, Detroit, Mich., August 6, 1990, Michigan State University Museum 90.081.019, 20.

112. Detroit Rainbow Stitchers (Deborah Moore, Sister Cathy DeSantis, Anita Garcia, Carol Shissler, Kathy Korff, Havannah Williamston, Vivian Padgett, and Anna Lee Barber), tape-recorded interview with Deborah Smith Barney, Detroit, Mich., July 24, 1990, Michigan State University Museum 90.81.13.

113. Josephine Collins, tape-recorded interview with Marsha MacDowell, Muskegon, Mich., August 28, 1986, Michigan State University Museum 87.23.15, 16.

114. See Eva Ungar Grudin, *Stitching Memories: African American Story Quilts*, exhibit catalogue (Williamstown, Mass.: Williams College Museum of Art, 1990).

115. See Barbara Glass, ed., *Uncommon Beauty in Common Objects: The Legacy of African American Craft Art* (Wilberforce, Ohio: National Afro-American Museum and Cultural Center, 1993).

116. Correspondence with Cynthia Patton-Long, April 17, 1995.

117. Mary Holmes, tape-recorded interview with Marsha MacDowell, Muskegon, Mich., May 13, 1986, Michigan State University Museum 87.23.20.

118. Allie Cooper, phone interview with Catherine Johnson Adams, 1991.

119. Denise Curtis Reed, tape-recorded interview with Deborah Smith Barney, Detroit, Mich., April 6, 1990, Michigan State University Museum 90.81.3, 4.

120. Lula Williams, tape-recorded interview with Deborah Smith Barney, Detroit, Mich., February 23, 1990,

Michigan State University Museum 90.81.1; see also Michigan Quilt Project 90.33, information provided by Lula Williams.

121. Elaine Hollis, tape-recorded interview with Deborah Smith Barney, Detroit, Mich., August 6, 1990, Michigan State University Museum 90.081.021.

122. Derenda Collins, tape-recorded interview with Wythe Dornan, Flint, Mich., November 30, 1989, Michigan State University Museum 89.121.03.

123. John Schneider, "Persistent Woman, 77, to Graduate with Great-Grandson", *Lansing State Journal*, June 1992.

124. Whitney Balliett, "Jazz," *New Yorker*, February 24, 1986, 82.

125. *Detroit News*, 3 March 1991.

126. *Lansing State Journal*, 29 February 1992.

127. *Flint Journal*, 14 May 1994.

128. "Memorial Tribute to Maggie Perdue Wood," privately printed, 1991, collection of Michigan Traditional Arts Research Collections, Michigan State University Museum.

129. *Detroit News*, 16 February 1992.

130. Rosie Wilkins, tape-recorded interview with Marsha MacDowell and C. Kurt Dewhurst, Muskegon, Mich., May 12, 1986, Michigan State University Museum 87.23.18.

131. Blanche Cox (Gardner's daughter), interview with Lynne Swanson, Muskegon, Mich., February 13, 1986.

132. Lillie Mae Tullis, tape-recorded interview with Denise Grucz, Detroit, Mich., October 16, 1990, Michigan State University Museum 91.14.07.

133. Rosie Wilkins, interview with Marsha MacDowell, Muskegon, Mich., February 15, 1986.

134. Derenda Collins, tape-recorded interview with Wythe Dornan, Flint, Mich., November 30, 1989, Michigan State University Museum 89.121.03.

135. Charline Beasley, tape-recorded interview with Deborah Smith Barney, Detroit, Mich., August 20, 1990, Michigan State University Museum 90.081.022.

136. Essie Lee Robinson, tape-recorded interview with Deborah Smith Barney, Detroit, Mich., July 25, 1990, Michigan State University Museum 90.081.15, 16; see also Susan Watson, "Reflections of Life Live in Her Quilts," *Detroit Free Press*, 28 February 1990.

137. Jeffalone Rumph, tape-recorded interview with Wythe Dornan, Flint, Mich., October 17, 1989, Michigan State University Museum 89.121.02.

## Bill Harris

*There are more things in heaven and earth, Horatio,*
*Than are dreamt of in your philosophy.*[1]

Carole Harris is an artist. Carole Harris is an African American artist. Carole Harris is a female African American fiber artist. Carole Harris is a female African American fiber artist who creates quilts. Carole Harris is a female African American fiber artist who creates quilts in the African American tradition.

Each of the statements, as far as it goes, is true. Each is a convenient label but is also reductive and therefore limiting and therefore less than true. These are but the first of many paradoxes to consider while discussing her work

The noun *quilt* as defined is, "a bed cover made of two layers of cloth filled with down, cotton, wool, etc. and stitched together in lines or patterns."[2]

The denotation of the verb *quilt* is "to stitch together, as two pieces of cloth, with a soft material between them . . ."[3]

Carole Harris makes quilt covers or tops constructed of strips of cloth of different sizes, shapes, colors, and patterns sewn or pieced together to form design. The end products are a fusion of ethnic, aesthetic, and emotional components. From quilt to quilt these elements vary in influence and intensity. The quality common to each is the improvisational and the intuitive blending of these components depending on the needs of the moment.

The guiding principles are her African American heritage combined with the elements informed by commercial and academic consideration of the Euro-American aesthetic. She tells us, "I don't understand it completely, but one of the things that I am learning about my work is that there is a definite cultural memory. I was trained in a very Western manner, but my work is in significant contrast, and there are a lot of non-Western things going on there."[4]

Rather than allowing this "lack of (conscious) understanding" of the fusion of these often conflicting ethnic and cultural entities to limit or inhibit her, Harris has been able to unify them into works that retain and expand on the essences of each.

The term *fusion* in an artistic context is most often associated with music. Its usual application is to a hybrid of a large percentage of rhythmically simple pop or commercial music combined with a small sampling of harmonically complex traditional (bebop) jazz. The result is pablum to the uninformed and an insult to purists.

In contrast, the fusion in Harris's work is much more aesthetically equitable and culturally pleasing. She brings her admiration for all of her influences—African, African American, and European—while retaining her sense of mystery of them individually and collectively as they embody themselves in her and her work.

In order to fully appreciate Harris's work, one must first consider the words that generally are used to label the work that she makes. The descriptive and analytical language employed must be one of discovery, clarity, and

✿

**Figure 127.** Carole Harris.

✿

**Figure 128** (opposite). Carole Harris, artist; Laura Rodin, quilter. *Appropriateness of Yellow,* made 1990, Detroit, Mich. Cotton, 63-1/2" x 71-3/4", MQP 90.47, MSUM 7423. Photograph by Mark Eifert.

joy, in keeping with the subject being considered. Redefinitions will be supplied as the need arises.

Quilting has historically been viewed, from a Western European perspective, as "craft" rather than "art." Until recently (think decades) this same perspective also automatically and officially defined all non-Western-based creative production as crafts, and therefore "primitive" in its most pejorative connotation: "characterized by or imitative of the earliest times; *crude; simple; rough . . .* " [author's emphasis], rather than its more positive interpretation, "pertaining to the beginning or the earliest times of ages; original."[5] That was what they said, how they said it, and what they meant.

In the Western lexicon, this definition was intended as a device of control of art evaluation by Europeans and continued dominance by Euro-Americans. The implication was that only their own sensibilities could produce art with a capital "A." The more impractical it was, the less utilitarian or connected with the lower classes, the more its possibilities of being "beautiful" and therefore "fine" or "refined" art and therefore valuable and worthy of being classified as "art." This attitude was equally pervasive in the American colonies. Such political incorrectness, arrogance, rationalism, and psychosis defined anything not created by a "high" or "fine" artist (read European or European-American male), as less than equal, and less than worthy of consideration according to its most elitist criterion. This Procrustean standard set by a jingoistic colonialist mindset cemented, for them, the division between crafts and "fine" arts.

The parallel aesthetics and methodologies of contemporary African American quilters and jazz musicians who still retain or are in the process of reclaiming the essentials of their cultural heritage continue to challenge the notion of what constitutes "art."

It is not out of the ordinary for Harris to wander away from what is considered to be the norm for an African American quilter. As with Africa, Africans, and African Americans, the African American quilter is not a monolithic entity—attempts by historians, anthropologists, or merchants not withstanding. As African American quilt historian Cuesta Benberry points out, "individuality, originality, creativity, varying degrees of skill and differences of approaches and ideas are typical of African-American quilters as of any other quiltmaking group."[6]

The approach Harris takes with her quilts is a result of her background. There is no direct quilting tradition in Harris's immediate family. She, however, has always worked with her hands in one creative way or another. She learned various needlework techniques as a youngster and was an art student through most of high school and all of college. She earned a degree in fine arts from Wayne State University. Her vocation for the past twenty-plus years has been that of commercial interior designer, graphic designer, and owner of a gallery specializing in Third World and Diasporic artifacts.

Her first quilt began as a personal project. She decided to use scraps left over from other sewing projects to make a quilt to commemorate her marriage, a project that was not finished by the time of her wedding. A common

question is how long it takes to complete a quilt. The first marriage quilt was not completed until years after it was begun. Another remained on the quilting frame for years.

Coincidentally, the first quilt she can remember being impressed with as an art object was a wedding quilt that a friend received from a relative living in the South. It was a scrap quilt, which had as the major design element thousands of triangular flaps adorning the quilt top. Coincidentally again, years later a housekeeper mentioned she was making a quilt. Harris asked to see a sample. The housekeeper's quilt contained the same triangular flap technique as her friend's earlier wedding gift. It was through the instruction of the housekeeper that Harris learned the technique, which began appearing in her work in 1990.

Harris's earliest quilts began with simple traditional geometric patterns such as the pin wheel. A student of a generation of art instructors influenced by the tenets of the Bauhaus (a school of design noted for synthesizing technology, craftsmanship, and technology), Harris began to favor the Log Cabin pattern. It was arguably the most "modern" of the traditional patterns she knew. The Log Cabin is at the same time geometrically simple, intricate, and adaptable to infinite variations without appearing unappealingly busy.

Despite the many color and pattern variations possible within this traditional pattern, Harris soon tired of its limiting formality. As with creative musicians who had mastered the basics of a tune, she began to stretch out and create her own variations using a basic strip-piecing theme. She soon abandoned traditional patterns altogether.

Her initial guides on her improvisational flights away from the traditional were her Euro-American-based art training. She soon found more evidence of an African aesthetic entering into the work. A number of things appeared in the quilts that were contrary to her Western-based education: things having to do with heritage, whether conscious or not; things such as selections of colors, patterns, and polypatterns (patterns on patterns) in combinations unusual from the Western perspective. It was when she began to consciously realize and acknowledge the African connection that she understood the elation Alex Haley must have felt when he made the connection, as depicted in *Roots*[7], with his ancestor Kunta Kente.

The parallels between Harris's techniques and those of jazz music are obvious. While experimental, it is never unconsciously haphazard, as, say, with unschooled artists. It is more like a thoroughly trained musician, able to draw upon a large vocabulary of chords, trills, runs, chromatics, and other colorations, inserting each as necessary for a required effect. As might be expected, Harris studied music as a child, specifically piano. Music remains an important part of her life. Like jazz musicians beginning a tune, Harris begins with a meticulously selected palette or color scheme and patterns. She has an idea of the direction in which she wants the work to go, but is confident enough as an artist to let the form and process take over. This has led to works of controlled design but with a sense of improvisationally playful spontaneity.

Harris prefers to design or compose "on the wall," or on the floor, much like a painter. What should be placed next to what is as much a decision based on tactility as on color and pattern compatibility. "I like the feel of fabric, with its various textures. . . ." Constantly sketching, making notes, and collecting fabrics Harris says,

> I usually start out with something in mind, an idea. But as I plan or work in a very intuitive, spontaneous way, other ideas and motifs want to be interpreted or want to be included. In the interplay between me and the work, I let the work take over and take me wherever it wants to go. I think that part of my being in control is being free to let the piece go where it wants to go.

Despite the seemingly chaotic possibilities of this freedom and mix in influences, Harris's work is always grounded in a solid tradition, the tradition of strip piecing. Harris says she "sees in strips": pattern in the blinds, mummy wrapping at the museum, aluminum siding, rows of pencils, stacks of CDs, ad infinitum. Strip piecing is basic to her, just as it is basic to the construction of African textiles. It can be seen in Zairian *kuba* cloth, Ghanian *kente* cloth, and Hausa strip-embroidered cloth, to name but three.

Viewers often mistakenly believe they see pieces of African materials in her work, *kente* cloth particularly. This comparison is often made more from overly quick observation than reality. *Kente* is a multicolored and multipatterned cloth made of narrow woven strips of cloth stitched together to form a larger piece of cloth. Harris's juxtaposition and use of colors, patterns, and strip piecing mimics this cloth and leads to this impression.

The trademark use of black in her designs, contrary to the prevailing presumption, is not intended as negative space. Black, which is the combination of all colors, is instead meant to be positive space. The black is a summation, a rest space, as in the music of Miles Davis or Ahmad Jamal. By her considerable use of black, Harris has extended what was often thought of as color and textural excesses by purists steeped in the Euro-American aesthetic.

That concept runs counter to that of African harmony in which all things are a part of the whole. This basic difference in the assumption of humankind's role in the universe was an essential reason for the clash of cultures between the West and Africa. It was a reason Africans were thought to be uncivilized, superstitious, and lacking a culture worth respecting. Once enslaved, Africans, and later African Americans, were encouraged and sometimes forced to abandon their cultural traditions. But the cultural retention that refused to separate the mental from the emotional only heightened the sense of awareness of cultural identity.

One only needs to remember enslaved African women's continuing desire for bright pieces of cloth to use for physical adornment, or picture

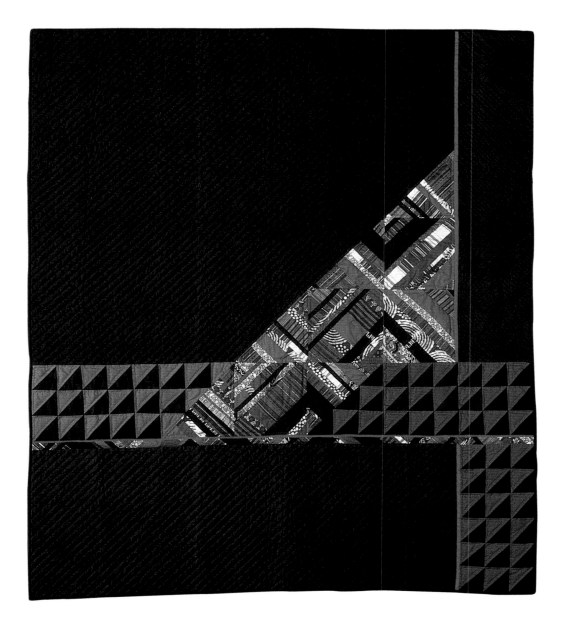

**Figure 129.** Carole Harris, artist; quilted by Laura
Rodin. *Where It's At*, made 1990, Detroit, Wayne
County, Mich. 61" x 70-7/8". MQP 90.0049. Photo
by Brad Iverson.

Baptist ladies in big hats and self-affirming primary color combinations; picture the ceremony of a rite of passage, on the hard-packed earth within the circle of the community, the dancers' outfits aswirl beneath the baking sun and boiling rhythms. Or picture a so-called scrap quilt, lovingly stitched by work-gnarled fingers, first thought by masses and academics to be purely utilitarian and simplistic.

There is a freedom of not having to color within the lines, or work by the numbers toward a preconceived end for the reproduction of a facsimile. For Harris there is the challenge and joy of continual discovery; the working without a net; where each decision is dependent on the one that immediately precedes it. But these moment-to-moment decisions are not as arbitrary as they first seem. They are grounded in Harris's background training and her blood memory connections to her aesthetic heritage.

It is these moments that form the basis of the spontaneity of her cloth manipulation and her design construction. It is the moments that register themselves visually to the viewer and at the same time translate the multiple energy sources that ignite each of these moments of creation.

Time in Harris's quilts is not static, nor can it be compartmentalized, or determined by clock or calendar. It is as ever moving as the eye of the viewer over her quilt surfaces. Each moment is one of complete communion. While there is often a horizontal line that runs through many of Harris's works, as a kind of reminder or security tether for the less adventurous, around it is the revelatory possibility, ever playful and joy-filled, of multidimensional realities: of all things, times, ideas, philosophies existing at any given moment on the linear and emotional plane.

What is being referred to is an emotional moment or, more correctly, emotional moments. Not "the" moment or "that" moment. Those are definitely constrictive rather than expansive, and therefore too specific, too limiting. Harris's work speaks of *a* moment; a collective moment containing all of the joy *and* darkness, all of the rhythmic and silent, all of the textural, *all* the possibilities within a moment. It is as with a Charles Mingus or Ornette Coleman composition, with their various elements: tempos, textures, rhythms, tones coming together, intersecting, interdependent, and yet free to change from moment to moment within a moment.

As jazz musicians "tell their story" during their solos, Harris, at any of the above-mentioned moments, in any section, strip, or design element of her work is relating her personal history as well as offering examples that contain all of her influences: the Western aesthetic; Gelede dance masks; the compositions of Duke Ellington; the orchestrations of Gil Evans; the use of space by Miles Davis and N'dbele house painting women; the color theories of Josef Albers and Piet Mondrian; the flair, daring, and attitude of the Mothers of the Holiness Church; the spirits of Robert Johnson, Big Mama Thornton, John Coltrane combined with the coolness of Nat King Cole, the fire of Etta James and James Brown backed by the power of the Brown Bomber.

In addition to being an aesthetic and an emotional moment, each is a healing moment that serves as an antidote to the bad medicine of merchants

with pigeonholer mentalities, intent on "defining" and thereby wielding control over African American quilting and quilt artists by the same restrictive standards they apply to "traditional" examples of the genre. Obviously it can be done. To their satisfaction, it has been done. But it cannot be done well or honestly or to the benefit of the art form or the art formers, because the basic premise is flawed, a Procrustean standard.

Harris's work, for the artist and the viewer, is a continuing journey into the heart of craft, art, and creative process. Her work, as contemporary as it is in design and quality of craftsmanship, as aware as it is of the rules of art according to the West, is also thoroughly and undeniably steeped in African and African American traditions.

When viewing any composition pieced by Carole Harris, the beholder is immediately in harmony with the evident joy that went into its conception and creation. The work is a narrative rather than a hypothesis, theorem, or categorization; telling a tale as universal as the universe; a moment that contains all possibilities and therefore, rather than constricting inward, refuses all enclosures and intensifies and expands, ever outward, as with the universe itself. Wherever you live, it will take you home and comfort you when you arrive.

## Notes

1.  William Shakespeare, *Hamlet*, act 1, scene 5.

2.  *Webster's Dictionary of the English Language Unabridged Encyclopedia Edition* (New York: Publishers International Press, 1977), 1480.

3.  Ibid.

4.  Nkiru Nzegwu, in *Uncommon Beauty in Common Objects: The Legacy of African American Craft Art*, ed. Barbara Glass (Wilberforce, Ohio: National Afro-American Museum and Cultural Center, 1993), 56.

5.  *Webster's*, 1430.

6.  Cuesta Benberry, "Carole Harris: Played with Ideas on How to Use Her Art before Deciding on Quilting," *American Quilter* 4, no. 1 (spring 1988): 24.

7.  Alex Haley, *Roots* (Garden City, N.Y.: Doubleday, 1976).

# TODD FAMILY

"It Is Said That"

Stephen Todd was married three times. First to a black lady. To this union, two children were born. She was beaten to death by the slave master. Second to another black lady. To this union, seven children were born. They separated or parted in some way. Third to a german lady, Caroline Kahler. To this union, ten children were born.

This according to William and Emma Todd.

**Charles Todd**
Born: 1875
Married:
Died: Jan. 11, 1899

**Louis Todd**
Born: Aug. 21, 1876
Married: Lena Allen
Died: Feb. 22, 1966

**Mary Todd**
Born: 1880
Married: Clarence Richarson
Died: Nov. 4, 1946

Section 10 of Wheatland Township
Section 34 of Sheridan Township
Section 34 of Sheridan Township
Section 29 of Sheridan Township

Memers In Good Standing At The Wheatland Church of Christ January 6, 1884

**Irene Todd**
Born: July 22, 1897
Married: George L. Norman
Died: June 11, 1983

Stephen Todd & Caroline Kaeler
Married
August 24, 1874
Windsor, Essex County, Ontario, Canada

Issac Berry Witness — William Berry Witness

**William Todd**
Born: Aug. 21, 1882
Married: Emma Norman
Died: Jan. 12, 1962

Variations Of Spelling
Kaeler
Kahler
Köhler

**Victoria Todd**
Born: Dec. 15, 1893
Married: Louis Henderson
Died: April 1, 1963

**Sophie Todd**
Born: Jan. 1, 1885
Married: Raymond Burns
Died: Feb. 8, 1981

**Fred Todd**
Born: April 10, 1891
Married: Verda Harris
Died: Dec. 30, 1975

**Florence Todd**
Born: Oct. 16, 1888
Married: Jack Green
Died: May 7, 1971

**John Todd**
Born: March 7, 1887
Married: Lucinda Norman
Died: Oct. 31, 1969

"Harold"

Names and Birth dates according to mother and attending mid-wife, Ester Cummings.
Sophia — Dec. 31, 1884
John — Dec. 20, 1896
Florence — Oct. 16, 1888
Fredrick — Sep. 12, 1840
Victoria — Dec. 15, 1893
Irene — June 15, 1896

STATE OF MICHIGAN

Pittsfield Cummins Todd

Oye Cemetery

Wheatland Township 1880 Census

January 1990

# ❦A CONVERSATION WITH QUILTERS DEONNA GREEN AND IONE TODD

The following is an excerpt from an interview conducted in 1991 by Marsha MacDowell with Deonna Green and her mother Ione Todd in which they describe the *Todd Family Quilt* and their experience of making it. Green and Todd provide information on the length of time it takes to research and execute their type of family story quilt as well as convey insightful commentary on the importance of this activity within their immediate family and the community at large.

In embroidered and painted pictures and text, the *Todd Family Quilt* chronicles the experiences of Todd family members in their journey to and settlement in a mid-Michigan farming community. Each block portrays carefully researched information about the Todd family, including lists of individuals within each generation, a pictorial depiction of a family story, an embroidered copy of a family document or historical photograph, painted coat-of-arms, and plat maps of family farmsteads. As Deonna and Ione so clearly reveal in the interview, the quilt is the result of painstaking research into their family history.

In addition to Deonna and Ione, the quilt was made by Dolores Todd, Marion Todd, Carol Norman, and Diana Green. Deonna and Ione made a second and third version of the *Todd Family Quilt* as well as *The Old Settlers' Quilt* which chronicles the history of the community. Deonna has also completed several other family history quilts for various branches of the family tree.

One can learn much about this remarkable family and the community by just viewing the narrative quilt. Todd and Deonna's oral narratives of making the quilt illustrate that the textile also serves as an important aid for sharing and interpreting history. Without their oral narratives, the pictorial stories are but partially understood, and even then they sometimes depict only one part or one version of a story.

When Green and Todd tell of how different versions of family stories are considered for inclusion in the quilt, one begins to understand how knowledge in the oral tradition is passed on. Each teller recalls and translates her stories in slightly varying forms. Sometimes the story is checked against another's memory, sometimes not. When the story is committed to print or, in this case, a quilt, only one version of the story is recorded. Only by knowing the variations of the stories, in both printed and oral forms, can one begin to reconstruct a sense of the history that is being shared.

**MM:** *Just introduce yourselves and then tell us how you got started on the first family history quilt.*

*DG:* OK. I'm Deonna Green.

*IT:* I'm Ione Todd.

*DG:* I had made my grandmother a family tree quilt, and Ken [Todd] saw that and decided that we needed a family quilt. And he asked if we

**Figure 130.** Deonna Green and Ione Todd.

**Figure 131** (opposite). Deonna Todd Green and Ione Todd. *Todd Family Quilt*, made 1989, Remus, Mecosta County, Mich. Collection of Michigan State University Museum. Painted and embroidered cotton/polyester, 82" x 79", MQP 90.001, MSUM 7005.

wanted to do one. And I said, "sure." And he said, "Well, will you design it? And will you do this, and will you do that?" And I guess he was delegating duties wasn't he? He told me what we wanted on it. We fought, too. I mean, we fought. I cussed this man out. I hung up on him. He's a cousin.

IT:     Fred Todd's.

DG:    Fred Todd's son, one of his. But we just fought about, just different things. I was wanting to do it like I wanted to do it, and he wanted to do it like he wanted to do it. I told him, "I'm doing it. I'm going to do it my way." So we did it my way. And we fought about that all the time. But it was fun.

IT:     It was made for the Todd Family reunion. They only have a reunion every . . .

DG:    Five or six years.

IT:     But, they haven't had one in years.

DG:    He thought it would get people out, you know. They knew there was going to be a Todd family quilt there, and they could raffle it off to the Todd family members. And that was back in 1986? I don't remember. When it was raffled off, my cousin got it.

IT:     Zane's daughter.

DG:    Yes. You know, we thought that the person that would get it would pass it around to family members, or keep it going. She kind of locked it up in the closet, or they did. Anyways, so it was unavailable. So I asked my Uncle if we could get it back so I could copy the names off from it, because I did not keep my patterns. I didn't keep anything. I do now. So I got it back and took all the information from that quilt. Then we decided to do another one. Mom and I. But the original one, the first one, six different women worked on it. Dolores Todd, Marion Todd, Carol Norman, Mom, myself and my sister Diana. And, it didn't look as good because there was too many different people, with too many different embroidery techniques. . . .Too different, I mean, it was a mess. But we decided to make another one to keep, so that we could pass it around. The second one, I think we finished in six or eight months, wasn't it? And it was a little bit better than the first one. That's the one that is on the traveling exhibition [*Stitching Memories*]. And then, of course, the [Michigan State University] Museum had to have one, so we made this one. And it's better yet, isn't it? It keeps getting better!

MM: *Now, could you describe, square by square, what you have put into this quilt?*

DG: In the four corners is the family coat of arms. My cousin sent for a book on the Todd family history book and the coat of arms came with it. And my sister thought it would be a good idea if we put them in the corners of the quilts. So I traced it, and I painted it, and then, ah, quilted over it. We needed something to fill up the empty spaces anyways! [Laughter.] The word "Todd" is across the top.

OK, each generation is coded by a different color thread. The first generation is in the center. That's ah, purple. The second's in red. The third is in blue. The fourth is in yellow. The fifth is in green, and the sixth is in brown. An asterisk indicates [someone is] deceased. Braces, or parentheses indicates twins.

Yes, every time you see the asterisks that means they're deceased. And the first, ah, let's see, the first, second [pause] all the first, second, I believe and third generations are deceased, aren't they? No. The first and second. OK, Mom, you can read the . . .

IT: [Reading the text on the quilt.] It is said that Steven Todd was married three times. First to a black lady. To this union two children were born. She was beaten to death by the slave master. Second, to another black lady. To this union seven children were born. They separated or parted in some way. Third, to a German lady—Caroline Kaeler. To this union ten children were born. This according to William and Emma Todd. OK.

DG: And, Mom, do you want to read from the paper wrote on the family history?

IT: OK, this is the family history of Steven Todd. [Reading from paper.] Steven Todd was born a slave in Gerrard County, Kentucky, in the early 1800s. Nothing is known about Steven's parents. They were believed to be a slave woman and a plantation owner. Steven escaped slavery and went from Kentucky to Indiana where he enlisted in the service. Steven met Caroline Kaeler, a German lady, from Pepper County, Indiana, and ran away with her to Canada, where they were married. Steven and Caroline Todd's first child, Charles, was born in Canada. And the other nine children were born in Michigan. Steven and Caroline were very poor. They possessed two cows, and twenty-four chickens, yielding about thirty dollars a year income. The children had to fend for themselves, with no relatives to help, as Caroline's parents disowned her. The children did remarkably well with no help available. It made them tough, stern, and hard workers to survive. Their children were Charles, Lewis, Mary, William, Sophia, John, Florence, Frederick, Victoria, and Irene. Charles, Lewis,

and Mary worked out as soon as they were able. William later worked at lumber camps, and was the head of the family until Sophia was able to manage. Sophia remained the head of the family until the last five were on their own. The boys, the youngest ones, John and Fred, could not attend school because they were needed on the farm to ensure food for the summer and winter. The family had to live from hand to mouth. God indeed did bring them through. Emma Todd, William's wife, taught him to read and write, as he only went through the second grade. The other boys could only write their names, and very, very little reading. For they were needed to work on the farm, and could only attend school for one year. The children of Steven and Caroline Todd became prosperous, many descendants lived in the communities that they helped establish. [Finished reading paper.]

DG:  We'll go to the map of Kentucky, Indiana, Michigan, and Canada. The map traces the steps of Steven Todd. He was born a slave in Gerrard County, Kentucky, and as the story goes, he tried to escape three times. I don't really know how he escaped. My aunt told the story that he saw a woman, a medicine woman or something, who gave him something to rub on his feet so the dogs couldn't track him . . . . He made it across the [unclear] river; went into Indiana, where he mustered in and out of the service in Indianapolis. He went to Peppertown, Indiana, where he met Caroline Kaeler. As the story goes, he was working on her father's farm and they ran away to Canada where they were married, and then back to Remus, Michigan. She was sixteen, I believe, and he was in his sixties.

IT:  [Whispers.] Thirties.

DG:  Thirties. Oh, Mom, he was not! [Laughter.] OK. So they ran away together to Port Huron, Michigan and went across into Canada. And then they were married, and then later moved back to Remus Michigan, where they died.

MM:  *How long did it take them to get to Canada from Indiana?*

DG:  Two or three days. That goes with the story on the other one, so I'll tell it then.

OK. The next one is Steven Todd's "Muster In and Out of the Service" records. I took his actual service records. I traced them and then I embroidered them. It took me about a hundred hours to do that particular piece because the writing is so small. But, it is readable. [Laughs.] And it looks, you know, I want it to be authentic. The next is a covered wagon. It just means transportation or travel, how they traveled, because they did come with other families to Michigan from Canada.

**Figure 132.** Detail, Todd Family Quilt.

MM: *Did you ever hear of any family stories about the travel from Canada to Michigan?*

DG: About that travel. You know, when the government took all, I hate to say this, the land away from the Indians, they started giving land grants. Isaac Berry came over, found the land, and then went back and got other black families and brought them here. He did keep going and getting people and bringing them back and that's how such a big area of black population is over there.

OK, the next four blocks are plats of land where Steven and Caroline Todd and their families lived. I can't remember years, but this was the first place they lived, the second place they lived, the third place they lived, and the last place they lived. It's just up the road from where we live. And his grandchildren still live there today.

MM: *Describe what kinds of crops were grown there.*

DG: Most of that land was kind of rocky. I think probably beans, corns, about the only crops that they raised there. Because part of it's blow sand. [Laughs.] It's not very good land at all. But they did have a garden and things like that.

The next square is a picture of the house that they lived in. This is on section 29 of Sheridon Township, that would be on the last plat there, that little piece of land. My cousin drew a picture of the house. And I just took that and traced it, embroidered it. It took me about a hundred hours to do that, too.

MM: *And how many families were there? One family?*

DG: Just one family. Well, then their ten children. I don't know if Grandpa still lived there when the younger kids got older, because as soon as they were able, they would get out on their own. I think Grandpa was fourteen when he bought his first farm. And that was up where we live now. Wasn't it? No, that was the back forty, wasn't it? That was the original. OK. Just behind our place, he bought his first farm when he was fourteen. So that goes to show you the kids had to grow up fast. Get out of the house, because there was always somebody behind them.

But ah, do you want me to go, the children's blocks? Like Charles was born in Canada in 1878. We found out that he had been married because on his death records they keep listing him as a divorced man, but we haven't went any farther on that. He died January 11, 1899. So he was only twenty-five years old, I think, when he died, or twenty-four. We did find that he worked as the local watchman in the lumber mills, maybe at Lake Charlevoix. That's where I found his death records at.

*Deonna Green and Ione Todd*

MM:    *Where are you finding that?*

DG:    OK. I found his death records in, as the story, [unclear] always told the story that he worked up north in a lumber camp up by Boyne Falls. And nobody had ever tried to find out anything about this man. I guess he was a lot lighter than the other kids. And I don't think he wanted to be associated as being black. He looked like he was white, so he ran away, more or less, and married, and possibly had a family, I don't know. But I just decided one day that I was going to track this man down when I was working on this quilt. So I got to making phone calls and I got a lady at the Boyne Falls courthouse up there. She sent a girl out to look at the library, because they didn't have it right there at the courthouse. And she called me back in about a half an hour with the information.

MM:    *So you don't know anything about his descendants.*

DG:    No, we don't. I didn't even know he was married until on his death records it said he was a divorced man.

IT:    But here's another interesting story about Steven Todd having a family before the last family that Marshall's father comes from. A few years ago, quite a few years ago, Mr. Todd, Marshall's father, my father-in-law, got a postcard from someone named Todd from Kentucky.

We had been trying to get a family connection there. He said that he claimed that he was Grandpa's half brother. But, he wouldn't pursue it any further. He said, "No, I don't want to know anything about it. Just leave them alone." And Marshall's brother Zane still has that postcard.

DG:    OK. Lewis Todd was born August 21, 1876. He married Lena Allen, and he died February 12, 1966, and it lists his children beside it. And they were her children, weren't they?

IT:    Yes, they were her children, he didn't have any children. And he had a beautiful farm in Rockford and he was a farmer most of his life.

Figure 133.  Detail, Todd Family Quilt.

DG:    And on the block next to his is the river raft. Now can I tell the story? [Laughs.] OK, as the story goes, when Steven and Caroline ran away together, Mr. Fred Kaeler was right behind them, I guess chased them down. He had two horses. He ran one horse to death, they said. When he got to the water [at Port Huron] the horse collapsed and died. Isn't that the story Daddy told? Um, he had chased them from Indiana all the way to Port Huron. And he, when he got there, they were already on the river raft. And he was hollering at the raft driver, "If you bring the black man back so I can shoot him, I'll give you a hundred

104

dollars." But I guess they were so close to the Sarnia, that he wouldn't come back. And the man must have been desperate. [Laughs.] Grandpa always told the story that as Mr. Kaeler got to the water, his horse collapsed and died. I don't know how the man got back. Ah, [laughs] probably walked! [Laughs.] But he started out with two fresh horses, they say. So that was our little folklore, I had to tell it.

MM:   *And was that story passed down?*

DG:   Steven Todd told his son, William, my grandfather. And Daddy told that story. I guess when we were making the quilts, and I'd tell Daddy, "tell me a story or something." And, so this is what he told. Mom had heard the story, but I hadn't.

OK, we'll go with Aunt Mary. Mary Todd, born 1880. She married Clarence Richardson, one of her three husbands. I don't think she was married to half the men. She died November 4 of 1946. I knew all of these children, except for Uncle Charlie and Aunt Mary here. But I remember all of them.

IT:   Well I, I remember Aunt Mary. She died the year that . . .

DG:   Marsha was born.

IT:   Marsha was born, our oldest daughter. That's how I remember her.

DG:   And she wanted to be buried back in Dye Cemetery with the rest of them, and it was so snow covered, in November, I guess we had had a big snowstorm or something,

IT:   It was.

DG:   . . . and they couldn't get back to Dye Cemetery, so my grandpa took her over and buried her at West Wheatland, and the lady's probably still spinning. [Laughs.] I shouldn't have said that, but that was a good story about . . .

MM:   *What was her occupation?*

DG:   I have found census records where she was a maid, usually a domestic servant, I believe that's what it [the records] listed them. Because I found her in Ionia . . . working for that rich black family that once lived down there. [Overtalk.] Some rich people.

MM:   *And they also farmed?*

DG:   And they also farmed. But see, the older girls, she was the oldest girl, uh, probably was out when she was sixteen, I believe her age was sixteen when I found her down there, working. See, and like I said,

Grandpa was fourteen and working in the lumber camps. So the older kids had to get out to, you know, help support the younger children. Because as is evident in the death records and stuff, this man was sick, and he was old. And, evidently, she was too. [Laughs.] Um, you know, because they died within a couple years of each other. But, ah, they probably needed a lot of help. Because I think I found on some of the records that I had for his pension, [which listed] all that was wrong with him. And . . . no wonder he died. He was sick! He had, you know, just this and that. And, what, he had piles on diarrhea and [laughs] infection of the male organs. That, that's the way it said, you know. [Laughs.] [Background talking, laughing.] Ah, we found church records that um, said that they, that Steven and Caroline were members in good standing at the Wheatland Church of Christ January 16, 1884. This is the church that's still there. You know where the church is now. OK. And we also found collection records, where they had put money in the collection. Everybody else was putting in a dollar at the time. Steven and Caroline was putting a quarter in. Because they were so poor. You know. So . . . .

MM: *Do you know if that congregation was of mixed descent, or was it all black families?*

DG: Ah, no. It was integrated at one time, because my husband's people went to it. And at one time, he said it was integrated, but it was primarily built by the blacks and for the blacks of the community, wasn't it?

IT: [Nods.]

DG: When Mr. Cross came from Ohio [IT: yea] ah, he immediately gathered up ah, whatever to build. This is not the original building, there was another building. And when they got enough money, and a larger congregation, then they built the frame building. Uh, but yes, it was built for, primarily blacks.

MM: *And what kind of social events went on there in addition to the religious services?*

DG: Ah, the first, I believe at first, it was the school, wasn't it? School was held there. Oh, the old church.

IT: Housed the school.

DG: Oh, yea. Housed the school. So it was the Cross School, I believe, and then later the Gingridge? Or did they?

IT: I think the Gingridge was a different school I believe. [Overtalk.]

DG: [Overtalk.] Oh, it was just right up the road.

IT:     . . . But anyway, as far as social events, I really don't know what they did.

MM:     *What denomination was it?*

IT:     It's Church of Christ.

MM:     *You didn't have a full-time pastor?*

IT:     When Mr. Cross was there, it was full time. But from then, they had a circuit riding preacher for years and years. I do know, I've heard my mother-in-law speak of this. And sometimes he would only come once a month. But they did hold Sunday school when they didn't have church. They would gather and have communion and have Sunday school.

DG:     Grandpa at one time administered it for a little bit.

IT:     Well, he and some of the elders take turns preaching. For a while it was run directly by the elders because it was hard times, and we were not able to get a minister, [laughs] couldn't afford one. So, that's the way the church existed.

MM:     *Did that church have a choir?*

IT:     Uh-huh. It does now. At one time, when I was in high school, I did sing with a group, and we were called the Union Gospel Singers. And we traveled around the state of Michigan. And then for a while, ah, there was no choir. They do have a choir now. They do go out and sing, and they are called The Testifiers.

MM:     *How far did they travel?*

IT:     Not too far, close. They don't travel as far as the Union Gospel Singers used to travel.

MM:     *And how far did they travel?*

IT:     Oh, we went to Grand Rapids and to Cassopolis. I can't even remember the name of all the towns.

        The settlers in Isabella County went to white churches, because my folks lived in Isabella County. They weren't as, what shall I say?

DG:     Prejudiced. [Laughs.]

IT:     Ah, in Isabella County, at least in that corner where my parents lived. Because there was nothing ever said, or they never felt that they weren't wanted in the churches. So they always just went to the white churches.

*DG:* The same probably goes for Montcalm County, because Montcalm County's a lot farther away than Isabella County is.

*MM:* **Let me just ask you two about Native Americans in your area.**

*DG:* Most of the blacks settled with the Indians there and intermarried with them. Matter of fact, my Grandma Todd's mother Mary Harding had her daughter born on the Indian Reservation in Mt. Pleasant. But this woman was a black woman, I [laughs]can't figure how, you know, unless she'd, well George Thompson must have been an Indian. That's all I can think of. Like when they lived on the Indian Reservation over there. So that, but they did ah, settle with the Indians. A lot of ah, was it the Berry's that intermarried with them?

And a lot of our family up there kind of jump the color line, or they jumped across. You know, instead of saying, well, . . . [if we aren't] black, we'll just be Indian. Now what difference does it make, you know? [Laughs.] So they just kind of jumped across [laughs] the line. So you see lots of Mamma's nieces and nephews walking around there being Indian. And that's the way, that's the way I think a lot of the black people did.

*MM:* **Was there a mission established for the Indians near you?**

*IT:* I don't know. I've, I never heard about anything except the reservation in Mt. Pleasant.

*DG:* Uh-huh. I think when they moved them out, that a lot of them went with the Ojibwas up to Sault Ste. Marie. Or North. They went North. And the ones that didn't go to the Indian reservation just ah, I did, I believe they did go North, but because that's where Connie and Grandma [unclear word] went.

*IT:* Well when I was a kid we had neighbors that were Indians. The parents had lived on the reservations, but they had moved. I don't know what kind of work they did, but I can remember the kids being small like we were, and we used to play with them. And that's about the only contact I ever had with Indians.

*DG:* OK. These are Irene's children, Paula, Caroline, Alvin, and their children, grandchildren, and great-grandchildren. And this is also a block for Aunt Irene. Maxine was her child. And this is all Maxine's generation here it looks like, isn't it?

*MM:* **Do you have any anecdotes about how you got this information?**

*DG:* A lot of telephone calls. Ken Todd was the one that came up with a lot of the information. But we have to keep updating and stuff. We know most of the people, anyways. I can usually sit down and write

down the generation without thinking too hard because I've worked on it so much.

MM:   *If you could comment on where those people are living now.*

DG:   Paula lives in Remus. Caroline lives in Mt. Pleasant, and Alvin lives in Remus. So there's still a lot of them around. Their grandchildren would probably be in the cities or in college or something.

MM:   *Who still farms in that area?*

DG:   I don't think anybody does. My uncle does a little bit of hobby farming, Daddy hobby farmed.

You can't make any money off from it, you know.

IT:   At one time, there were sections of land owned by black people, but no more. They've sold it, and, or, lost it on back taxes. Or whatever. So that's the way it is.

DG:   You know we live on a piece of the big farm. But nobody does anything with it, it's just kind of blow sand. Daddy will put corn here and corn up on the other farm, more-less for the deer. Or they'll do a bunch of beans. When they harvest them, then the kids usually get something out of it. What did they get? A new bike or something last time? So it's more or less either for the kids, or, Daddy just takes care of it. I guess, it gets in his blood once in a while, you know.

MM:   *That reminds me, were any of you in Future Farmers, 4-H, or participated in county fairs?*

IT:   I was when I was a kid. I was in 4-H. They had the county fair in Mt. Pleasant. We took our sewing and our canned goods and our crafts, whatever we worked on, and [laughs] entered them. I don't remember ever winning anything great, you know, ribbons or so forth.

DG:   We were in 4-H for a little bit. Mrs. Hatfield had it up there. We stayed in it for two weeks, I think two weeks tops. [Laughs.] OK. The next is Irene Todd. She was born July 22, 1897. She married George Lindley [unclear name] Norman. She died June 11, 1983. That was the baby. She was the last one to die, wasn't she?

The heart in the center is about Stephen and Caroline, where they were married. [Reading.] Stephen Todd and Caroline Kaeler married August 24, 1874, Windsor, Essex County, Ontario, Canada. [End reading.] And there's a picture of them here. And, in the corners by the hearts, are the witnesses, Isaac Berry and William Berry. Now we found these on an affidavit. Evidently she had sent for her marriage records so she could get a pension, or something.

*IT:*   [Reading.] William Todd, born August 21, 1882, married Emma Norman. He died January 12, 1962. [End reading.] And his children are Dward, and Dward was never married, he's deceased; Virgil; Norma; Marshall, my husband; Zane; and one child, baby boy, deceased. And the variations of the spelling; gives three different variations. I don't think we're sure how the name Kaeler was spelled, K-a-e-l-e-r, K-a-h-l-e-r, K-o-h-l-e-r, with two little dots above it.

*DG:*   I think I found one on her death record with her dad's spelled Keller, [laughs] or something like that.

*MM:*   *Back to the middle. Where did you find that photograph of Caroline Kaeler?*

*DG:*   Fern Cross, the minister's wife, had a bunch of her father-in-law's old pictures. And they pulled that out. We don't know if that's them, we're just going to say it's them. [Laughs.] Evidently there was only one picture that was ever taken that Daddy had seen when he was a little boy, and this man had this picture, and so, Ken went over there to see if he could find this picture of Grandpa and Grandma. They must have been camera shy.

We're going to go to this letter that Grandpa had somebody write; he couldn't read or write; so he had somebody write this letter to the senator. If you notice the spelling was wrong on here, [laughs] but I wanted to trace that and do it just like it said. He's writing this to Honorable J.C. Boroughs, U.S. Senator, Washington D.C. "Dear Sir: By request of my attorney, I write you to have you call up my claim for pension number 757694 and see what reason, if any, it should not be allowed on the evidence already furnished and on file with the pension office. And now, if you do not have anything to do with pension matters, will you kindly hand this letter to Congressman Avery of Michigan and request him to look the matter up. I am now 69 years and very feeble, and am very much in nead [spells n-e-a-d, laughs] of the pension. I have a wife and six small children to support, and I am very poor and out of health. Please look this matter up at once, and much obliged, a feeble old soldier. Respectfully yours, Steven Todd."

*IT:*   This was written on the stationery of the Heavy Shelf Hardware store.

*DG:*   It says, "Sash, doors, agriculture, [laughs] [unclear word] paints, oils, . . . Remus Mich. December 5, 19, 1895." So, you know, it's just off their stationery. Evidently, somebody wrote it for him. I thought that was interesting and it would be nice to put that on the quilt because it is . . .

*IT:*   Original.

*DG:* Yeah, original.

*MM:* *How long did it take to do that?*

*DG:* Probably about fifty or sixty hours. It wasn't as complicated as the pension record, or the "muster in and out of the service" records, or the house, it was not really complicated, just took a lot of patience.

OK, we'll move to the next one. That's one of Aunt Victoria's blocks with her children Hermida, and I don't know these people. These are the ones that were away from us. She was a old married woman when I remembered her. I put in the lumbering because all the boys worked in the lumber camps in the area. And I think this is on the other quilt in that tree too. But once I get a good picture, I keep doing it.

*IT:* That was a large lumbering area.

*DG:* There were a lot of lumber camps right in the areas. Ah, Hughs was setting right up on the corner from our place.

*IT:* And they had a shingle factory.

*MM:* *And what were the names of some of the companies?*

*DG:* Commer Diggings. Was it Cowens, what was the one over at Horsehead Lake? And the funny thing about it Grandpa tells that when they brought the logs from where they cut them down, they would take them to the Shinglevilles and the lumber camps, you know, to be processed, and they would have to come across Dye Lake. Now that's right down from our place near the cemetery. And in the spring. Was it Uncle John driving the horses? They had a horse with a sleigh and it was so thawed by the spring, they said every time the horses would jump, their front feet would go in the water. You know, they were doing that. Uncle John used to do that. Grandpa did it also, but I don't think he took one across when it was spring.

A cyclone hit Hughes Camp, and I think took it all apart. There's a old house there, or a old basement, or something. See, a lot of people get lost up in Hughes's swamp, and, so nobody ever goes in it, or stays around it or anything because they always have to send people out to get them.

It was just a big lumbering community. Even the women worked. Aunt Bessie worked as a cook in the lumber camps. Remember seeing those pictures in the Centennial Book of Aunt Bessie? She even drove the team, she even drove the horses too.

*IT:* Aunt Bessie!

*DG:*   That's before they'd let women do that stuff, and she was like seventeen or eighteen, and she was driving the horses in the lumber camps.

OK. We'll go on to the next one. [Reading.] Victoria Todd, born December 15, 1893, married Lewis Henderson. Died April 1, 1963. [End reading.]

*IT:*   [Reading.] Sophia Todd, born January 1, 1885. Married Raymond Burnes. Died February 8, 1981. [End reading.] Her children were Odine: her child.

*DG:*   Yes. That was an adopted child, wasn't it? And that was, that's just one of Aunt Soph's blocks. I put the kids working in the fields because they did. You know, they had to work in the field.

*IT:*   It's just a story of them.

*DG:*   What is that, corn or wheat? What am I trying to make there? [Laughs.] I put them up in bundles! You know, up into old shocks, like they used to bundle them.

*IT:*   I think that's what it represents.

*DG:*   And the family tree down here. It's got a picture of the kids in it. Charles, Lewis, Mary, William, Sophia, John, Florence, Fred, Victoria, and Irene. Some of the pictures didn't come out too good. Not as well as I would have liked them to. I took their photographs to Graphic Specialties. First I had my husband get them the size I wanted. He kept reducing and blowing them up. And then I took them to Graphic Specialties. They put them on this piece of material for me. Then I drew a tree around it, embroidered it, to make it look like they were sitting in the tree, so. That's how I did that. And I think that probably took me about a hundred hours to do that. Because I put tree bark on the tree, you know. . .

*IT:*   [Reading.] Fred Todd. Children: Dorothy, Lucille, Bernice, Fred Jr., Jack, and a baby boy deceased. Fred Todd. Born April 10th, 19, 1891. Married Verna Harris. Died December 30, 1975. Florence Todd, born October 16, 1888. Married Jack Green. Died May 7, 1971. John Todd. Born March 7, 1887. Married Lucinda Norman, died October 31, 1964. [End reading.]

*DG:*   And Herald, John's Herald.

*IT:*   John Todd's son, Herald.

*DG:*   And I just put the man working in the fields to burn up the [unclear].

*IT:*   [Reading.] Names and birth dates according to mother and attending midwife, Esther Cummings. Sophia, December 31, 1884; John,

December 20, 1886; Florence, October 16, 1888; Frederick, September 12, 1890; Victoria, December 15, 1893; Irene, June 15, 1896. . . .[End reading.]

*DG:*  And we got that affidavit in the package that we got. The funny thing about it is that Aunt Irene's got her birthday as June 15, and I believe she was born in July. And Fred's says he was born September 12, 1890, and he was actually born April 10, 1891. I haven't looked at the other children, they might be wrong too. But they had to have, I guess, a sworn statement of how many children there was when she was trying to file for this pension. And, you know, she probably didn't remember. If you deliver a hundred babies in the community, you know, you probably can't. . . .

OK. Next my chickens. The story goes that, Steve and Caroline were very poor. And their personal property consisted of twenty-four chickens and two cows, yielding about thirty dollars a year income. So I had to put my twenty-four chickens on there, and my two cows are over there. [Laughs.] I thought it was very, very nice, because my other chickens on my old quilt looked terrible, and I think these are really nice chickens [laughs].

**Figure 134.** Detail, Todd Family Quilt.

*MM:*  *Where did you get your information about the twenty-four chickens?*

*DG:*  It was in an affidavit in this package that we got from this packet from Washington D.C., from the archives. When my sister sent for it, we were only looking for service records, I believe. And when they got it back, I was just so thrilled. Like the thing with his mark on it, you know, with X, you know, it was just thrilling. Because that's more than we ever knew anything about the man or his wife. Only the stories that Daddy would tell. You know, that his father would tell him.

*IT:*  [Reading.] Fred Todd's children: Robert, Connie, James, Gerald, Walter, Frances, Kenneth, Lawrence, and Gary . . . . [End reading.] Only eleven of the fifteen.

*DG:*  Most all their children live there. The only ones that don't is Bob and Dorine. They live in Grand Rapids.

*IT and DG:*  Connie lives in Detroit.

*DG:*  And Lucille and Ron live in Grand Rapids. And Dort, Dort lives in Allendale. So, all of the rest of the kids are here. So that's OK.

The next one is Grandpa's death records. I went to the courthouse in Big Rapids and got a copy of his death records. I traced them and embroidered them. That took probably a hundred hours to do that, because the writing's so small. But I did fake the top of it, because the whole thing had about that much writing on it. I kind of cut the top

off, brought it down to here, so it'd fit on my piece of material here. But these are the actual death records, and I think those are nice.

**MM:** *Can you read the information that's on there?*

**DG:** OK. It just says that Grandpa died July 9, 1898. His full name is Steven Todd. Ah, male. Black. Is married. He was 86, it says he was 86 years old, but I gotta tell you something about this. This is a funny story. He died in Sherman Township. Cause of diseases, it says Titis. I believe that was spelled wrong on something. Birthplace: Kentucky. Occupation: Farmer. Parent's names: unknown and unknown. Date of record: August 1, 1898. As the story goes, the man was really 102 or 3 years old. [IT: laughs.] Is that what Daddy told?

**IT:** Yes.

**DG:** So that's why I was laughing about this death record, it says eighty-six, and then one census records we found that she [Caroline] was really young, like twenty-six, and he was, sixty-nine or seventy or something at that time. And then we found other records where, he was eighty some years old, and she was a young woman, you know, and I'm thinking, this man didn't know how old he was! Really, he didn't. [Laughs.]

**IT:** Ah, if he was 102 when he died, then his youngest child would have been born when he was pretty close to a hundred years old. So that's why I say. . . .

**DG:** But still, Momma! This man is still eighty-six, and still have a three-year-old child! Maybe he had help! [Laughter.]

**MM:** *Tell me something about Steven Todd's name. Where did Steven Todd come from?*

**DG:** Probably from the people that owned him, he probably worked on, was owned by, a farmer on Todd plantation. Because you know, if you go down South, you open the phone book: Todd, Todd, Todd: all these Todds. [IT: well, yes.] And I have found some Todd plantations that used to be Todd plantations. I haven't had a chance to go back and do any research. One of these days, I'm going. Years ago when we used to go to Kentucky, oh, once a month because my brother-in-law was stationed over there. And why didn't I think about that then? You know, because we were right there. And now I can't get a trip back there. So I wish I would have, you know, started looking. But I'm going to try to find it. They say that Steven's mother is listed and the children are listed like cattle. I believe they said her name was Sara, is that what Marguerite [Berry Jackson, another descendant of a pioneer family] said? See Marguerite's father, uh, grandfather also was

born and raised right in that area. And so when she started research-
ing records. But Daddy tells the story that Steven's mother was cap-
tured from Africa and taken to Spain, I believe, where she evidently
interbred with the Spanish, and then was sent here, because he was
born, I guess, shortly after she got here. Now that's the story that
Daddy tells. I don't know if it's so or not. Something that his father
told him, that Grandpa's father told him, so, they're just kind of pass-
ing them down.

IT:    The next is Dye Cemetery, where Steve and Caroline are buried and
that's West.

DG:    And there are tombstones in the actual places where these tomb-
stones are, because I went and checked them out.

IT:    The cemetery's not being used now. It's closed. And it is fenced in.
The kids always say that the cemetery is haunted.

DG:    It is.

IT:    They claim all sorts of weird things happen and, every once of a
while, they'll have company, and they'll want to take them to Dye
Cemetery to see if they see anything. [Laughs.] Tombstones moving
or something.

DG:    Reverend Barres tomb's supposed to open.

IT:    Oh.

DG:    I never saw it [laughs]. But I don't know. The last time I was in the
cemetery, I got so spooked . . . I wouldn't go back, but I was just there
to make sure that this is the way they set. I put some flowers up there.
There's my old yellow flower's that kept sinking in the ground. The
graves are sunken because they used to bury them in pine boxes. Here
I'm digging around trying to put some flowers in and it kept sinking
in the hole, and I kept [laughter] reaching down there and getting it.
I was so scared! And Buzz was with me or I would have thought I
was losing my mind. So he saw it too. And I said, "Come on, Buzz.
Let's get the hell out of here." And I started running to the car, and
we got in the car. And I said, "Did you see that?" And he said, "Yea,
but I wasn't going to say anything about it."

MM:    *You don't know who made those stone markers, do you?*

DG:    No. Uncle John always took care of the cemetery, but I don't know
who made the markers. Because, there were very few people buried
there, and because his parents, [who lived] in the township, used to
didn't take care of it. And so, Uncle John would go back there and

Figure 135.  Detail, Todd Family Quilt.

take care of it, because of Mother and Father. And he had a baby buried back there, also. . . . It's a nice little cemetery, if you like cemeteries. And this big tree, they cut down.

*IT:*  Cut down the old pine tree. [Laughs.]

*DG:*  No, it was a big tree that set there . . . . There's a story behind this tree [laughs]. We want to tell that story about the cemetery. OK. As the story goes, there was an old tree setting up there. And I'm going to tell about the burning too.

*IT:*  OK.

*DG:*  Somebody had said never cut the tree down. It was, I guess, kind of a warning. And so the man that takes care of the cemetery and his wife burnt or cut this tree down and took it home with them. And their house burnt down from this tree. And in the other story, they said there's too many witches buried in this cemetery, because the cemetery will not burn. And this is really true, because we went and looked at it. There was a forest fire, there's pines all the way around it. I guess some kids went back there and got to smoking and set the place on fire. All these trees were destroyed. I don't know how many acres of pine trees and things. And burnt for three or four miles, all back in there, went right around the cemetery, right around the fence, never burnt, never touched it. Never touched it. Is that so Mamma?

*IT:*  Uh-huh.

*DG:*  That really is so. And so that's why I say, don't ever go to the cemetery. It spooks you! [IT laughs.] It's spooky! It's haunted. [Laughs.] Oh, there's so many things I could tell you about the cemetery. That's where Uncle Dick saw his mother. [Laughs.] She slapped him in the face. [IT: laughs.] Uncle Dick claimed he was walking through that cemetery one day, and said that he, he kicked at this ghost or whatever it was and said, "Get out of my way!" And said it was a white woman. Well, Grandma was, you know. Said that, this woman jumped up and slapped him across his face, and he said, he wore the print for two weeks across his face of a woman's hand print. That's the story. We got to laughing about that. Oh, they just scared me to death with their stories, and I just won't go there anymore.

*IT:*  That's Grandma's actual death record. OK. The next is the register of death of Caroline Todd, February 8, 1902. Caroline Todd. Her residence at home, the time she lived there: twenty-seven years. Female, White, Date of Birth; and there's no . . .

*DG:*  She's fifty-seven.

*IT:* OK. She was married. She was a domestic. Father's name: Fred Kaeler. Birthplace: Indiana. Mother's name: says unknown.

*DG:* Unknown.

*IT:* Birthplace: Germany. She died from consumption. Her medical attendant:

*DG:* Not any.

*IT:* Not any. Place of burial.

*DG:* This says uh, what did you say, Momma?

*IT:* I said, it says Hope or White. The writing is very poor.

*DG:* She's buried back in Dye Cemetery. Her headstone's there.

The first place where they lived, see it says [reading] Steven Todd, male, sixty-six years old, farmer, he was born in Kentucky. [End reading.] I think he used the X, he couldn't read or write. Why didn't I put that on there? I guess I was trying to hurry or something, or doing it different. [Reading.] Caroline white, female, twenty-six. [End reading]. See, he's forty years older there. OK. [Reading.] Occupation: keeping house. Birthplace: Indiana. Parent's place of birth: Saxony. Charles, male son, born in Canada. Lewis, male, "mulatto." [End reading.] Isn't that funny how they left them as mulattos. They left him as a mulatto, but on a lot of them, they were black. [On] one record, I even found where he was white. He was black. I mean real black, black. Mary Jane, ah, five, it looks like she was five, what is it? It looks like she was five months old. Five, Twelfth of December.

*IT:* That's all the children they had at that time.

*DG:* At that time.

*IT:* On the census.

*DG:* My cows and my stone piles. I had to put on Grandma and Grandpa's place, where Ken and them's got the little pond. I had to put the little pond there and I had to put our little stone piles, because the Todd's were known for making stone piles. Every time they picked the land, they would put a stone pile here, a stone pile there. You would have to farm around the stone pile. Now it didn't make sense. Why didn't they put them up against a tree or something, you know? Stone piles sitting all over.

*IT:* When we had our farm, my husband had a man with the bulldozer come and bury a lot of those stone piles to get rid of them. [Laughs.]

*DG:*     Stones! [Laughs.]

*MM:*    ***Did the rest of your family in the area put them up into fence rows or . . .***

*IT:*      Yea! Some did.

*DG:*     Some did, but not with us. We had to put them in the middle of the fields. So we could go out two years later and move these stone piles. I guess that was our summer job.

*MM:*    ***[Laughs.] Are any of those stump fences up in your area, like they are up around Trufant [Michigan] ?***

*DG:*     Yes, we have stump fences, a lot of stump fences. What we do is usually get some of the pine off the stump fence, bring them home, and use it for a bonfire to roast weenies . . .

*IT:*      Well, another thing, they used the stump fences for, or the stumps they pulled out of the fences, was for kindling wood. Oh, that was the good way to start a fire for kindling, because it burns fast. Daddy was always over there with pine. Here, get some of this pine stump and throw it in your stove.

*DG:*     I think on the first one [quilt] I did try to put some pine stumps, and they didn't work out. So I guess my art's getting a little bit better. But, to draw a pine stump, you know, it's hard to make it look like a pine stump.

*MM:*    ***Could you describe a little bit more about that coat of arms. . . . Before Steven Todd, you don't know where the Todd family came from.***

*DG:*     [On the bottom] it's a coat of arms again, and it says, "Deonna Green and Ione Todd, January 1990." This is our adopted coat of arms. Well, evidently, it's our adopted name, I guess we could call ourselves Madame X, couldn't we? Or [laughs] Deonna X or, you see what I'm trying to say.

[At this point the descriptions of all the blocks were completed and MacDowell thanked Green and Todd for sharing their wonderful stories.]

# REFLECTIONS OF SARAH CAROLYN REESE ON THE WEDNESDAY QUILTING SISTERS AND AMERICAN AFRICAN QUILTING

In 1978, Dr. Sarah Carolyn Reese, a long-time member of Hartford Memorial Baptist Church, was asked by her pastor, Dr. Charles Adams, to develop an educational program for church membership that would explore and celebrate their African heritage. Reese, along with her late husband, Dr. Arthur Reese, established the American African Heritage Council and initiated a series of ambitious, diverse programs and activities ranging from poetry readings, lectures, classes, workshops, exhibitions, and performances to demonstrations by African and African American artists, scholars, and specialists. In 1984, as part of this series, Sarah Carolyn Reese organized a Wednesday gathering of women interested in quilting and other textile forms. The Wednesday Quilting Sisters has played an influential role in nurturing and sustaining sewing skills among members, expanding their awareness of the African roots of particular textile forms, and strengthening a sense of identity with a shared heritage. The annual exhibition of African textiles and African American quilts held in October at Hartford Memorial Baptist Church has provided an important mechanism to bring to a wider audience, both within the church and within the larger community, the uniqueness, richness, and variety of these historical and contemporary material expressions of culture.

On March 6, 1995, Marsha MacDowell and Anita Marshall talked with Dr. Reese at Hartford Memorial Baptist Church in Detroit about the history and philosophy behind the development of the church's quilting activities as well as about Reese's own experiences in quiltmaking. Dr. Reese had just returned from one of her numerous visits to Africa to visit friends and do research on beads and textiles. The following text was extracted from the audio-taped conversation. It opens with Reese sharing her observations and thoughts on the nature and role of artmaking in Africa and how they relate to the activities in which she has been involved.

Figure 136. Sarah Carolyn Reese.

SR:   Anything that pertains to what we call art in the West is not necessarily [considered] art in Africa. So many American African women say in their quilting that "well, we did this because we needed a comforter. We needed to keep warm." But, I notice throughout Africa, whether it's a pot [or a bead or a cloth], it's designed. Nothing is just plain, unless it's a particular wood that's so gorgeous and it is just polished to the ultimate. Or [sometimes] a piece of cloth doesn't ask for a lot of design. But if it does, then it will be put in. People do whatever's necessary to bring out the spirit of the moment. . . . And that's how I feel about quilting, about my beads, and about African beliefs . . . [there is] this spiritual aspect: the spirituality that goes into the making of objects for a particular purpose. And we [in America] see it as just something nice to look at. But for the people who made it, there's a whole other cultural tradition that goes with that piece, that we can't overlook.

Figure 137 (opposite). Sampler, Wednesday Quilting Sisters, Detroit, Wayne County, Mich.

You know this great debate about who African people are in this country? As I see it, oft times we're displaced because we don't know all the things that make us move. We know that we feel differently than people from ethnic identities feel. And yet when we go to Africa, depending on what we're looking for, of course, [and] if we go with the Western attitude, we're not going to get it. But if we just go and let things flow, we'll see why we feel the way we do. I'm so delighted when I'm there it's almost like [pause, sighs] . . ."Why didn't I know this? Look how long it's taken me to learn this!"

MM:     *You must have made good friends over the years.*

SR:     Yes, I've made good friends and I make friends as I go along. It's interesting in Africa. People say when they see Americans, "Oh, you've come home." And so they welcome you whether you've known them a long time or, or a now time. And it's always refreshing. If they decided they want to continue with you, they find ways to do so. But, I have never been rejected, ever. And of course when my husband was alive, they used to say to him, "You're more like us than any American we've seen." And he's buried there. The people in the village go up to his grave [in the Krahu Mountains in Ghana]. They have his picture on his monument. I didn't give them or tell them to put that picture there. They look at him, and they say he's come home.

MM:     *It's wonderful to have that sense of affinity, that sense of . . .*

SR:     Sense of belonging.

MM:     *Belonging, yes. And it's so rare for any of us. [Overtalk.]*

SR:     I'm really a word person I guess. But words fail me when I think about it. For instance, when I was at the estate of a woman who came back to the States. She's an African, but she lives here part of the time. So she left me at her home with the servants, some of whom wanted to go on vacation. She said [to them], "When Dr. Reese leaves, then you may take your leave." And they were so delighted and so attentive and so solicitous . . . until I got sick! [Laughter.] I mean they wanted to make sure that everything was just right, even the fruit on the tree. There was a particular odd fruit that I had never seen and the gardener said, "It will be ready by next Tuesday." And when I got ready to go, he had picked it and wrapped it for me.

MM:     *How could you leave!*

SR:     I mean, it was hard! [Laughter.]

MM:     *[When you were in Africa] did you meet with people who were quilting?*

*SR:*     No, it's interesting. My topic [of study] has been "From the African loom to the American African quilt"—you know, that's always been my theme. And in Africa the need to quilt is not there. It's only for, say, when the horsemen used to have those fancy horses, you know, and they had these covers. They're quilted. But that's a particular ornament. When I have hung [on exhibit] textiles from Africa, people have not been able to tell at first whether the piece was quilted, whether it's a quilt top, or it was a woven piece. What they still do [in Africa] is strip weaving. They don't need quilts. We needed quilts [in America] because we didn't have the loom at our disposal. Although there were loom houses in the United States on the various plantations, they weren't available to the slaves. So what they had to do was take what they knew and apply it, you know, take the materials that they could find and apply that to the woven pattern [they had learned in Africa]. That's why the quilts look like they do. So that's what's still going on in Africa: the weaving which looks like Kente strips. If it's from Mali or Senegal or any of the other places, it's still the strip, no matter what. Even if it's a blanket, like in Mali, those heavy wool blankets, they're strip woven. So they don't have to patch. The adkinkra cloth: same thing. It's stripped and then stamped. That's some of the things that I've been having our quilters [at Hartford] do. You know, I bring in various artists to teach all the kinds of techniques that they do in Africa. We had a principal weaver here from Africa to weave and lecture: to show our quilters how to do it. And so, in turn, they applied that to their quilts. What they still do in Africa is appliqué. That's one of the foremost practices.

*MM:*     *Have you seen that more in some areas than in others?*

*SR:*     In Dahomey, for instance, artists excel in the appliqué, from long ago until today, even on their flags. . . . Oh, they're great. There was a display of the flags at the African Festival in Atlanta last August. . . . There are certain things women don't do. They work hard as needle-crafters, but the men appliqué.

*MM:*     *Have you made any contact with quilters [in Africa] who are not working so much in the tradition of creating fabrics for daily use, but are more contemporary [art] quilt makers?*

*SR:*     No. I've been concentrating on my bead research. I learn about quilting and textiles, because I have a textile collection. . . . And I only approached the textiles that I get from all over Africa. I approach it from the standpoint of how it applies to sewing and how it, the patterns, can apply to quilting. So if I bring something made from raffia it will be to show the same stripping, the same gorgeous stitching. Some of our quilters have, have studied the stitching which is very intricate with raffia. The designs that they do with their needle and

Figure 138.  Detail, Sampler.

123

raffia are just wonderful. And we have some superb needle women in the Quilting Sisters.

AM: *I'm just wondering if you noticed any similarities between the adkinkra symbols that are used in some of the designs that are in some of the early slave quilts.*

SR: Oh yes, Gladys-Marie Fry [scholar of slave-made quilts] was here last year . . . and she had some cloths that were interesting. They were subtle, but they were there. The adkinkra goes back to the first century. And so the symbols have been something that has gone on and on in pottery, woods and so on, long before it went to the cloth. Those symbols are available on metals even.

AM: *What does that one [referring to Reese's necklace] mean?*

SR: This is a "Gyame." It means I fear none but God.

AM: *For sure. [Laughter; overtalk.]*

MM: *Now we're talking about religion.*

Figure 139. Detail, Sampler.

SR: Well you get a different concept of where God is when you start dealing with how other people handle their lives. You know even a quilt or a hanging is not just a quilt. It embodies not only the utilitarianism of it, but also the spirituality of it.

MM: *Do you see in your experiences in Africa, particularly in Ghana, forces that are jeopardizing that kind of continuation of creativity, in crafts, especially?*

SR: Well I think the exploitation of the work is devastating. People who are very poor have to find ways to make do. And the Europeans, particularly, will come and say, "I want this to be red, and I want this to be this, and I want it here." Well, it's violating everything you can imagine. But when people come with the bank roll, they can make things different. I noticed that in the beading, for instance.

MM: *We would like to hear about the history of quilting activities here [at Hartford].*

SR: We started the cultural programs here at Hartford in 1978. It was Dr. Adams's whole motive to request me to bring my experience to some kind of fruition at church. To not only benefit the church, but the community. So it's never been just a church program. We started out with the George Norman collection. He had these history boards, almost 500 of them. And it was the history of Africa, the transportation of Africans here, the bondage and so on. And then famous people and, or noted people throughout the whole genre of art. And it

124

occurred to me that it wasn't enough to show pictures, but we need-
ed to do. So we started having activities that relate to the African lega-
cy in American African lives. And what I thought I was doing
[laughs] was helping our people understand that we have come from
a very rich and old tradition. And it doesn't only involve music, as
most people think, but it involves everything that we do, including
the food we often prefer. We had African drummers, balopone play-
ers, hair design, fashions, and an African exhibit, plus quilts. So, for
eleven years, I've been doing a quilt exhibition, but it stemmed out of
my wanting to encompass everything.

So, this American African Heritage Council, at first, was programs of
culture. I brought in speakers and things like that. But I said, there's
something else missing. I wanted to incorporate something else in
the program that was constant. So I dreamed up this idea of having a
quilt group. And the Bryant sisters and Yancy that you've mentioned
in your book [this book] were the first ones. Now you don't have to
belong to Hartford to be a member of the quilting group. But you
have to be a sister. And in so doing, I would try to form a sisterhood.
We stopped being "Miss So and So" to each other, and we became
sisters.

. . . we developed our own workshops from our own skills and we
don't have to depend on outside consultants, outside our particular
group for specialties like beading, machine embroidering, or some-
thing like that, which is very popular in Africa. We used all these
resources to bring to our quilting beyond that which was practiced
prior. We can think of our own, and we can do our own thing. I began
bringing in [to the quilt sessions] pieces of African art. You remem-
ber Justine Burnell's quilt? The Madonna holds her babies so. And I
said, "African mothers do not hold their babies in that manner." I
brought in an African art exhibit of mothers from my collection.

MM:   *Do you choose a theme or technique every year that becomes one of
the quilting sessions?*

SR:   No, we just use the theme "from the African loom to the American
African quilt . . . the African legacy in quilting." Recently I've had a
series of workshops by Pat Kabore. Pat's a fiber artist and does all
kinds of magical things. She just is wonderful with fabrics. She has
taught them to tie dye and to make photographs on cloth, and vari-
ous things like that, to add variety, and yet give substance to the same
thing. Now in Africa, you see a celebration cloth for the various activ-
ities, like when there's a festival and so on, you'll have a picture of the
president, you'll have pictures of the important people and so on. We
have used [adkinkra] stamps in our art classes, if you want to call it
that: our quilting art classes. We're trying to incorporate as many
things; this year they're supposed to try to make a quilt made from

their own cloth. If they can't get a whole quilt, at least do some pieces, and incorporate their own work. . . . So, you see, I just don't let them get away from it, that's all. My advantage is that I can go to Africa and I have all these African friends that I can keep bringing back to the group. And many people now are traveling, and they're seeing things that before they paid no attention to. And now it has a new significance for them. And they can bring that back to what they do.

MM: *It seems like now there are available so many more quilting materials, African inspired materials, then there were even seven years ago, or eleven years ago . . .*

SR: Or five years ago.

MM: *Or five years ago [overtalk]. And certainly that is a boon to the Quilting Sisters.*

SR: Well, it's a boon to people who wish to quilt, and it is good for them if they want to. However, they [the Quilting Sisters] have available quilt material from Africa.

AM: *Is there a source where adkinkra cloth can be purchased in the Detroit area?*

SR: I only know the Shrine [of the Black Madonna, Royal Oak] carries some sometimes. But to get adkinkra cloth as such, you need somebody to go there and then, understand that it isn't easy. But there are sources. This past visit, I went to the weaving district, miles of it, through the adkinkra district, where communities do nothing but that. And you see people sitting on the front of these stoops, working, weaving.

MM: *I was just wondering if since there's this rise in available facsimile fabrics, and simultaneously, there's a rise in awareness of quilters of colors, that there will be more demand for the real fabric. Maybe more fabric will be imported, maybe somebody will become an entrepreneur and . . .*

SR: But you know the problem is that Minnesota Fabrics can sell . . .

MM: *Dirt cheap.*

SR: Absolutely. You know, I will pay $8 a yard or $12 a yard, for material like the material that's in my adkinkra quilt. It has cloth from five different countries. And there isn't one piece that wasn't brought to me from the Continent. And you can't buy a yard. You have to buy six yards because it comes in six yards. So you can see how prohibitive it is. So when I, you, go to Minnesota Fabric, who knows the difference.

*MM:*   *Right.*

*SR:*   You know, it's like our saying, I don't like the women to use machines, and I've held out as long as I could. I [laugh] don't want them to use polyester. So we start out cotton, no machines, and so, those who can stick to the hand are special . . . . The authenticity, you know, to me, puts value to whatever you're doing. If it's cloth from Africa, and it's hand-done, then it's of more value I would think.

*MM:*   *What ages are involved in the quilting activities?*

*SR:*   Well we've had from age three to eighty something. There's no limit on age. There are some, there are several little girls who don't always continue because, you know, after a while, they want to run and do something else. But there's one little girl who learned to hold the needle to stitch, to sew buttons and do little things. And there's another little girl who came at age seven and stayed until her mother moved away. She's a designer, she said. She's about ten years old now. And she does design. She makes clothes for her little classmates. And I taught her to stitch. I'm not the one that does all the teaching. I just ask, "Will you do this and do this" and so on. Because nobody's better [at teaching quilting] than Shirley Gibson and Elaine Hollis. Those women are supreme. But I make some tiny stitches. And this little girl liked to learn to do the tiny stitches. And so that's what she does now. She makes clothes by hand. You know, we've had some great experiences. That's how it started.

Figure 140.   Detail, Sampler.

You know, most African people think that quilting belongs down South and to the old people. And there's a guard here who refers to us—in fact she's the lieutenant—she refers to us as the junior-seniors because we're not all seniors.

*MM:*   *Are there any programs that the American African Heritage Council has that are specifically geared for kids?*

*SR:*   Well again, this is an African cultural thing. One does not separate, and even when, even if the church separates, it's for learning, practical, work-related reasons. They're doing the African thing! Because in Africa, everybody is together.

*[AM:*   *What is the name of the group?]*

*SR:*   [The quilting group is not called] the Hartford Quilting Group. It is part of the American African Heritage Council, and they are the Quilting Sisters.

*AM:*   *Why do you use American African rather than African American? That's why I made that switch in my mind.*

*SR:* We've been using it for over twenty years, maybe twenty-five years, and the idea being that the, who we are politically, nationally is American, and we are culturally African. Hence we are American African people.

The other continuing program of the American African Heritage Council is the festival when we have also an annual American African Quilt and Fabric Arts Exhibition. I have a doll show, fashion show, and hair show, along with the quilts. Women who want to sell quilts can do so.

*AM:* *Oh, I'd like to see it. So it's American African Quilt and Fabric Arts.*

*MM:* *When is the exhibit held?*

*SR:* Well, it's always the third weekend [of October]. We change as little of the schedules as possible so that people know this is what you have. Last year we used only the Quilting Sisters [in our fall exhibit]. It was the most beautiful exhibit I think we've probably had, so far as quilts were concerned. We had thirty-six quilts. Two quilts came from the community when people just came with them and we accepted them, but we didn't really advertise for other quilts. It was so colorful and beautiful.

Did you know that we had shown at Chicago, at the Museum of Science and Industry in 1989? They asked me to come and give a talk on the African influence in quilts. And I took African fabrics to show how they were linked. And there were fifteen of our quilts on display for a month. And we have shown in the Fisher Building [in Detroit]. Three years I think it was, the exhibit was in the concourse of the Fisher. And we were trying to negotiate a gallery. The problem is [laughs] that the people want to buy, and our quilters don't want to sell. So, we're trying to get some women who will sell some, and still allow us to hang, because it's very difficult for me to get up a piece.

*MM:* *You have been the initiator of these programs; are there individuals who will carry on these programs?*

*SR:* And I'm not sure how far I can go. It has to do about whether I should pass it on? I would like to. I don't want to lose the cultural impetus. And that's the only reason I've kept at it as long as I have. Because, you know, I have a background of struggle, a background of commitment. You know how preacher's daughters are: preacher's children. You've got to, so on and so on. I've been exposed to so much, you know, having worked in the Civil Rights Movement, and just been active, that I don't expect anybody to come and do what I do. It's probably time for it [the American African Heritage Council] to be something different. But I hope that I can find someone who

**Figure 141.** Detail, Sampler.

can keep the flavor. And if not, then we can go and each one teach one. And carry on. Some of the people have gone on to be their singular persons, quilt wise, like Denise Reed. I think I read that she was doing an exhibit at the Lincoln Library [in Detroit]. Some of the quilters in the Wednesday Quilting Sisters participate in other exhibits. So I don't feel that I have a one-person option on them. I just feel that I've done the best I could in serving our cultural interests.

MM: *It seems like it's unique and it would be great if it could be maintained.*

SR: Thank you.

AM: *I was wondering if you have an archive of information about your quilting exhibitions and the individual quilters and if, you know, at some point someone will begin to leave a written legacy rather than just an oral legacy of what has transpired over these years.*

SR: Well, I write, but I don't know anybody else that does it. You know, I keep a record of all the exhibitions and the pieces that I pass out, pieces that sometimes the other people bring to share. I haven't collated it in the sense that I have my bead information but I hope to do so. I've thought about it [writing the history], but I didn't start these programs for anything other than the good I thought of the community.

MM: *What do you think of the quilters who are forming an organization I believe called the African American Quilters Association?*

SR: Yes, I've heard about them. I haven't connected with them yet, but I really believe it's important that African people somehow come together. Not to be necessarily separate in the sense that people who are concerned may think, but it's a matter of guarding our past, and seeing what it is we have in common, and how we can recoup our losses. When you think about what it means to be of one ethnic identity as opposed to another, there are certain things that one should cherish, there are certain things that one should build upon, there are things that may be negative that you don't need as extra baggage. But by the same token, if you've got something that is compatible, and historically important, then I think it's time that it should be done. And we're the only people in this country that haven't been about the business of getting this together, getting ourselves together. Maybe the musicians are together, more than anybody else.

MM: *I was wondering, did you have any experience in quilting in your family?*

SR: Oh, that's interesting, because I'm not from a quilting family. I saw quilts, but they were not major in my life. I think that I understood blankets and comforters. I'm a minister's daughter, you know, and I think the women must have quilted at the church, but that was not part of my life. Not until my mother died did I know anything about how quilts were constructed. And there was a woman who belonged to our church who took this little seven year old under her wing. She didn't teach me to quilt; she taught me to sew. And that's how I learned the tiny stitches which she applied to her quilt. But for me, she taught me to make little things, like little blouses and pinafores and things like that. So I didn't come up quilting. But always I was fascinated by the beauty of them, and thought, that's what they do. You know, it's just way out of my realm.

MM: *Are you still quilting?*

SR: I'm not doing much. I'll do a few more, just a few more. I'm not really committed like some of the women are. I think [pause] the quilting that I did, was to prove I could do it. I really don't have the time. I would if I could! [Laughter.] I would!

MM: *Well, you've also got a book on beads to write, a book on textiles, a book on the church's quilting [laughs]. And you can't do it all! I've run out of questions right now . . . is there anything you would like to add?*

SR: I'd like to just say thank you. This has been a wonderful conversation.

MM: *It has been.*

AM: *Thank you.*

# ✤AN INTERVIEW WITH ROSA PARKS, THE QUILTER

Rosa Parks brought two quilts to the African-American Quilt Discovery Day held June 14, 1986, at the Detroit Historical Museum, to be registered as part of the Michigan Quilt Project. One was made by her mother, Leona McCauley, and the other by Parks. It is not surprising that Parks, raised in a Southern community rich with quilting traditions and by occupation a seamstress, should also be a quilter. She learned quilting within her family, made quilts for gifts and as covering for her beds, and enjoyed seeing quilts on exhibit at museums and at county fairs. Scraps left over from her work as a seamstress provided material for piecing quilts.

In 1992, Mrs. Parks was the honored recipient of a quilt specially constructed for her by the Boise Peace Quilt Project. The top of the quilt is filled with pictorial references to the events in Parks's life that have made her famous and the back is pieced of a wide variety of rose-patterned fabrics. The quilt was presented to Mrs. Parks at a special ceremony in Boise, Idaho along with a scrapbook explaining all of the panels and the stipulation that she had to sleep under the quilt at least once. Mrs. Parks considers this one of the most cherished awards she has received because of the "work that went into it, the dedication, and the historical demonstration through this quilt of the Civil Rights Movement. It makes it not only a very beautiful piece of handwork, but also historical."

In this edited interview, conducted in Mrs. Parks's Detroit home on June 30, 1994, Deborah Smith Barney explores with Mrs. Parks the place of quilting within her life. These words provide a glimpse into an activity that has played a continuing, yet little-known role in her life.

**DSB:** *Mrs. Parks, it's an honor to meet you and an honor to interview you for MSU Museum.* OK. *When did you first learn about quilting? Do you remember where you were and what you were doing when you first discovered quilting?*

**RP:** Well it was at home, in [Pine River], Alabama. My mother and my grandmother would be making quilts and I started making quilts, you know, piecing quilts when I was very young—probably about six years old.

**DSB:** *That early!*

**RP:** Yes. Just learning then, how to put the squares together. So it's just one of those things that was done at the home when we're not busy doing something else.

**DSB:** *Did you like it right away?*

**RP:** Yes, I think so. I had learned to use a thimble. My mother bought a very small thimble for me when I was little, and I learned to use it then, and, just wanted to be doing what I saw them doing.

✤

**Figure 142.** Rosa Parks. Photograph by Marsha MacDowell.

**Figure 143** (opposite). Rosa Louise Parks (b. 1913). Appliquéd Floral Medallion, made 1949, Montgomery, Ala. Collection of the artist. Cotton with cotton filling, 78" x 90", MQP 86.733.

DSB:    *Did everyone in your family sleep under a quilt?*

RP:     Well that was our main cover for cold weather. Of course quilts was sometimes made out of various things. There would be little scraps and maybe some parts of old garments would be cut up and used, the best part of them. We had different kinds of quilts, we did. But most probably would be cotton material and have a cotton batting on the inside, between the lining and the top of the quilt.

DSB:    *Now, did your mother and grandmother also use the patterns to make quilts? You know, the Wedding Band and the Grandmother's Flower Garden—all those different patterns. Did they use those?*

RP:     Well my father's mother did the fan—did fancy quilts. Of course, I didn't grow up with her. But I know she made all kinds of patterns, the same old Irish Chain, Double Irish Chain, and yes, Wedding Band and the Star quilts, and then some. Years ago I made one of the Wedding Band quilts out of very small pieces.

DSB:    *So did she buy her patterns from the store?*

RP:     Oh no! [Laughter.] I don't remember buying any. I may have bought one after I got grown, but it seemed like they just made up their own patterns. Maybe took a piece from another quilt and you made patterns.

DSB:    *And they taught you how to do that as well?*

RP:     Well I, yes I guess I learned from them. [Laughter.]

DSB:    *What did you like about quilting?*

RP:     Well what I like is the finished product, and I also like the fact that when you do your sewing and put aside the scraps, that you can make use of the small scraps by making quilts.

DSB:    *Do you remember the very first quilt you made all by yourself?*

RP:     Oh, well I was pretty young then. I put my very first quilt together when I was probably about ten. It was very seldom, though, that we made a quilt alone, because most of the times it was sort of a family project.

DSB:    *Was it a patchwork quilt?*

RP:     It was a patchwork. I hadn't gotten into the appliqué.

Figure 144. Leona McCauley. Nine Patch, made ca. 1950-60, Montgomery, Ala. Collection of Rosa Louise Parks. Satin, 48-1/2" x 80", MQP 86.734.

*DSB:* *So who in the family would quilt, and, was there a particular time of day, or a particular time of week when that would happen?*

*RP:* We usually did it, if you're speaking about in a rural area, it would be when we didn't have the field work to do and didn't have the other chores to do. And we would finish up and have a saved time that we could find convenient to sit down and work on the quilts.

*DSB:* *So now when you say the family worked on it together, would, that would be your mother, your grandmother—who else would be involved?*

*RP:* Well, sometimes in quilting maybe somebody would come in to visit, it might be a friend and would just join in and help.

**Figure 145.** Boise Idaho Peace Quilt Project. *The Rosa Parks Quilt.* Courtesy of Boise Idaho Peace Quilt Project.

*DSB:*    *Now. We know that you're also a seamstress. When did you start sewing and how did that tie into your quilting work? Or did it?*

*RP:*    Well, I started sewing quite young too. My mother was a teacher, but she also did sewing. She taught me a good deal about sewing until I went to school in the city. I was eleven years old and of course, we had sewing then so I started sewing quite young. First dress, I remember making was a very simple dress. It was the first dress I could wear [laughs].

*DSB:*    *Did your sewing and your quilting kind of work together for you?*

*RP:*    Well, whenever we had scraps left from the garments that we made, we'd just put them aside, until we had a chance to work on the quilt, using scraps that were left over, whatever, from sewing.

*DSB:*  *Do you have any idea how many quilts you have made?*

*RP:*  No. [Laughs.] I actually I have . . . [coughs] actually count the number [unclear words], and we'd use them for cover, and then, of course you can use them only for so long, and they'd eventually wear out, so we would just keep making them all the time.

*DSB:*  OK. *When is the last time you've done some quilting?*

*RP:*  I believe the last time I was working on a quilt was when my mother was making a quilt and I was helping her. But it's been quite a while. She died in 1979, and she was ill and unable to work on the quilts. I think her hands probably had arthritis. I was very busy working on the job, and looking after her, so I wasn't able to do any quilt work. I have some pieces around that she wasn't able to finish. Some quilt tops. One day, if I can find the time, I will probably get those together, and maybe do something.

*DSB:*  *I'm just curious. I know that, in some areas, when girls were prepared to become brides, they had to have a certain number of quilts [laughs] and quilt tops ready. Was that something that was a part of your story?*

*RP:*  Oh well, I did make a few quilts before I got married.

*DSB:*  *Tell me about the beautiful quilts that you lent to the MSU Museum. I think one had a white background.*

*RP:*  Well I bought the material for that. And the package [of pattern and material]. And of course all I had to do was cut out the material for it and put them on the top—appliqué it on there.

*DSB:*  *Did you still use a cotton batting, or did you use a polyester blend?*

*RP:*  No it was, it was cotton.

*DSB:*  *Cotton,* OK

*RP:*  It was not very good, the cotton. It was already made up, but it was not polyester. But I guess I made it with polyester on the back and top of it! [Laughs]. . . I started that in the [19]40s. I've used it some, but I haven't used it a great deal. Of course the other one that my mother made, the pink one. The different types of fabric, mostly rayons and silk, or whatever class of materials she could get, she'd use that for scraps.

DSB: *Well is there any special material you like working with? I know the cotton batting, you said that. But do you prefer cotton? Or, silks or satins?*

RP: Well that soft cotton material. Now some material, you find that, you can't do hand sewing on there because it's hard to get your needle through with ease.

DSB: *Do you do lap quilting or do you have the big hoop?*

RP: Well I have had quilting frames that you just have a span, but after I moved to a small apartment seven years ago, I just gave them away to one of my cousins.

DSB: *Now, when you think about quilting now, [as opposed] to all the other things you've done and continue to do in your life, is there a special place that quilting has in your mind and your heart and if so, what is it?*

RP: Well I think it—I've got into so many other things that I don't think about it as much as I probably once did. And I also crochet and knit. It was just something that I enjoyed doing when I was married, and didn't ever seem to be a burden of any kind. You know I always like to look at quilts in museums and exhibits. That's one of the things I used to do, when I went to the state fair, used to enjoy looking at the hand work of various people, and liked especially the quilts.

DSB: *Well, I want to thank you for talking with me about your quilts and sandwiching me in your busy day here. God bless you and thank you again.*

RP: And thank you.

# THE MOORE FAMILY QUILT

The Moore Family Quilt *Commemorating Fifty Years of Service*, pictured in figure 89 on page 60, was presented to Reverend N. Roosevelt Scott on March 11, 1983, for fifty years of service as a minister with the African-American Episcopal Zionist Church. The pictured blocks depict family and church events that occurred over the fifty years of his ministry. Their descriptions follow.

**ROW 1**
*Picture 1*
> Wedding photograph of Dolores Moore, the quiltmaker (Reverend Scott's daughter)

*Picture 2*
> Herbert Scott (Reverend Scott's son) in his Air Force uniform

**ROW 2**
*Picture 1*
> Moore family (Dolores's family)
> Lisa Moore (Reverend Scott's granddaughter)
> Reverend Scott
> Forty-fifth wedding anniversary of the Reverend and Mrs. N. Roosevelt Scott

*Picture 2*
> N. Roosevelt and Elizabeth Scott

*Picture 3*
> Peter and Pamela Moore (Reverend Scott's grandchildren)
> Dolores, Herb, and Joe (Reverend Scott's children)
> Fourth Eagle Scout in the family (news item)

**ROW 3**
*Picture 1*
> Dolores teaching
> Great-grandmother Scott
> Great-grandmother Scott with Moore great-grandchildren
> Herb Scott (news item)

*Picture 2*
> Moore grandchildren
> Reverend Scott at the family home
> Dolores and Bill Moore
> Dolores at Disneyland
> Reverend Scott receiving his doctorate with wife Elizabeth at his side

**ROW 4**
*Picture 1*
> Lori Scott (Reverend Scott's granddaughter)
> Herb and Lorraine Scott's wedding photo
> Kevin Scott (Reverend Scott's grandson)
> Lori Scott
> Paula Scott

*Picture 2*
> Bill and Dolores Moore's wedding photo
> Billy's baby
> Dolores on her honeymoon
> Dolores in high school
> Great-grandmother Scott
> Dolores and Bill's wedding

*Picture 3*
> Dolores with Mary and Queen at church (Bill's sisters)
> Linda Horn, Bernard, and April Scott (Reverend Scott's son and family)
> Pat Whitefield
> Bernard Scott

**ROW 5**
*Picture 1*
> Pamela Moore in high school

*Picture 2*
> Peter Moore in high school

**ROW 6**
*Picture 1*
> All four photographs taken at Elizabeth Scott's funeral

*Picture 2*
> Reverend N. Roosevelt Scott

*Picture 3*
> First two photographs of Reverend Scott, with Elizabeth, receiving his doctorate
> Christopher awards wings to Dolores Moore (family memento)
> Dolores receives her master's degree
> Lisa Moore

# AFRICAN AMERICAN QUILTING IN MICHIGAN: A QUILTING BIBLIOGRAPHY

Anita Marshall

## I. Quilting Experience in Michigan

Fitzgerald, Ruth D., and Marsha MacDowell. *Michigan Quilts: 150 Years of a Textile Tradition.* East Lansing, Mich.: Michigan State University Museum, 1987.

The first publication to come out of the Michigan Quilt Project included only two African American quilters: Ione Todd and Deonna Green. The project, however, set in motion the study of African American quilting in Michigan.

Fry, Gladys-Marie. "Stitched From the Soul: Slave Quilts From Ante-Bellum South." Gallery talk in series *African-American Quiltmaking Traditions in Michigan*, Michigan State University Museum, East Lansing, Mich., 8 December 1991.

Gallery talk by one of the foremost authorities on African American quilting and professor at University of Maryland, College Park related to exhibition of same title.

Gash, Barbara. "More Than Ever Before, The Quilt Can Tell the Story." *Detroit Free Press*, Metro Final, 12 October 1993, Sect. WWL, p. 10.

A review of book by Ami Simms that includes a piece about Julie Richardson-Pate who made her first quilt in the aftermath of her young adult son's death.

Green, John. *Negroes in Michigan History.* Detroit, Mich.: Privately published, 1985.

This volume contains a reprint of the 1915 *Michigan Manual of Freedmen's Progress* in which several quilts were mentioned.

Honore, Sheridan. "Quilts Made in African-American Style On Display." *Lansing State Journal,* Date unknown.

Review of Michigan State University Museum quilt exhibition.

MacDowell, Marsha, and Lynne Swanson. "Afro-American Quilts." *Michigan History* 75, no. 4. (July/August 1991): 20–23.

Article gave a historical review of the development of the exhibition *African-American Quilting Traditions in Michigan*. It includes photographs and brief notes for a slave quilt and quilts made by Viney Crawford, Mary Williams, Mary Adkins, Sina Phillips, and Deonna Todd Green and Ione Todd.

Michigan State University Museum. *African-American Quiltmaking Traditions in Michigan.* Traveling exhibition. Michigan State University Museum, East Lansing, Mich., 17 November 1991–5 January 1992; African American History Museum, Detroit, 5 November 1991–5 January 1992; Flint Institute of Arts, Flint, Mich., 23 February–5 April 1992; Ella Sharpe Museum, Kalamazoo, Mich., 15 January–15 March 1993.

A sampling of quilts showcasing the diversity inherent in quilts made by African American quiltmakers living in Michigan. Also included quilts owned by members of Michigan's African American population.

Michigan Women's Historical Museum. *Exhibition featuring quilts by Michigan State Quilter, Rosie Wilkins, from Muskegon, Mich.,* Lansing, Mich., 1 August–24 September 1989.

In conjunction with the exhibit, Rosie Wilkins led a quilting workshop at the MSU Museum on 16 September 1989 from 9 a.m. until 3 p.m., followed by a reception.

Simms, Ami. *Creating Scrapbook Quilts.* Flint, Mich.: Mallery Press, 1993.

Includes a quilt made by Julie Richardson-Pate. This first and only quilt was made by Richardson-Pate to come to terms with the sudden death of her twenty-year-old son, Theron Richardson.

Warfield, Carolyn. "African-American Quilts at MAAH." *Michigan Citizen* 14, no. 4 (21 December 1991): 82.

Highlights *African-American Quilting Traditions in Michigan* exhibition at the Museum of African American History in Detroit, Mich.

Watson, Susan. "Nobel Winner Also Wins a Heart." *Detroit Free Press*, Metro Final, 18 October 1993, Sect. NWS, p. 18.

Column includes an announcement of Hartford Memorial Baptist Church's Ninth Annual American African Quilt and Fabric Show which was held the week of 23 October. This show featured a lecture by Gladys-Marie Fry entitled "Slave Women's Legacy to African American Needle Art."

**Afro-American Quilters' Guild, Flint, Mich.**

"African-American Quilting Traditions in Michigan." *FIA* (Flint Institute of the Arts) (January/February 1992): 5.

Articles reviewing exhibition of same name at the institute, which featured quilts made by five Flint quilters.

Afro-American Quilters' Guild. "African American Heritage in Quilting." Demonstration and slide lecture at the Flint (Michigan) Public Library, 17 and 28 February 1990.

Azizian, Carol A. "Piece Works: Stories are Part of the Fabric of Quilt-Making." *Flint Journal*, 23 February 1992, Tempo, G1, 4.

Article spotlights members of the Flint Afro-American Quilters' Guild whose quilts were part of the *African-American Quilting Traditions in Michigan* exhibition at the Flint Institute of Arts. Included are Lucille Rolston, Derenda Collins, Jeffalone Rumph, Cora Lee Vanderson, Teressie May, Dolores Moore, and Taylorie Bailey.

Barlow, Jaynaya. "Saginaw's Garment District." *Saginaw (Mich.) News*, 22 August 1993.

Announcement for the 26th Annual Saginaw African Cultural Festival featuring a photograph of Jeffalone Rumph with one of her quilts.

Flint Afro-American Quilters' Guild. *Annual Quilt Show*. Exhibitions. Second Annual Show: 8–9 November 1991, Charity United Methodist Church, Flint, Mich.; Fifth Annual Show: 14–15 October 1994, Charity United Methodist Church, Flint, Mich..

Michigan Historical Museum. "Celebrating Michigan's Black Heritage." Demonstrations. Michigan Library and Historical Center, Lansing, Mich., 1 February 1992; 6 February 1993; 5 February 1994; 4 February 1995.

Flint Afro-American Quilters' Guild presented a small display and demonstrated quiltmaking.

Michigan State University Extension Program. "Visual Arts, Crafts and Folkpatterns." Workshop. Kettunen Center, Tustin, Mich., 23–25 October 1992.

Teressie May and Jeffalone Rumph presented workshop on quiltmaking for 4-H leaders.

Moses, George. "Local Group Hosts Colorful Display of Quilters' Talents." *Flint Journal*, 14 November 1991, Tempo, G1.

George Moss reviews the guild's second annual quilt show.

Peoples-Salah, Dionne. "Ties That Bind: Quilters Piece Together African-American Tradition." *Flint (Mich.) Journal*, 20 August 1994, B1–2.

A review of the fifth annual quilt exhibit sponsored by the Flint Afro-American Quilters' Guild, the article presents historical information about the guild and features quilters Iris Marable, Jeffalone Rumph, and Derenda Collins.

Saginaw Black Cultural Alliance. "Roots Quilting Exhibit." *25th Annual Saginaw African Cultural Festival*, 20, 21, and 22 August 1993, Saginaw, Mich.

Included quilts made by the Flint Afro-American Quilters' Guild, including quilts by Teressie May.

_____. "Roots Quilting Exhibit." *26th Annual Saginaw African Cultural Festival*, 19–21 August 1994, Saginaw, Mich.

Included quilts made by the Flint Afro-American Quilters' Guild, including quilts by Teressie May.

Smith, Jeff. "Quilting Man." *Flint Journal*, 9 May 1993, B1–2.

> Article spotlights Leo McClain, the only male member of the Flint Afro-American Quilters' Guild, whose mother taught him to quilt as a child.

**Gwen Gillespie, Detroit, Mich.**

Gillespie, Gwen. "Rapid Stitch: New Methods in Quilting." Lecture in series *African-American Quiltmaking Traditions in Michigan*, Michigan State University Museum, East Lansing, Mich., 7 December 1991.

> Lecture/demonstration featuring Gwen Gillespie, a Detroit quiltmaker.

**Carole Harris, Detroit, Mich.**

Benberry, Cuesta. "Style of Their Own—Two Black Quiltmakers." *American Quilter Magazine* 4, no. 1 (spring 1988).

> Discusses characteristics of African American quilts and includes interviews with Carole Harris, Michigan quilt artist, and Lillian Beattie of Chattanooga, Tennessee.

Carterette, Pat. "Library Leadership 2000: Quilting a Vision for Ohio Libraries." *Wilson Library Journal* 68, no. 10, p. 39.

> Quilt by Carole Harris is featured in photograph at head of this article.

Colby, Joy Hakanson. "Art by Man or Machine." *Detroit News*, 11 November 1994, E10.

> Reviewer focuses on the visual appeal of Harris's quilts. A brief biographical note is included.

Harris, Carole. "Color and Design in Quilts." Lecture in series *African-American Quiltmaking Traditions in Michigan*, Michigan State University Museum, East Lansing, Mich., 23 November 1991.

> Lecture/demonstration featuring Carole Harris, professional designer and quiltmaker.

_____. "September." *The 1995 Girl Scout Calendar*. New York: Girl Scouts of the United States of America, 1994.

> Photograph of Carole Harris demonstrating quilting techniques of a trio of girl scouts.

_____. Exhibitions

*National Black Arts Festival*. Atlanta, Ga., date unknown.

1989. *International Quilt Festival*. Invitational exhibition. Houston, Tex.

1990. Detroit Gallery of Contemporary Crafts. Detroit, Mich.

1990. Mount Clemens, Mich.

> Received best of Original Quilt Designs award.

1991. Janis Wetsman Gallery. Birmingham, Mich.

1991. *Michigan Quilt Traditions*. Birmingham, Mich.

1992. *International Quilt Festival*. Houston, Tex.

1992. Central Michigan University, Mt. Pleasant, Mich.

1992. *Spirit of the Cloth*. Traveling exhibition to Frank Hale Black Cultural Center, Ohio State University, Columbus, Ohio; American Museum of Quilts and Textiles of San Jose, San Jose, Calif.; National Afro-American Museum and Cultural Center, Wilberforce, Ohio; Junior Black Academy, Dallas, Tex.; Quiltworks '93, Louisville, Ky.

1992. *10th Annual National Quilt Festival*. Silver Dollar City. An invitational challenge held in Branson, Mo.; Joliet, Ill.; Arlington, Tex.; Springfield, Mo.; Aledo, Ill.; Atlanta, Ga; Harlingen, Tex.; Minden, La.; Lancaster, Penn.; Thief River Falls, Minn.; Madisonville, Ky.; Paducah, Ky.; Grand Island, Nev.: Indianapolis, Ind.; Eureka, Calif.; Sauder Village, Ohio.

1991-94. *Michigan Metro Girl Scout Council Art Exhibit and Benefit Sale*. Detroit, Mich.

1994. *New Aspects: Quilted Works by Carole Harris*. Solo exhibition. Arnold Klein Gallery, Royal Oak, Mich., 14 October–19 November.

1994. Solo exhibition. Art Klein Gallery. Royal Oak, Mich.

1994. Solo exhibition. Gallery 7. Detroit, Mich.

**Teressie May, Flint, Mich.**

Bowers, Claudia. "Leaving a Legacy." Unpublished manuscript, Charity United Methodist Church, Flint, Mich., 6 May 1994.

A drama about quilting presented at the Mother and Daughter Banquet sponsored by the Charity United Methodist Women, starring quilter Teressie May.

Crossroads Village. *Gospel at the Crossroads.* Exhibition. Saturday, 22 August 1992.

Program included quilting demonstrations and display in which May took a prominent part. Lois Flowers's Irish Chain quilt won third place.

Genesee Valley Center. *Quilting: A Piece in Time.* Exhibition. Flint, Mich., 19–24 October 1982.

Included quilts made by members of the Senior Citizen Quilt Factory. Teressie May was an instructor for this group.

R.S.V.P. (Retired Senior Volunteer Program). Interview with Teressie May by Margaret Burwell. *Planning for Tomorrow*, ACTION Project under the auspices of the Flint Community Schools, Spring 1984.

An interview with May in which she provides tips to newcomers on how to get started, materials and supplies needed, and other advice.

**Ione Todd and Deonna Green, Mother and Daughter Team, Romulus, Mich.**

Ashbaugh, Rosalie. "Mecosta Has Generations of Black History." In East ??, 25 February 1991, 1, 7.

Discusses the settlement of African Americans in Mecosta County, the Old Settlers' Reunion, and the family history quilt made by Ione Todd and Deonna Green to preserve their family history.

Douglas, Karen. "People, etc." *Lansing State Journal*, 24 July 1991, D2.

Reviews *Michigan History Magazine* article that features a Green/Todd quilt and announces quilting exhibition at the Michigan State University Museum.

Ella Sharp Museum. *Insight.* Ella Sharp Museum, Jackson, Mich., January 1993.

Announcement of the opening reception for the *African-American Quiltmaking Traditions in Michigan* exhibition organized by Michigan State University Museum which ran from 14 January through 7 March 1993. February 20 was Family Heritage Day, February 28 was Family Quilt-History and Heritage lecture, and included quilting demonstrations. Featured story about Dionna Todd Green and Ione Green's family history quilt and Ione Thomas, aged ninety-one. Her quilts were part of the Community African History Project portion of the exhibit.

"Family History Quilt." *QNM*, September 1988, 32.

Article used the Todd Family Quilt as a representative of this category of quilts, including a brief caption which gave the history of this quilt.

Fred Hart Williams Genealogical Society. "Notes from the Membership." *Fred Hart Williams Genealogical Society Newsletter*, Burton Historical Collections, Detroit Public Library, 6, no. 2 (June 1987): 2.

Announces Deonna Green's inclusion in publication *Michigan Quilts, Celebrating 150 Years of a Textile Tradition* and participation in exhibition of the same name.

Green, Deonna, and Ione Todd. "Family History Quilts." Lecture in series *African-American Quiltmaking Traditions in Michigan.* Michigan State University Museum, East Lansing, Mich., 14 December 1991.

Lecture/demonstration featuring Deonna Green, Ione Todd, and genealogist Fred Hart Williams.

Michigan State University Museum. *Michigan Quilts, Celebrating 150 Years of a Textile Tradition.* Exhibition. Michigan State University Museum, East Lansing, Mich., 31 September–15 November 1987.

Exhibition features quilts by Michiganders, including the Todd/Green team, shown in three locations: Michigan State University Museum, Kresge Art Museum, and the Michigan Women's Historical Museum.

_____. "Quilts on Computer?" *The Associate* (Newsletter of the Associates of Michigan State University Museum, East Lansing) 8, no. 3 (spring 1991): 7.

Overview of a forty-five-minute interactive computer program developed for a quilt exhibition that focused on the various blocks in the Todd Family Quilt under the supervision of Peter Wehr and executed by Catherine Johnson and Kevin Hendrickson.

Romsta, H.D. "Green, Todd Turn Family History Into Art." *Big Rapids (Mich.)*, 16 August 1989, B2.

An interesting article giving excerpts from the Todd/Green family history and the quilters' zeal to communicate their history through the medium of quilts.

Rose, Judy. "Pieces of Family History." *Detroit Free Press*, 3 March 1991, H1–2.

The *Todd Family Quilt* and history are used to introduce readers to African American quilting exhibit at Michigan State University Museum featuring forty-eight quilts made in Michigan or connected to Michigan in some way. Includes photographs of Deonna Green, Ione Todd, and Carole Harris.

"Wheatland Music Organization recognizes Black History Month on 9 February 1991." Presentation. Gladys Wernette Building, Remus, Mich.

Deonna Green and Ione Todd Family Quilt Project presentation on techniques for depicting family history through quilt making.

**Hilda Vest, Flint, Mich.**

Vest, Hilda. "Your First Quilt: An Introduction to Quilting." Lecture in series *African-American Quiltmaking Traditions in Michigan.* Michigan State University Museum, East Lansing, Mich., 16 November 1991.

Lecture/demonstration featuring Hilda Vest.

**Lula Williams, Detroit, Mich.**

Williams, Lula. Exhibition. Chicago Museum of Science and Industry, Chicago, Ill., February 1988.

Two quilts exhibited during Black History Month exhibition.

_____. 1988 Michigan State Fair Community Arts Division. August/September 1988.

Received an "Honorable Mention" for pieced patchwork quilt.

_____. *Art in the Autumn.* 1989 Christian Art–Mixed Media at the Lutheran Center, 579 Nine Mile Road, Ferndale, Mich., 28–29 October.

Featured the *I Am* quilt and *Cross & Crown* pillow designed and made by Mrs. Williams.

_____. *Art in the Autumn.* 1990 Christian Art–Mixed Media at the Lutheran Center, 579 Nine Mile Road, Ferndale, Mich., 27 and 28 October.

Featured the *I Am* quilt and *Cross & Crown* pillow designed and made by Mrs. Williams.

_____. "An Introduction to Friendship Quilts and Appliquéing." Lecture in series *African-American Quiltmaking Traditions in Michigan.* Michigan State University Museum, East Lansing, Mich., 21 December 1991.

Lecture/demonstration featuring a Michigan quiltmaker and quilt instructor.

_____. "Detroit Senior Centers Showcase." Demonstration. 1991 Michigan State Fair, Detroit, Mich., 30 August 1991.

Lula Williams demonstrated quiltmaking.

_____. *Evans Piecemakers Present a Quilt Showing on Friday, 11 December 1992 at 13950 Jos Campau.* Exhibition.

Quilts by Lula Williams and other Piecemakers were shown at the Evans Senior Citizens Center along with a raffle and Christmas Party.

_____. "Quilting Workshop." Demonstration in series *African-American Quilting Traditions in Michigan.* Museum of African American History, Detroit, Mich., 1992.

Evans Piecemakers Quilting Guild members Lula Williams, Gwen Gillespie, and Hilda Vest conducted a quilting demonstration.

## II. Exhibitions and Exhibition Catalogs

Adams, Monni. "Who'd a Thought It: Improvisations in African-American Quiltmaking." *African Arts* 21, no. 4 (August 1988): 88.

Review of exhibition catalogue supporting Leon's thesis promulgating the African cultural connection in African American quilting.

*Always There: The African-American Presence in American Quilts.* 1992 traveling exhibition to Museum of History and Science, Louisville, Ky.; San Diego Historical Society, San Diego, Calif.; Museum of American Folk Art, New York; Valentine Museum, Richmond, Va.; Anacostia Museum, Washington, D.C.; Spencer Museum of Art, Lawrence, Kans.; Butler Institute of American Art, Youngstown, Ohio; Minnesota Museum of American Art, Minneapolis, Minn.; Museum of American Life and Culture, Dallas, Tex.

Exhibition included a quilt made by Carole Harris, Detroit, Mich.

Bell, Michael Edward and Carole O. Bell. *Quilting: Folk Tradition of the Rhode Island Afro-American Community.* Exhibition at Rhode Island Black Heritage Society. n.d.

Exhibition catalogue of the work of women at the Quilting Club at the St. Martin DePorres Center.

Benberry, Cuesta. *Always There: The African-American Presence in American Quilts.* Louisville: Kentucky Quilt Project, 1992.

This exhibition catalogue includes quilts by Michigan quilt artist Carole Harris.

Bennett, Marcia. "They Are What They Seam." *Pittsburgh Post-Gazette,* 7 September 1994, 13, 17.

A review of crafts exhibition at the North Hills Art Center which featured quilts by members of Pittsburgh's African-American Quilters Guild. Several quilts explain quiltmaking techniques.

Birmingham Museum of Art. *Black Belt to Hill Country: Alabama Quilts from Robert and Helen Cargo Collection.* Exhibition at Birmingham, Museum of Art, 13 December 1981–24 January 1982 and Montgomery Museum of Art, 16 September–24 November 1982. Birmingham, Ala.: Birmingham Museum of Art, c. 1982.

An exhibition catalogue featuring Alabama's quilting culture.

Burchard, Hank. "The Quilts of Color." *Washington Post,* 6 August 1993, 53:1 (newspaper abstracts).

Burchard reviews the exhibition *Always There: The African American Presence in American Quilts,* on display at the Anacostia Museum in Washington, D.C. through 17 October 1993.

California Afro-American Museum. *Traditions in Clothing: African American Quilts/West African Textiles.* Exhibition. Los Angeles, 5 January–23 March 1986.

Exhibition highlighting the commonalties between African American use of cloth design in quiltmaking and West African textile techniques.

Chaveas, Lucille. "Who'd a Thought It: Improvisations in African American Quiltmaking." *Journal of American Folklore* 105, no. 418 (fall 1992): 477–79.

A very critical review of the exhibit and accompanying catalogue.

Dailey, Cleo. "African-American Quilters Take the State." *Lady's Circle Patchwork Quilts*, no. 102 (October 1994): 28–31.

Article gives an overview of the Second Annual African-American Quilt Show and Conference sponsored by the National African-American Council. The meeting was held in Lancaster, Pennsylvania. Featured are photographs of quilts by the Pittsburgh area's African-American Heritage Quilters Guild members Julianne McAdoo, Gerri Benton, Lucille Clark, and Ruth Ward.

Dilworth, Robert. *The Ties that Bind*. Detroit, Mich.: New Initiatives for the Arts, 1995.

A small catalogue of a traveling exhibition that featured two of Carole Harris's quilts.

*Folk Heritage Festival Program*. Exhibition. Johnstown, Penn., 4–6 September 1992.

The African-American Heritage Quilters Guild, which is open to all Pittsburgh women of color, was one of the groups who participated in this three-day exhibition of crafts by local artisans and artisan groups.

Freeman, Roland L. *Something to Keep You Warm: The Roland Freeman Collection of Black American Quilts from the Mississippi Heartland*. An exhibition at the Mississippi State Historical Museum, a division of the Department of Archives and History, 14 June–9 August 1981. Jackson, Miss.: Department of Archives and History, Mississippi State Historical Museum, 1981.

An exhibition catalogue published to accompany exhibition of the same title.

Fry, Gladys-Marie. *Broken Star: Post Civil War Quilts made by Black Women*. Dallas, Tex.: Museum of African-American Life and Culture, 1986.

_____."Harriet Powers: Portrait of a Black Quilter." In *Missing Pieces: Georgia Folk Art 1770-1976*, ed. Anna Wadsworth. Atlanta, Ga.: Georgia Council for the Arts and Humanities, 1976.

_____. *Stitched From the Soul: Slave Quilts from the Ante-bellum South*. New York: Dutton Studio Books, 1990.

Exhibition catalogue that accompanied this exhibition of slave quilts.

Glass, Barbara, ed. *Uncommon Beauty in Common Objects: The Legacy of African American Craft Art*. Wilberforce, Ohio: National African American Museum and Cultural Center, 1993.

This exhibition catalogue includes quilt made by Carole Harris, Michigan quilt artist. Includes African American quilters among the urban quilters in this quilt show.

Griffith, James S. *Geometry in Motion: Afro-American Quiltmakers*. Eugene, Ore.: Visual Arts Resources of the University of Oregon Museum of Art, n.d.

A brief description by the director of the Southwest Folklore Center, University of Arizona, of quilters from Pima County, Arizona that were part of a traveling exhibition.

Grudin, Eva. "The Exquisite Diversity of African-American Quilts." *Fiberarts* 16, no. 3 (Nov/Dec): 41.

A review of the exhibit, *Stitching Memories: African-American Story Quilts*, mounted by Williams College Museum of Art, in which the diversity of quilt styles represented is discussed.

_____. *Stitching Memories: African-American Story Quilts*. Williamston, Mass.: Williams College of Art, 1990.

Exhibition catalogue that accompanied exhibition with same title. Text gives an historical analysis of quilting traditions and the place of these traditions within quilting literature. A quilt made by Michiganders Deonna Todd Green and Ione Todd is included.

Gutcheon, Beth. "All Things Bright and Beautiful." *Washington Post*, 5 December 1993, Sect. WBK, p. 6, col. 1.

A comparative book review which includes a review of Maude Southwell Waldman's *Signs*

*and Symbols: African Images in African-American Quilts 1750–1950.*

Hansen, Rena. "Painted Story Quilts [exhibition at] Bernice Steinbaum Gallery, New York (Faith Ringgold)." *Women News Artist* 12 (June 1987):24.

Review of composition and technique used by Faith Ringgold in creating her story quilts.

Homewood Art Museum and University of Pittsburgh Art Gallery. *Hands of Praise.* Exhibition co-sponsored by Homewood Art Museum and University of Pittsburgh Art Gallery at the Frick Fine Arts Gallery in Oakland, Penn., 1 October 1993–31 October 1993.

Exhibition of African American artisans included works by quilters Ardelle V. Robinson and Sandra Ford.

Janeiro, Jan. "African American Quilts Feature Flexible Patterning." *Fiberarts* 15, no. 2 (1988): 41–42.

This review of the exhibit *Who'd a Thought It: Improvisation in African-American Quiltmaking* includes a photograph of Henderson, Texas quilter Willia Ette Graham, and a quilt made by Charles Cater.

Jones, Rebecca. *Protecting the Past: Photo Quiltmaking with Artist Rebecca Jones.* Demonstration. National African American Museum Project, Smithsonian Institution, Arts & Industry Gallery Studio, Washington, D.C., 22 October 1994.

Koplos, Janet. "Who'd a Thought It: Improvisation in African-American Quiltmaking." *Crafts* 103 (March/April 1990): 49.

Leon, Eli. *Arbie Williams Transforms the Britches Quilt.* Exhibition at the Mary Porter Sesnon Art Gallery, University of California at Santa Cruz, 2 November–10 December 1993 and Berkeley Art Center, 24 April–5 June 1994. Santa Cruz, Calif.: Mary Porter Sesnon Art Gallery, University of California, 1993.

The exhibition showcases the work of Arbie Williams who uses discarded pants or "britches" to create her quilts in the strip style.

_____. *Models in the Mind: African Prototypes in American Patchwork.* Winston-Salem, N.C.: Diggs Gallery, 1992.

An exhibition catalogue linking patchwork quilting techniques to indigenous West African textile traditions. Includes biographies of quilters whose works are featured in text.

_____. *Who'd a Thought It: Improvisation in African-American Quiltmaking.* San Francisco: San Francisco Craft and Folk Art Museum, 1987.

Exhibition catalogue for this show featuring quilts made by Oakland, California residents.

Mason, Marilyn. "Sewing Together a Lost Tradition." *Christian Science Monitor*, 29 November 1993, 20:1.

Discusses Waldman's book *Signs and Symbols . . .* as an introduction to African American quilting exhibition *Who'd a Thought It . . .* that opened 17 December at the Metropolitan State College in Denver.

McCoy, Mary. "A Patchwork of African American History at Anacostia Museum." *Washington Post*, 16 September 1993, Sect. DC, p. 6:1.

A review of the exhibit *Always There: The African American Presence in American Quilts* featured at the Anacostia Museum.

McWillie, Judith. *Another Face of the Diamond: Pathways Through the Black Atlantic South.* Exhibition catalogue. New York: Intar Latin American Gallery, 1989.

Miro, Marsha. "Artist's Imagination Shapes Collages of Vivid Color." *Detroit Free Press*, Metro Final, 21 February 1989, Sect. FTR, p. G3.

Article includes a brief historical and descriptive overview of the exhibit *Something to Keep You Warm*, which was on display at the Detroit

Historical Museum. This exhibit of quilts made by rural Mississippi women was organized by Roland Freeman.

Museum of American Folk Art. *Great American Quilt Fest 4*. Quilt show. New York, at Pier 92 on the Hudson River, 12–16 May 1993.

Includes African American quilters among the urban quilters in this quilt show.

Nadelstern, Paula. "Citiquilts A Show of Diversity." *Clarion* 16 (spring 1991): 55–59.

Brief sketches of four urban quilters whose work appears in *Citiquilts, the Great American Quilt Fest 3* in New York City. Included is Michael Cummings.

National African-American Quilt Council. *Second Annual African-American Quilting Exhibition and Conference*, Lancaster, Penn., April 1994.

Includes quilts by Carolyn Mazloomi, Gerry Benton, Cleo Dailey, Michael Cummings, and Julieann McAdoo.

_____. *Third Annual African-American Quilting Exhibition and Conference*, Bowie State University, Bowie, Md., 22–25 June 1995.

Third show and conference sponsored by the National African-American Quilt Council which was formed under the leadership of Cleo Dailey.

National Afro-American Museum and Cultural Center. *Towards Definition: An Examination of African American Craft Art*. A symposium hosted in Dayton, Ohio, 12–24 November 1993 by the National Afro-American Museum and Cultural Center in conjunction with *Towards Uncommon Beauty . . .*, traveling African American craft art exhibition.

_____. *Uncommon Beauty in Common Objects: The Legacy of African American Craft Art*. Exhibition. 23 October 1993–31 January 1994, National Afro-American Museum and Cultural Center, Wilberforce, Ohio; 10 March–12 June 1994, American

Craft Museum, New York, N.Y.; 1 July–10 September 1994, African American Panoramic Experience Museum, Atlanta, Ga.; 1 October–10 December 1994, Museum of African American Life and Culture, Dallas, Tex.

A project of the National Afro-American Museum and Cultural Center located in Wilberforce, Ohio and the Ohio Historical Society, this traveling exhibition includes utilitarian objects or "craft art" common to the African American experience such as bowls, bed coverings, tools, jewelry, and other ceremonial and useful objects. Art quilts by Sandra German, Carole Harris of Detroit, Mich., and Carolyn Mazloomi are included.

Newman, Joyce Joines. *North Carolina Country Quilts: Regional Variations*. Chapel Hill, N.C.: Ackland Art Museum, University of North Carolina, 1978.

North Hill Arts Center. *African American Quilts: Smockers Group*. Exhibition. Pittsburgh, Penn., 18 July–10 August 1991.

Exhibition of featured quilts made by African American Heritage Quilt Guild.

*Pennsylvania National Quilt Extravaganza*. Fort Washington, Penn., 15–18 September 1994.

This exhibition include pieces by outstanding African American quilters.

Pittsburgh, Penn. City Council. *African-American Heritage Quilters Day*, 1 April 1994.

"Quilt Exhibit Explores African-American Traditions." *Philadelphia Tribune*, 14 January 1994, 2–C.

A review of Philadelphia Museum of Art's exhibition *Community Fabric: African-American Quilts and Folk Art*. Background information on the mounting of the exhibition and ancillary activities are given.

*Quiltfest, USA*. Louisville, Ky. Convention Center, 24–27 August 1994.

This exhibition included pieces by outstanding African American quilters.

Ringgold, Faith. *Change: Painted Story Quilts.* Exhibition at the Bernice Steinbaum Gallery. New York: The Gallery, 1987.

Exhibition catalogue in which Faith Ringgold, a textile artist, is shown as a narrative visual artist and masterful storyteller.

San Francisco Craft and Folk Art Museum. *Who'd a Thought It: Improvisation in African-American Quiltmaking.* Traveling exhibition. 1 February–21 March 1991, Indianapolis Museum of Art; 13 April–26 May 1991, Discovery Museum, Bridgeport, Conn.; 13 June–8 September 1991, Long Beach Museum of Art, Long Beach, Calif.; 28 September 1991–5 January 1992, Renwick Gallery, Washington, D.C.; 1 February–29 March 1992, Ackland Art Museum, University of North Carolina, Chapel Hill; 28 April–31 May 1992, Honolulu Academy of Art; 2 June 1992–15 September 1992, Wichita Falls Museum and Art Center, Wichita Falls, Kans.; January–February 1993, Kirkpatrick Arts Center, Oklahoma City, Okla.

Talley, Charles S. "African-American Improvisations." *Artweek* 19 (20 February 1988): 3.

Article reviews and critiques exhibit and catalogue in terms of their perspective as a showcase for displaying the improvisation and individuality associated with African American quiltmaking as reflective of African cultural base.

University of Michigan, School of Art. *For John Cox' Daughter: African-American Quilts from the Southeastern United States.* Ann Arbor, Mich.: School of Art, University of Michigan, c. 1991.

Exhibition catalogue for display mounted by Gallery, University of Michigan's School of Art.

Verdino-Sullwold, Maria Carla. "Stitched From the Soul." *Crisis* 96, no. 9 (November 1989): 10.

In this review of the exhibition of same title, the author views slave women as "creative artisans" with highly developed textile skills.

Wahlman, Maude Southwell. *Community Fabric: African-American Quilts and Folk Art.* Exhibition.

Philadelphia Museum of Art, Philadelphia, Penn., 13 February 1994–10 April 1994.

A unique exhibition that focused on Southern visual aesthetics. It consisted of 120 pieces, including fifty quilts on loan from North Carolina, Tennessee, Alabama, Georgia, and South Carolina. The wood carvings, metal work, fans, quilts, decorated boxes, drawings, paintings, and ceramics were produced between 1860 and 1980. It included lectures by Maude Wahlman and Cuesta Benberry.

_____. "Continuities Between African Textiles and Afro-American Quilts." In *Traditions in Cloth.* Los Angeles, Calif.: California African-American Museum, 1985.

_____. *Signs and Symbols: African Images in African-American Quilts.* New York: Dutton Books, c. 1993.

_____. *Ten Afro-American Quilters* . Exhibition catalogue. University, Miss.: Center for the Study of Southern Culture, 1983.

Williams College Museum of Art. *Stitching Memories: African-American Story Quilts.* Williamstown, Mass.: Williams College Museum of Art. Exhibition appearing 15 April–1 October 1989, Williams College Museum; 8 October 1989–31 December 1990, Studio Museum in Harlem, N.Y. (combined with *From the Studio: Artist-in-Residence,* 1988–89, featuring Willie Cole, Renne Green, John Rozelle exhibition); 2 Feb 1990–15 April 1990, Oakland Museum, Oakland, Calif.; 26 June 1990–26 August 1990, Baltimore Museum of Art, Baltimore, Md.; 21 September 1990–16 December 1990, City Gallery of Contemporary Art; 31 January–10 March 1991, Taft Museum, Cincinnati, Ohio; 14 April 1991–26 May 1991, Memphis Brooks Museum of Art, Memphis, Tenn.; 10 August 1991–27 October 1991, Strong Museum, Rochester, N.Y.

Exhibition included *Todd Family Quilt* by Deonna Green and Ione Todd

## III. General Works

"The African American Presence." In *New Jersey Quilts 1777 to 1950: Contributions to an American Tradition*, eds. Rachel Cochran, Rita Erickson, Natalie Hart, and Barbara Schaffer. Paducah, Ky.: American Quilter's Society, 1992, 146–49.

Gives a historical sketch of slavery and quilting in state of New Jersey.

Benberry, Cuesta. "Woven Into History." *American Visions* 8, no. 6 (December–January 1993): 14–18.

A brief historical analysis of the role patchwork quilting has played in the lives of African American women, both as a necessity and as an aesthetic expression.

Cabeen, Lou. "Contemporary Political Fibers: Criticizing the Social Fabric." *Fiberarts* 17 (summer 1990): 32–35.

In this critical review of three fiber artists, Cabeen discusses Faith Ringgold's story quilt technique using painted images and lettering and patchwork borders for her works and the story behind the stories portrayed.

Calahan, Nancy. *The Freedom Quilting Bee*. Tuscaloosa, Ala.: University of Alabama Press, 1987.

Chinn, Jennie A. "African-American Quiltmaking Traditions: Some Assumptions Reviewed." In *Kansas Quilts and Quilters*, eds. Barbara Brackman, Jennie A. Chinn, Gayle R. Davis, Nancy Hornback, Sara Reimer Farley, and Terry Thompson. Lawrence, Kans.: University of Kansas Press, 1993.

Clark, Ricky. *Quilts in Community*. Nashville, Tenn.: Rutledge Hill Press, 1991, 6, 19, 160.

Includes a brief biographical sketch of Mary Bell Johnson from Massillon, Ohio, and a photograph of one of her quilts, *Pine Burr*. Also shown is a photograph of the *Underground Railroad Quilt* made by descendants of former slaves living in Oberlin, Ohio and those active in the underground railroad.

Coleman, Floyd. "Mediating the Natural: Craft Art and African American Cultural Expression." *International Review of American Art* 11, no. 2 (spring 1994): 24–27.

Author discusses the need to legitimize quilting art through creation of a scholarly definition, research, and publication.

Dewhurst, C. K., Betty MacDowell, and Marsha MacDowell. "Afro-American Religion and Art." In *Religious Folk Art in America: Reflections of Faith*. New York: E.P. Dutton in Association with the Museum of American Folk Art, 1983, 46–48.

Provides a cursory linkage between Harriet Powers's quiltmaking techniques and Fon (Dahomey, West Africa) ethnic group.

Dobard, Raymond. "Quilts as Communal Emblems and Personal Icons." *International Review of American Art* 11, no. 2 (spring 1994): 39–43.

Discusses nineteenth-century quiltmaking as a folk art that produced a covenant in cloth where ideals of redemption and emancipation coexist. Includes photographs of Dobard's *Evening Flowers* and *Tranquillity Quilts* and Harriet Powers's *Pictorial Quilt*.

Ferrero, Pat, Elaine Hedges, and Julie Silber. *Hearts and Hands: The Influence of Women and Quilts on American Society*. San Francisco, Calif.: The Quilt Digest Press, 1987.

Ferris, William, ed. *Afro-American Folk Arts and Crafts*. Boston: G.K. Hall, 1983.

Freeman, Roland L. *A Communion of the Spirits: African-American Quilters, Preservers, and Their Stories*. Nashville, Tenn.: Rutledge Hill Press, 1996.

Chronicles growing up with quilts and, beginning in 1974, documenting quilters and their stories across the nation.

Hollander, Stacy C. "African American Quilts: Two Perspectives." *Folk Art* 18 (spring 1993): 44–51.

A critique of Maude Southwell Wahlman and Cuesta Benberry's diverse perspectives on the aesthetic origins of African American quilting.

Horton, Laurel. "Always There: The African-American Presence in Quilts." *Journal of American Folklore* 106, no. 421 (summer 1993): 355–57.

Review of Cuesta Benberry's book with same title.

Horton, Laurel, and Lynn Robertson Myers. *Social Fabric: South Carolina's Traditional Quilts.* Columbus, S. C.: McKissick Museum, University of South Carolina, 1985.

Jeffries, Rosalind. "African Retention in African American Quilts and Artifacts." *International Review of African American Arts* 11, no. 2 (spring 1994): 28–38.

Argues the case for African American quilting traditions that continue old cultural themes, motifs, and images from African past.

Kusserow, Karl. "Threads of Evidence: Attributing an Anonymous Quilt to an African-American Maker." *Folk Art* 19, No. 1 (spring 1994): 46–47.

Author uses Maude Southwell Wahlman's six broad design elements shared by African American quilters to identify a quilt given to the Museum of American Folk Art. Oral history placed the quilt between 1920 and 1930 and the maker as a black woman who worked in a socking factory. The characteristics included tendency towards strip organizational pattern; use of large design motifs; the use and contrast of colors; tendency to alter common patterns and designs so as to produce an "out of sync" visual image; variation more common than regularity of design elements; and use of multiple patterns within a given piece.

Lewis, Maggie. "Afro-American Quilts: Patching Together African Aesthetics, Colonial Craft." *Christian Science Monitor*, Section B, 1 December 1982.

Lippard, Lucy. "Up, Down, and Across: A New Frame for New Quilts." In *The Artist & The Quilt*, ed. Charlotte Robinson. New York: Alfred A. Knopf, 1983.

Mainardi, Patricia. "Quilt Survivals and Revivals." *Arts Magazine* 62 (May 1988): 49–53.

McDonald, Mary Anne. "Because I Needed Some Cover: Afro-American Quiltmakers of Chatham County, North Carolina." M.A. thesis, University of North Carolina at Chapel Hill, 1985.

McMorris, Penny. "Afro-American Quilts." In *Quilting II.* Bowling Green, Ohio: WBGU-TV, Bowling Green University Press, 1982.

McWillie, Judith. "Another Face of the Diamond: Black Traditional Art from the Deep South." *Clarion* 12, no. 4 (1987).

Nzegwu, Nkiru. "Spiritualizing Craft: The African American Craft Art Legacy." *International Review of African American Art* 11, no. 2 (spring): 16–23.

Author takes a careful look at valuing the African aesthetic in African American craft art. Carole Harris, Michigan quilt artist, is one of the artisans reviewed whose work is pictured in this article.

Price, Sally. "The Afro-American Tradition in Decorative Arts: Basketry, Musical Instruments, Wood Carving, Quilting, Pottery, Boat Building, Blacksmithing, Architecture, Graveyard Decoration." *Ethnohistory* 39, no. 2 (spring 1992): 242–44.

Critical review of the reissue and update of Vlach's 1978 text from the perspective of a Caribbeanist in which the chapter on quilting has been expanded.

Puckrein, Gary A. "Signs and Symbols: African Images in African American Quilting." *American Vision* 8, no. 4 (August–September 1993): 34.

A review of Maude Southwell Wahlman's book.

"The Purple Quilt." *Art Magazine* 61 (January 1987): 7.

Ramsey, Bets, and Gail Andrew Trechesel. *Southern Quilts: A New View.* McLean, Va.: EPM Publications, 1991, 28–30.

Features a brief discussion of African American quilting experience in the South, and quilters Matilda Wood, Mattie Ross, and Lillian Beattie. This book does not include photographs of African American quilts.

Ramsey, Bets, and Merikay Waldrogel. *The Quilts of Tennessee*. Nashville, Tenn.: Rutledge Hill, 1986.

Robinson, Beverly J. *Aunt [ant] Phyllis*. Washington D.C.: American Folklife Center, Library of Congress, 1982.

An overview of the life of a woman who was known for many things, including her stories, her knowledge of traditional medicine, and her quilts.

Stone, Sherry. "Penn Teacher Traces Black History Through Quilting." *Philadelphia Tribune*, 11 February 1994, 5–B.

Announcement of a new class "Appreciating African-American Quilting" at the University of Pennsylvania taught by Ph.D. candidate Cassandra Stancil. The class focused on quilts as a part of African American folklore and material culture.

_____. "The Art of Attracting Blacks to the Museum." *Philadelphia Tribune*, 15 February 1994, 1(A).

Philadelphia Art Museum's Vice President for External Affairs Cheryl McClenney Brooker discusses folk art, which includes quilts, as a legitimate artistic expression worthy of exhibition in mainstream fine art museums and as a means for attracting minorities into the museology.

Thompson, Brian. "Songs of My People." *Indianapolis Recorder*, 1 January 1994, 1(C).

Treece, Jim. "The Patchwork Quilt." *Business Week*, 6 May 1991, 140(1).

Reviews Faith Ringgold's *Tar Beach* and Valerie Flournoy's *Patchwork Quilt*.

Wahlman, Maude Southwell. "African-American Quilts: Current Status." *Folk Art Finder* 12, no. 1, 1991.

_____. "African-American Quilts: Tracing the Aesthetic Principles." *Clarion* 14, no. 2 (spring 1989): 36–44.

Article discusses the African cultural influences on African American aesthetics that emerge quite naturally in the quilt art of African Diaspora women in the new world.

_____. "African Symbolism in Afro-American Quilts." *African Art* 20 (November 1986): 68–76.

_____. "Afro-American Quiltmaking" and "Pecolia Warner, African-American Quiltmaker." In *The Encyclopedia of Southern Culture*. University, Miss.: Center for the Study of Southern Culture, 1990.

_____. "Religious Symbolism in African-American Quilts." *Clarion* 14, no. 3 (summer 1989).

_____. "The Art of Afro-American Quiltmaking: Origins, Development, and Significance." Ph.D. dissertation, Yale University, History of Art Department, 1980.

Wahlman, Maude Southwell, and John Scully. "Aesthetic Principles in Afro-American Quilts." In *Afro-American Folk Arts and Crafts*, ed. William Ferris. Boston: G.K. Hall, 1983.

Walker, Marilyn I. *Ontario's Heritage Quilts*. Erin, Ont.: Boston Mills Press Book, 1992, 108.

Photograph and brief discussion of an A.M.E. *Conference Quilt* made by members of the local Missionary Mite Societies in the Canadian Annual Conference. The project was coordinated by Hattie Johnson M.M.S. Includes a brief reference to black presence in Canada.

## IV. Quilting Artists and Groups

"Black Quilters Emerging as Part of History." *Los Angeles Sentinel*, 4 February 1993, A–13.

A review of Cuesta Benberry's work in documenting 200 years of quiltmaking by African American women.

Boston Museum of Fine Arts. *Harriet Powers, Afro-American quilt, 1895–1898*. Slide set. Boston: Museum of Fine Arts, 198?.

A set of forty slides showing examples of Harriet Powers's quilts.

Bourne, Kay. "Quiltmaker Ringgold Spins Historic and Colorful Yarns." *Bay State (Wisc.) Banner*, 15 April 1991, 14.

Review of a slide/lecture presented by quilt artist Faith Ringgold at the Isabella Stewart Gardner Museum on 25 March 1993, in which the thematic thrust of her artwork—liberation and self- determination—were incorporated into her remarks.

Cotter, Holland. "Black Artista: Three Shows." *Art in America* 78 (March 1990): 164–65.

Faith Ringgold's *Over 100 Pound Weight Loss Story Quilt* is mentioned in the article. A photograph of the quilt is included.

"Dancing on the George Washington Bridge." *Art News* 88 (February 1989): 29.

Farrish, Jean S. "Hands of Praise Celebrates the Work of Slave Artisans and Modern Artists." *New Pittsburgh Courier*, 16 October 1993, B–6.

Review of *Hands of Praise* exhibition held at the Frick Fine Arts Gallery in Oakland, Pennsylvania, which "celebrated with love and appreciation the creativity and the spirit of thousands of slave artisans," including quilters.

Fry, Gladys-Marie. "Harriet Powers: Portrait of a Black Quilter." *Sage* iv, no. 1, (spring 1987): 11–16.

Galligan, Gregory. "The Quilts of Faith Ringgold." *Art Magazine* 61 (January 1987): 62–63.

Gouma-Petterson, Thalia. "Faith Ringgold's Narrative Quilts." *Art Magazine* 61 (January 1987): 64–69.

Leon, Eli. *Arbie Williams Transforms the Britches Quilt.* Santa Cruz, Calif.: Mary Porter Sesnon Art Gallery, University of California at Santa Cruz, 1993.

Lyons, Mary. *Stitching Stars: The Story Quilts of Harriet Powers.* New York: C. Scribner's Sons, 1993.

Meyer, Jon. "Faith Ringgold." *Art News* 88, no. 2 (February 1989): 139–40.

Perry, Regina. *Harriet Powers' Bible Quilts.* New York: Rizzoli International, 1994.

Harriet Powers's, a quilter from Athens, Georgia, use of religious themes in her quilts is explored in this text.

Rapko, John. "Community Spirit, Faith Ringgold: A 25-Year Survey at Mills College." *Artweek* 23 (22 October 1992): 1.

Review of retrospective exhibit that ranges from Ringgold's political paintings of the 1960s through her last medium, the story quilt. Each medium expresses her articulation of communal values among a dispersed people.

Reed, Victoria. "The Revenge of Aunt Jemima." *Artweek* 21 (29 November 1990): 12–13.

Author critiques exhibit *Faith Ringgold: A 25-Year Survey.* . . . which appeared at Arizona State University Art Museum in terms of Ringgold's emphasis on what it means to be a woman and African American that permeates her work. Emphasis was on analysis of story quilts.

Ringgold, Faith. "An American Artist." *Sage* 4, no. 1 (spring 1987): 73–74.

_____. *Tar Beach.* New York: Crown Publishers, 1991.

A Ringgold quilt made into a children's book.

Ringgold, Faith, and Yi, Lisa K. "My Best Friend (a collaborative story quilt)." *Heresies* 6, no. 4 (1989): 44–45.

Roth, Moira. "Dinner at Gertrude Stein's." *Artweek* 23 (13 February 1992): 10–12.

In an interview with Moira Roth, Faith Ringgold discusses her story quilt *Dinner at Gertrude Stein's* which appeared in the exhibit at the Steinbaum Gallery in New York, as a literary work, an artistic piece, and place in her series *French Connection* and *Paris Connections: African American Artists in Paris.*

Thorne, Samuel. "Quilter's Labor of Necessity Becomes Fabric of Love." *Atlanta Journal and Atlanta Constitution*, 6 March 1994, sect. M, 1:4.

One of the finest African American quilters, Mozell Benson from Waverly, Alabama, and her work are featured in this article.

Vanelli, Jill. "On the roof." *Instructor* 100, no. 9 (May–June 1991): 64.

A critical analysis of Faith Ringgold's works.

Virginia, M. "The Bitter Nest." *High Performance* 9, no. 1 (1986): 89.

## V. Quilts: Historical and Literary Focus

Abbandonato, Linda. "Patches: Quilts and Community in Alice Walker's 'Everyday Use." In *Alice Walker Critical Perspectives Past and Present*, ed. Henry Louis Gates and K. A. Appiah. New York: Amistad, distributed by Penguin U.S.A., 1993.

Birch, Eva Lennox. *Black American Women's Writing: A Quilt of Many Colors*. New York: Harvester Wheatsheaf, 1994.

Literary criticism and historical overview in which the quilting motif is used as the basis for discussing the intricacies of African American women's written expressions.

Brown, Elsa Barkley. *African American Women Quilting*. Chicago: The Field Museum, 1988, 9–18.

Author evokes quilting imagery as she attempts to create an aesthetic milieu for creative energy found in African American women's prose.

_____. "African-American Womens' Quilting: A Framework for Conceptualizing and Teaching African-American Women's History." *Signs* 14, no. 4 (summer 1984): 921–29.

Author uses Wahlman'a and Scully's descriptions of African American quiltmaking as polyrhythmic, nonlinear, nonsymmetrical to structure her course on African American women's history in which "individual and community are not competing entities."

Clifton, Lucille. Quilting: *Poems 1987–1990*. Brockport, N.Y.: Boa Editions Ltd., 1991.

Clifton opens this poetry collection with the poem "Quilting" and uses quilt motifs to introduce each section.

Doty, Mark. "A in Shades of Black: The Black Aesthetic in Twentieth-century African Ameri-can Poetry." In *A Profile of Twentieth-century American Poetry*, ed. Jack Myers and David Wojahn. Carbondale, Ill.: Southern Illinois University Press, 1991.

The aesthetic diversity seen in quilts is used to construct a framework for discovering the meaning of African American poetic forms.

Dunn, Margaret M., and Ann R. Morris. "Narrative Quilts and Quilted Narratives: The Art of Faith Ringgold and Alice Walker." *Exploration in Ethnic Studies* 15, no. 1 (January 1992): 227–32.

A criticism and interpretation of quilting through the lenses of a visual artist and as a narrative technique by and artist of the written word.

Elsey, Judy. "The Color Purple and the Poetics of Fragmentation." In *Quilt Culture: Tracing the Pattern*, eds. Cheryl Torsney and Judy Elsey. Columbia: University of Missouri Press, 1993, 68–83.

Work in which quilting is used as a metaphor to explain the intricacies in the style, characterization, conceptualization, and motif that appear in works by Alice Walker and other African American women writers.

Fry, Gladys. *Night Riders in Black Folk History*. Knoxville: University of Tennessee Press, 1975.

Work based on thesis submitted to Indiana University by one of the leading authorities on African American quilting and folklore.

Hess, Janet Berry. "Paternational, Community and Resistance: The African American Quilt." Master's thesis, University of Iowa, 1992.

This master's thesis explores the place of quilting traditions in the social life and custom of African American slaves.

Jonas, Ann. *The Quilt*. New York: Greenwillow Books, 1984.

Kelley, Margot Anne. "Sister's Choices: Quilting Aesthetics in Contemporary African American Women's Fiction." In *Quilt Culture: Tracing the Pattern*, ed. Cheryl Torsney and Judy Elsey. Columbia: University of Missouri Press, 1993, 49–67.

Contemporary African American women writers' works of fiction are the basis for this critical analysis using the patterning and piecing of quilt-making as a tool for literary discovery.

Kendrick, Walter. "Sister's Choice." *New York Times Book Review* 96 (29 December 1991): 9–10.

A book review in which the author uses quilting terminology to discuss this text.

McMillan, Terry. "Quilting on the Rebound." In *Calling the Wind*. New York: Harper Perennial, 1993, 597–608.

National Council of Negro Women. *The Black Family Dinner Quilt Cookbook*, ed. Dorothy I. Height. New York: Simon and Schuster, 1994.

Ostriker, Alicia. "Kin and kin: The Poetry of Lucille Clifton." *American Poetry Review* 22 no. 6 (November–December 1993): 41–48.

Critical analysis of Lucille Clifton's poetry including her monograph entitled *Quilting Poems, 1987–1990*.

Peacock, John. "When Folk Goes Pop: Consuming 'The Color Purple.'" *Literature-Film Quarterly* 19, no. 3 (July 1991): 176–80.

Discusses the omission of quilting from the film *The Color Purple* and the subsequent denial of quilting and face scarring as the means through which African American women reinforced gender and racial identity and used as a mechanism for coping with oppression.

Peppers, Cathy. "Fabricating a Reading of Toni Morrison's *Beloved* as a Quilt of Memory and Identity." In *Quilt Culture: Tracing the Pattern*, eds. Cheryl Torsney and Judy Elsey. Columbia: University of Missouri Press, 1993, 84–95.

*Beloved*, a novel by Toni Morrison, undergoes critical literary assessment using "quilting" in a metaphorical sense.

Reed, Ishmael, and Al Young. *Quilt*. Berkeley, Calif.: The Authors, 1981.

The author uses a quilt as the culture symbol for this fictional work.

Showalter, Elaine. *Sister's Choice: Tradition and Change in American Women's Writings*. New York: Clarendon Press, Oxford University Press, 1991.

The title of this monograph is taken from Alice Walker's novel *The Color Purple*. The author uses "quilting" to underscore the multilevel, disparity background and experiences, and vision that come together to form a literary genre or quilting mosaic that unifies diverse, irregular pieces into a common racial/cultural identity.

# ❧TAPE-RECORDED INTERVIEWS

Additional information, photographs, and materials are located in vertical files, Festival of Michigan Folklife records, and field collections by Yvonne Lockwood, Deborah Smith Barney, Catherine Johnson Adams (catalogued under Catherine Johnson), Denise Pilato (catalogued under Denise Grusz), Kurt Dewhurst, Lynne Swanson, Wythe Dornan, and Marsha MacDowell located in the Michigan Traditional Arts Research Collections at Michigan State University Museum.

## By Deborah Smith Barney with:

Charline Beasley, Detroit, Mich., August 20, 1990, MSUM 90.081.022

The Bryant Sisters (Effie Hayes, Mary Turner, and Mattie Douglas), Detroit, Mich., July 25, 1990, MSUM 90.081.14

Justine Burnell, Sterling Heights, Mich., June 20, 1994, MSUM 94.76.1

Evelyn Chambers, Detroit, Mich., June 27, 1990, MSUM 90.81.9

Detroit Rainbow Stitchers (Deborah Moore, Sister Cathy DeSantis, Anita Garcia, Carol Shissler, Kathy Korff, Havannah Williamston, Vivian Padgett, and Anna Lee Barber), Detroit, Mich., July 24, 1990, MSUM 90.81.13

Zelma Dorris, Detroit, Mich., July 16, 1990, MSUM 90.81.11

Frances Green, Detroit, Mich., July 30, 1990, MSUM 90.81.18

Elaine Hollis, Detroit, Mich., August 6, 1990, MSUM 90.081.021

Maggie Jones, Detroit, Mich., March 24, 1990, MSUM 90.81.2

Rosa Parks, Detroit, Mich., June 30, 1994, MSUM 94.76.2

Kittie Pointer, Rodney, Mich., June 24, 1990, MSUM 90.81.8

The Quilting Six Plus, Detroit, Mich., April 7, 1990, MSUM 90.81.5, 6, 7

Denise Curtis Reed, Detroit, Mich., April 6, 1990, MSUM 90.81.3, 4

Essie Lee Robinson, Detroit, Mich., July 25, 1990, MSUM 90.081.15, 16

Daisy Vann, Detroit, Mich., July 24, 1990, MSUM 90.081.12

Marie Vincent, Detroit, Mich., June 28, 1990, MSUM 90.81.10

Beverly Ann White, Pontiac, Mich., June 23, 1994, MSUM 94.76.2

Lula Williams, Detroit, Mich., February 23, 1990, MSUM 90.81.1

Ollie Williams, Detroit, Mich., July 28, 1990, MSUM 90.081.17

Mattie Woolfolk, Detroit, Mich., August 6, 1990, MSUM 90.081.019, 20

## By C. Kurt Dewhurst with:

Several quilters at Idlewild Quilt Discovery Day, July 11, 1986, MSUM 87.102.1, 2.

## By Wythe Dornan with:

Ruth Buckner, Flint, Mich., October 16, 1989, MSUM 89.121.01

Derenda Collins, Flint, Mich., November 30, 1989, MSUM 89.121.03

Teressie May, Flint, Mich., October 16, 1989, MSUM 89.121.01

Dolores Moore, Flint, Mich., October 16, 1989, MSUM 89.121.04

Leona Morris, Flint, Mich., November 24, 1989, MSUM 89.121

Jeffalone Rumph, Flint, Mich., October 17, 1989, MSUM 89.121.02

*By Kouessi-Tanoh Remi Douah with:*

Carole Harris, Detroit, Mich., February 22, 1991, MSUM 91.66 (videotape)

*By Denise Grucz with:*

Roberta Allen, Holly, Mich., February 1, 1991, MSUM 91.14.02

Shirley Bell, Detroit, Mich., March 7, 1991, MSUM 91.14.03

Lillie Mae Jamerson, Detroit, Mich., October 10, 1990, MSUM 91.14.05

Irene Maddox, Detroit, Mich., February 18, 1991, MSUM 91.14.01

Susie Porchia, Detroit, Mich., January 15, 1991, MSUM 91.14.06

Lillie Mae Tullis, Detroit, Mich., October 16, 1990, MSUM 91.14.07

Jessie Wheeler, Holly, Mich., December 21, 1990, MSUM 91.14.04

*By Melissa Prine with:*

Mary Holmes, Muskegon Quilt Discovery Day, Muskegon, Mich., February 15, 1986, MSUM 86.69.1

*By Yvonne Lockwood with:*

Marguerite Berry Jackson and Jerilyn Smith, Remus, Mich., January 18, 1988, MSUM 88.62

*By Marsha MacDowell with:*

Josie Bibbs, Muskegon, Mich., July 24, 1986, MSUM 87.23.14

Josephine Collins, Muskegon, Mich., August 28, 1986, MSUM 87.23.15, 16

Deonna Green and Ione Todd, Lansing, Mich., January 26, 1991, MSUM 91.70.1, 2, 3

Deonna Green and Ione Todd, Remus, Mich., April 12, 1989, MSUM 89.11.2.1-2

Mary Holmes, Muskegon, Mich., May 13, 1986, MSUM 87.23.20

Marguerite Berry Jackson, Lansing, Mich., December 13, 1990, MSUM 90.135

Sina Phillips, Muskegon, Mich., July 24, 1986, MSUM 87.23.13

Sarah Carolyn Reese, Detroit, Mich., March 6, 1995, MSUM 95.70.1, 2

Velma Roundtree and Mary Burt, Muskegon, Mich., August 28, 1986, MSUM 87.23.17

*By Marsha MacDowell and C. Kurt Dewhurst with:*

Rosie Wilkins, Muskegon, Mich., May 12, 1986, MSUM 87.23.18

*By Lynne Swanson with:*

Carole Harris, Detroit, Mich., December 14, 1990, MSUM 90.127.1, 2

Sina Phillips, Muskegon Quilt Discovery Day, Muskegon, Mich., February 15, 1986, MSUM 86.68.1

# INDEX OF ARTISTS

*Although the following artists are not cited in the text, their work is included in Michigan Quilt Project (MQP) research and their names appear on MQP forms, in tape-recorded interviews, and in field notes deposited in the Michigan Traditional Arts Research Collections at the Michigan State University Museum.*

*The index of quilt names (in italic) and quilt pattern names represents a partial compilation of names as given by quiltmakers, owners, or other individuals who completed quilt inventory or loan forms. At the end of the index are names not cited in the text but included in field notes and tape-recorded interviews with quilters. The list provides an indication of the diversity of pattern use and the popularity of particular block patterns within the African American experience.*

  *Although the following quilt names and pattern names are not cited in the text, they are named in Michigan Quilt Project (MQP) research, on MQP forms, in tape-recorded interviews, and in field notes deposited in the Michigan Traditional Arts Research Collections at the Michigan State University Museum.*

Anvil
Appliqué Quilt
Arkansas Snowflake
Attic Windows
Baby Blocks
Basket
Bear Paw
Beautiful Butterflies
Blazing Sun
Bridal Wreath
Broken Arrow
Crazy
Crazy Patchwork
Creative
Dutch
Fan
Farm Hand
Flower Garden
Four Leaf Clover
Friendship
A Garden of Tulips
Grandmother's Flower Garden
Mama's Baby Quilt
Momma's Quilt
Ocean Waves

Ohio Star Dahlia
Pedigree Puppy Quilt
Poinsettia
Postage Stamp
Rail Fence
Rectangle Patchwork
Red Arrow
Reversible Quilt
Ring
Silk Tie Quilt
Six Point Stars
Spring Garden
Snowball Variation
Star of Bethlehem
Sunburst
Sunflower
Tree Everlasting
Tulip
Wandering Foot
Wreath of Flowers
Wrench
Yellow Quilt
Zinnia Variation
Z Quilt